Digital Photo Projects

FOR

DUMMIES®

Digital Photo Projects

FOR

DUMMIES®

by Julie Adair King

BICENTENNIAL
1807
WILEY
2007
BICENTENNIAL

Wiley Publishing, Inc.

Digital Photo Projects For Dummies®

Published by
Wiley Publishing, Inc.
111 River Street
Hoboken, NJ 07030-5774
www.wiley.com

WILEY

About the Author

Julie Adair King is the best-selling author of many books about digital imaging, including *Digital Photography For Dummies, Shooting & Sharing Digital Photos For Dummies,* and *Digital Photography Before & After Makeovers.* When not writing, she teaches at various locations, including such noted photography schools as the Palm Beach Photographic Centre in Florida.

A native of Ohio and a graduate of Purdue University, King now resides with her furboy, Mocha the Wacky Wheaten Terrier, in Indianapolis, Indiana.

Author's Acknowledgments

This book is the result of the creative efforts of many people, and I am deeply grateful for their input. First, a big thank you goes to project editor Kim Darosett; copy editor Virginia Sanders; and technical editor Alfred DeBat. Your thoughtful comments and suggestions made this a far better book, and I appreciate your hard work and attention to detail more than you know. The Wiley production team, led by Patrick Redmond, also did their usual stellar job on the design front.

In addition, I'm indebted to the friends and family members who allowed me to photograph them for this book. Having a reason to spend time with you is by far the best part of my job, and I value your patience, support, and love even more than your willingness to pose.

Publisher's Acknowledgments

We're proud of this book; please send us your comments through our online registration form located at www.dummies.com/register/.

Some of the people who helped bring this book to market include the following:

Acquisitions, Editorial, and Media Development

Project Editor: Kim Darosett

Senior Acquisitions Editor: Steven Hayes

Copy Editor: Virginia Sanders

Technical Editor: Alfred DeBat

Editorial Manager: Leah Cameron

Media Development Specialist: Angela Denny

Media Development Coordinator: Laura Atkinson

Media Project Supervisor: Laura Moss

Media Development Manager: Laura VanWinkle

Editorial Assistant: Amanda Foxworth

Sr. Editorial Assistant: Cherie Case

Cartoons: Rich Tennant (www.the5thwave.com)

Composition Services

Project Coordinator: Patrick Redmond

Layout and Graphics: Brooke Graczyk, Denny Hager, Joyce Haughey, Heather Ryan, Christine Williams

Proofreaders: Betty Kish, Dwight Ramsey

Indexer: Broccoli Information Management

Anniversary Logo Design: Richard Pacifico

Publishing and Editorial for Technology Dummies

Richard Swadley, Vice President and Executive Group Publisher

Andy Cummings, Vice President and Publisher

Mary Bednarek, Executive Acquisitions Director

Mary C. Corder, Editorial Director

Publishing for Consumer Dummies

Diane Graves Steele, Vice President and Publisher

Joyce Pepple, Acquisitions Director

Composition Services

Gerry Fahey, Vice President of Production Services

Debbie Stailey, Director of Composition Services

Contents at a Glance

Table of Contents

Introduction

*I*f you browse the shelves of your local bookstore, you can find many books about digital photography, including several by yours truly. As a smart consumer, you're probably wondering what makes this book different from the rest and, more important, how those differences can benefit you.

Well, for one thing, most digital photography books go into more detail than you may want (or need) to know right now. In-depth coverage is great for photography enthusiasts, but if you're just getting your digital legs, it also can be overwhelming, not to mention time consuming. In addition, most digital photography books don't say much about all the ways you can use photo software to manipulate your pictures after you get them out of your camera and onto the computer. For help with that aspect of digital imaging, you need another book altogether — especially if you're interested in working with your old film photos as well as those from your digital camera.

Digital Photo Projects For Dummies, however, gives you the best of both worlds. It gives you the basics you need to get good results from your digital camera, without overloading you with lots of technical background. And when you're ready to fire up your photo software, you get step-by-step instructions that show you exactly how to retouch and enhance all your pictures, whether they started life in digital or film form.

Here's just a sampling of what this book can help you do:

- Find the right camera, printer, scanner, computer, and software for all your digital photo projects.
- Take better digital photos by gaining control over image quality, exposure, color, and focus.
- Use simple photo-editing tools to correct just about any photo flaw.
- Retouch portraits by removing red-eye, covering blemishes, and whitening teeth.
- Scan and restore fading, discolored, or damaged prints and slides.
- Get creative with your pictures, turning them into digital collages, postcards, screen savers, and more.
- Add text, digital frames, special effects, and other enhancements.
- Produce great prints, share your photos online, and safeguard your digital files for the next generation.

At the risk of sounding like one of those late-night infomercials — but wait, there's more! — this book offers one other important feature that sets it apart from its cousins on the store shelves. Glued into the back of the book is a DVD that contains video tutorials in which I demonstrate how to accomplish some of the projects in this book as well as a few additional ones. The DVD also contains free trial versions of a variety of photo-editing software, including the program featured in this book, Adobe Photoshop Elements.

To sum up, *Digital Photo Projects For Dummies* shows you how to get the shot, edit the shot, and create something extra special with the shot. And here's the best part: Because it's a *For Dummies* book, you don't need any experience to join the fun.

About the Project Software

To provide you with step-by-step guidance for the photo-editing projects, I had to choose a specific photo-editing program. I selected Adobe Photoshop Elements, one of the few programs available for both Windows and Macintosh computer systems. Elements also offers a great assortment of easy-to-use tools at a reasonable price (under $100), which is one reason why it's among the most popular consumer photo-editing programs. (And no, I don't get paid by Adobe to sing its products' praises.)

Specifically, the steps and figures feature Photoshop Elements 5.0 For Windows. However, where version 5.0 differs significantly from version 4.0, the latest version available for Macintosh users, I include alternative instructions in the steps.

For readers who don't own Elements, the DVD included with this book contains a tryout of version 5.0 for Windows. If you prefer some other software, that's fine, too. The basic concepts apply no matter what software you use, and most programs offer similar retouching and editing tools, so you should be able to translate the instructions to your program without much trouble.

How This Book Is Organized

The Table of Contents at the front of the book spells out exactly what topics are covered in each chapter. But here's a quick preview of what each part of the book contains.

Part I: Digital Demystified

Few creative endeavors involve more confusing jargon and technical stuff than digital photography. So you have good reason to feel a little lost at first. But no worries: This part of the book helps you sort through all the mumbo jumbo and gives you a firm footing in the digital landscape.

Chapter 1 guides you through the process of choosing the right camera, photo software, and other imaging tools. Chapter 2 shows you how to get the best results from your camera, discussing such baffling options as resolution, file format, ISO, and white balance. And Chapter 3 explains how to transfer your pictures to your computer, prepare them for print and online use, and protect them from possible digital destruction.

Part II: Easy Digital Darkroom Repairs

The term *digital darkroom* refers collectively to computer software and hardware that you can use to do the kinds of things that film photographers do in a traditional darkroom — and then some. This part of the book shows you how to use those tools to fix the most common picture problems.

Chapter 4 details how to correct exposure and focus, and Chapter 5 shows you how to retouch portraits. Chapter 6 tells you what you need to know to restore and repair old film photographs; correct colors; and cover up dust, scratches, and other photo flaws.

Part III: Beyond the Frame: Project Idea Kit

When you're ready for some real creative fun, turn to this part of the book. Chapter 7 introduces you to the art of photo *compositing,* which is the process of combining photos to produce an entirely new image. You can use the techniques found there to create a digital collage of your vacation pictures, for example. Chapter 8 presents a variety of additional creative possibilities, from surrounding a photo with a digital frame to turning a color photo into a black-and-white or sepia-toned image.

Part IV: The Part of Tens

Like all *For Dummies* books, this one concludes with chapters that each provide ten easy-to-digest tidbits of information. Chapter 9 offers up ten more ways to use your digital photos, along with step-by-step instructions for tackling those projects, and Chapter 10 offers my top ten tips for improving your digital photos.

On the DVD: Bonus Content

In the introduction to this introduction, I mention that this book ships with a DVD containing some extra goodies. To get a little more specific, here's a partial list of what the DVD holds:

- **Video tutorials:** In these digital movies, which you can play on any computer that has a DVD drive, you hear my voice as I show you how to step through some of the book's projects and also how to use some Photoshop Elements tools not covered in the book. For your added viewing pleasure, the DVD also contains a couple of additional tutorials by my friend, the noted photographer Rick Sammon.

- **Photo software:** The DVD contains a free, 30-day trial version of Photoshop Elements so that you have everything you need to complete the book's projects. But so that you can experiment with other options, the DVD also offers trials of an assortment of other leading photo-editing and photo-organizing programs. As with Elements, you can use most of these trial versions free for 30 days — a great way to try before you buy.

- **Demo images:** I include copies of many of the images used in the book so that you can use them as you follow along with the steps if you want.

For details on how to access all this stuff, see the DVD appendix at the back of the book.

Icons, Symbols, and Other Stuff to Know

One goal of *For Dummies* books is to make it as easy as possible for you to find the information you need. To that end, the following icons call your attention to certain types of information:

Tip icons highlight techniques that enable you to accomplish a task more easily, in less time, or with better results.

If you see a Warning icon, the text points out a potential pitfall to avoid.

This icon labels information that provides you with background details that can prove especially handy for one-upping the techie types in your life.

When I think it's really, really important for you to retain some piece of information, I mark it with this icon.

This final icon alerts you to related content that's provided on the DVD.

You also need to know that in parts of the book that cover photo editing, the little arrows in the text indicate that you need to choose commands from the program menus. For example, if you see the phrase "Choose Enhance⇨Adjust Colors⇨Remove Color Cast," you click the Enhance menu, click Adjust Colors to open a submenu, and then click Remove Color Cast.

Finally, this book is designed, as much as possible, to enable you to dip in and out of chapters as you please — you don't need to read Chapter 4 to understand Chapter 5, for example, or even read the first part of Chapter 4 to make sense of the last part. If a project in a later chapter requires some knowledge found elsewhere in the book, I point you to that information. Of course, the index at the back of the book also helps you navigate to specific topics.

With those details out of the way, it's time for me to stop introducing so you can start reading. Flip through the book, find a project that interests you, and enjoy!

Part I
Digital Demystified

The 5th Wave — By Rich Tennant

BUNGCO
BUNGEE CORDS

"Come on, Walt-time to freshen the company Web page."

*D*on't know a pixel from a poundcake? A file format from a file drawer? Relax, you're not alone — everyone feels like a clueless outsider when they're getting started with digital photography. But the chapters in this part help you get up to speed in no time.

Chapter 1 provides the background you need to set up a digital photography studio that matches your creative interests, explaining how to decipher the product ads and giving you the inside scoop on what features are critical and which you can do without. Chapter 2 helps you understand and troubleshoot the most common digital photography problems, explaining which camera settings to change to produce the results you want. And Chapter 3 guides you through the part of the process that's often the most confusing of all: transferring your pictures to your computer and then preparing them for print and online sharing.

1

Going Digital: Gearing Up for a Great Ride

*I*magine trying to dance the tango wearing oversized, steel-toed work boots, playing a Beethoven sonata on a piano that has only 25 working keys, or painting a portrait with a 12-inch-wide roller. You might be able to get the job done — eventually — but working with the wrong equipment would quickly turn what should be an enjoyable pursuit into a frustrating chore.

To make sure that your experience with digital photography doesn't become a similar headache, this chapter helps you assemble the best equipment for the kind of projects that you want to do. If you're in the process of shopping for a digital camera, you can read my take on what features are "musts" and which ones you can do without. I also spell out what you need for a decent digital darkroom, discussing the minimum computer specs and offering advice about buying photo software, printers, and scanners.

Finally, because even the best-equipped digital photography studio can sometimes suffer minor breakdowns, this chapter concludes with a list of online resources where you can get help with questions that are beyond the scope of this book.

Choosing the Right Digital Camera

When I wrote the first edition of *Digital Photography For Dummies,* way back in 1997, only a few digital cameras existed, and most offered the same set of features, making shopping fairly easy. All you needed was cash — and lots of it.

The good news is that prices have come way, way down. The bad news is that choosing the right camera has gotten pretty complicated, with every manufacturer offering a broad lineup of styles, models, and feature sets. And your job is made all the more headache-inducing by the geekspeak used in camera ads and brochures: "Captures 8-megapixel images in Raw or JPEG!" "Built-in image stabilization!" "More than 20 scene modes!"

To help you narrow your choices, the following sections explain the most important digital camera features and how they impact your picture-taking possibilities. With this knowledge under your scalp, you can select a few top candidates for your purchase and then seek out detailed reviews to help finalize your decision. (See the list of online resources at the end of the chapter to track down reviews.)

When you're ready to buy, I suggest that you go to a camera store rather than a big-box electronics store. Salespeople in camera stores tend to be photography enthusiasts, which makes them better able to guide you to a camera that will suit your needs. In addition, most big-box stores charge a "restocking fee" — that is, you pay a percentage of the purchase price if you return the camera. Traditional camera stores are usually more reasonable (although you should ask to be sure). This return policy is especially important if you're buying the camera as a gift for someone else.

Megapixels: How many are enough?

In most camera ads, the feature that gets the most play is *resolution,* which is measured in *megapixels. Pixels* are the tiny squares of color used to create a digital image; Figure 1-1 gives you a close-up view. One million pixels add up to 1 megapixel, often abbreviated as 1 mp. (*Pixel* is short for *picture element,* if you care.)

Pixel count is directly related to picture quality. If you have too few pixels, your picture is lousy, as shown in Figure 1-2. I shot this photo with a first-generation digital camera, and the pixel population in those early models simply wasn't sufficient to produce good prints except at a thumbnail size. Note especially the jagged appearance of curved and diagonal lines, such as the edge of the girl's face.

So how many megapixels do you need? Well, for a good-quality print, you need at least 200 pixels per linear inch. For example, a 4 x 6-inch snapshot requires 800 x 1200 pixels, or a total of 960,000 pixels — just under 1 megapixel. Pictures for e-mail and Web pages require significantly fewer pixels; a pixel count in the 450×400 pixel range is appropriate for e-mail photos, for example.

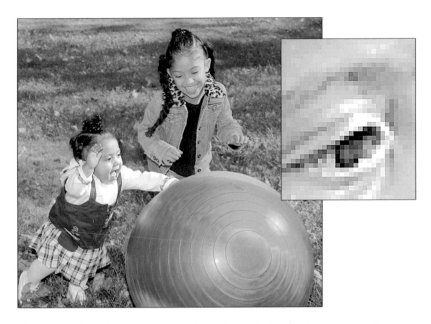

Figure 1-1: Digital images are created out of tiny blocks of color known as pixels.

Figure 1-2: An inadequate pixel count causes poor picture quality.

With the exception of cell phone cameras and toy cams for kids, all new digital cameras offer a minimum resolution of 3 megapixels, so, again, you're set for snapshot prints and even 5 x 7-inch prints. For reliable 8 x 10 and 11 x 14 prints, move up to the 4- to 6-megapixel range.

An even greater pixel count comes in handy when you want to crop your original and then produce a large print of the remaining image area. For example, the top image in Figure 1-3 contains 3008 x 2000 pixels, or 6 megapixels. That high pixel count gave me the flexibility to crop away a huge portion of the image and still have enough pixels to produce a quality print of the cropped area, as you see in the lower image.

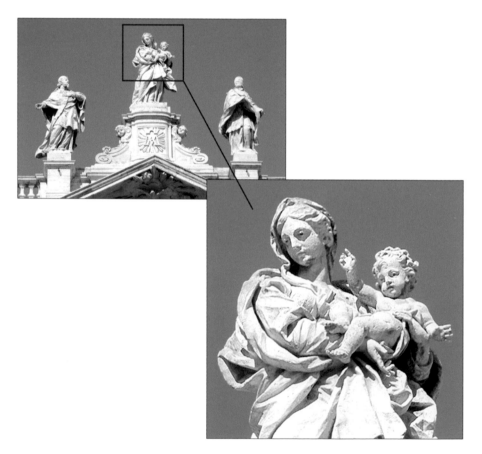

Figure 1-3: Starting with a high-resolution original enables to you crop the image tightly without sacrificing picture quality.

Unless you routinely crop photos or make large prints, though, don't spend extra for a super-megapixel camera. Put your savings into other camera features, such as a longer zoom lens, or invest in a high-capacity picture-storage card.

A look at lenses

Too many people get so caught up in megapixels and other digital specs that they don't pay enough attention to the camera's lens. But just as with a film camera, a good lens is critical to the camera's picture-taking capabilities, so the next few sections offer some lens-shopping guidance.

Focal length: What does the camera "see"?

Focal length, measured in millimeters, determines how much of a scene a lens can capture as well as how large and how far away the objects in the scene appear. Here's the scoop:

- **Short versus long:** With a short focal length, you get a wide angle of view, and subjects appear smaller and farther away. As you increase focal length, the angle of view narrows, and subjects appear closer and larger. As an example, I stood at the same spot to shoot the images you see in Figures 1-4 and 1-5 — bravely ignoring the impending thunderstorm in the name of art, I might add. But I took the first image at a focal length of 42mm; the second, 97mm.

- **Categories:** Lenses are commonly grouped into three categories based on focal length:

 - *"Normal":* A focal length of 50mm is considered "normal" and is standard on most point-and-shoot cameras. This focal length is good for capturing the type of snapshots that most people enjoy shooting.

 - *Wide-angle:* A lens with a focal length under about 35mm is considered a wide-angle lens. A wide-angle lens is great for shooting landscapes and also comes in handy for photographing a group of people from a short distance away. (The wide-angle perspective enables you to fit more people in the shot.)

 - *Telephoto:* A focal length of about 80mm or longer is referred to as a telephoto lens. A telephoto lens enables you to get close-up pictures of distant subjects, making it a favorite of travel, wildlife, and sports photographers.

- **Depth of field:** Focal length also affects the apparent *depth of field,* or the range of sharp focus. At a long focal length, objects near your subject appear sharp, but faraway objects appear blurry. At a short focal length, distant objects are more sharply focused. You can explore this issue more in Chapter 2.

42mm

Figure 1-4: At a short focal length, you capture a wider area, and objects appear smaller and farther away.

97mm

Figure 1-5: Zooming to a longer focal length narrows the angle of view and makes objects appear larger and closer.

Focal lengths: Digital versus film

Lens focal length is determined by measuring the distance between the center of the lens and the recording medium — the film negative in a film camera or the image sensor in a digital camera. But the results you get from a particular focal length depend not just on that distance but also on the size of the recording medium.

With a camera that uses 35mm film — the kind you've been putting in your film cameras for years — the size of the recording medium is consistent, as is the position of the film in the camera body. So a lens with a particular focal length provides the same view on one film camera as it does on another. This standard enables photographers to predict the capabilities of a lens based on its focal length.

The digital world is different, however. Image sensors vary widely in size, as does the location of the sensor. And because of these variations, a particular focal length on one camera may produce completely different results on another camera.

To address this issue, digital camera manufacturers describe lenses by using both the actual (digital) focal length and the equivalent focal length on a 35mm film camera. For example, a camera manual might state the lens specifications as: "5.8–23.2mm; 35mm film equivalent: 35–140mm." Don't get confused by the "35mm film" part; again, that number refers to the size of the film negative, not the focal length. And you thought computers were complex....

✏ **Zoom:** A zoom lens enables you to capture an image at a range of focal lengths. For example, I own a zoom lens that offers a range of 28 to 200mm. In everyday lingo, we use the term *zooming in* when we shift to a longer focal length and *zooming out* when moving to a wider-angle view (shorter focal length). A few cameras instead offer a choice of two or three specific focal lengths — say, 35mm and 80mm.

Speaking of a zoom lens, if that feature is important to you, be sure that the camera offers a true *optical zoom* and not just a *digital zoom*. Digital zoom is nothing more than some software manipulation that crops your image and enlarges the remaining area. The result is always lowered image quality.

A camera's focal length is usually printed around the outer band of the lens or, in some cases, elsewhere on the front of the camera body. Focal length is also stated in the camera manual. Be sure to see the nearby sidebar, "Focal lengths: Digital versus film," for some important information about the numbers you see.

If you have trouble remembering all this focal-length stuff when you're shopping, most camera stores have charts that offer a visual representation of what a lens sees at various focal lengths.

Lens quality: More important than megapixels?

In my opinion, yes, considering that all current digital camera models now offer enough megapixels for the average user, but lens quality varies greatly. A low-grade lens can cause all sorts of image defects, including:

- ✓ **Vignetting:** Often a problem with telephoto lenses, vignetting causes the corners of a picture to appear darker, as in Figure 1-6.

- ✓ **Barrel and pincushion distortion:** The former gives your subject a bloated look, as if it were wrapped around a barrel; the latter does the opposite, pinching the subject inward.

- ✓ **Color fringing:** Also known as *chromatic aberration,* this defect creates little halos of solid color around the edges of objects. Because the halos are usually purple, this defect is sometimes referred to as *purple fringing.*

Figure 1-6: Vignetting causes light falloff at the corners of an image.

Unfortunately, the monitors on digital cameras aren't large enough or clear enough to give a good indication of lens quality, although you may be able to spot serious distortion or vignetting. Theoretically, you could bring your own camera memory card to the store, shoot some test pictures, and then review the images on your computer — but that presumes that you already own the right type of memory card and that you can find subjects suitable for evaluating lens quality.

For a simpler solution, trust this aspect of your purchase decision to the pros who review cameras for a living. Read the latest issues of respected magazines such as *Shutterbug* and *Popular Photography* and also check out the Web sites listed at the end of the chapter. I probably shouldn't admit it, but that's exactly what I do when I'm in the market for new equipment.

How much control do you want?

If you're a casual photographer, you're probably used to working with a fully automatic camera. You frame the shot, press the shutter button, and rely on the camera to set the focus and exposure. And that's a perfectly legitimate approach; the auto-focus and autoexposure systems on most cameras work amazingly well.

However, if you'd like to develop your photography skills, consider a camera that enables you to better manipulate exposure and focus. By investing just a little more in your camera, you can enjoy the following features, which fall in the "semi-manual" category (or "semi-automatic," depending on how you look at it):

- **Aperture-priority autoexposure:** This feature enables you to specify the aperture setting, or *f-stop,* an exposure control that also affects *depth of field,* or the range of sharp focus in a picture. After you set the aperture, the camera selects the other key exposure setting, shutter speed (explained next).

- **Shutter-priority autoexposure:** This feature enables you to specify shutter speed, an exposure control that also affects whether moving objects appear blurry or sharply focused. For example, I took the top picture in Figure 1-7

1/120 second

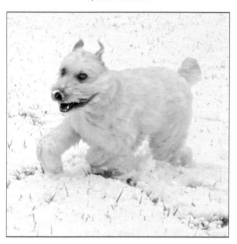

1/500 second

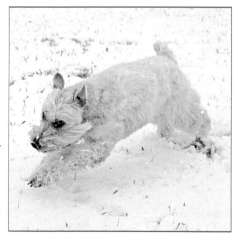

Figure 1-7: By adjusting shutter speed, you can control whether moving objects appear blurry or frozen in time.

at a shutter speed of 1/120 second, which wasn't fast enough to freeze my frolicking snow baby in mid romp. To capture the action without a blur, I upped the shutter speed to 1/500 second. In shutter-priority AE, the camera selects the appropriate aperture to properly expose the image.

✔ **Flexible (or variable) autofocus:** This feature enables you to choose from a variety of autofocusing schemes, with each option locking focus at a different distance or on a different area of the frame.

For even more creative flexibility, you can move up to a model that offers complete manual exposure and focus control. Of course, that level of control adds to the camera price.

Before you pay more for manual focusing, find out how the feature is implemented. With an SLR (single-lens reflex) camera, you adjust focus by twisting the lens barrel, as you might expect, and with some practice, you can focus in no time. But with most point-and-shoot models, you must select a specific focusing distance from a camera menu, as illustrated in Figure 1-8. This system is a little cumbersome, to say the least.

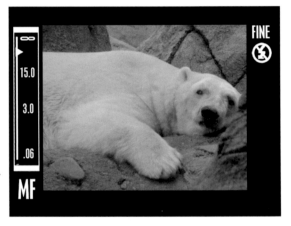

Figure 1-8: On most point-and-shoot cameras, manual focus mode requires you to select a focusing distance from a scale displayed on the monitor.

Here's one more bit of potential money-saving advice: Most cameras now offer something called *creative shooting modes* or *scene modes*. With this feature, you choose a type of picture — portrait, landscape, action, and so on — and the camera then selects the aperture, shutter speed, and, sometimes, focus mode that is considered appropriate for that type of shot. For many people, scene modes provide the best of all worlds: a little more creative control without the necessity of becoming a photography expert or spending more for the camera.

Usually, scene modes are represented by little symbols like the ones you see in Figure 1-9. Some cameras offer more than a dozen of these scene modes, giving you everything from a fireworks mode to a museum mode (which disables flash and mutes all camera sounds). Most cameras provide access to the main modes via a camera dial or button on the camera body; you have to dig through menus to choose the other modes. The more modes you can get to without going to menus, the better.

Chapter 2 provides more details about manipulating focus and exposure.

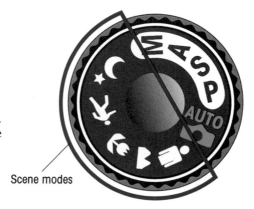

Scene modes

Figure 1-9: Creative scene modes simplify the task of shooting better portraits, landscapes, and action shots.

Raw capture: Worth the hype?

Are you the type of photographer who would enjoy going into a darkroom and developing your own film negatives? Do you demand the absolute top image quality? If so, you may want a camera that offers *Raw capture*.

A little background: The data in a digital camera file, as in any computer file, is nothing more than a series of numbers. In the case of a digital photo, those numbers represent the pixel brightness values that the camera records when you snap the picture.

At some point, those numbers have to be translated into an actual photo. Traditionally, this work is done by software built into the camera. Think of this system as the equivalent of in-camera developing of film negatives, if such a thing were possible. After the camera processes the data, the final image file is recorded to the camera memory card. In most cases, the data is stored using a file format known as JPEG (say it *jay-peg*).

File format simply refers to a type of computer data file. Many formats have been developed for storing digital art, but JPEG is the most prevalent for photographs.

A few years ago, camera manufacturers introduced another alternative, known generically as *Raw capture, Camera Raw,* or simply *Raw.* With this system, the camera writes the original, unprocessed — uncooked — data onto the memory card. Then the photographer opens the file on a computer, using special software known as a Raw converter, and takes over the process of translating the image data into a picture. Figure 1-10 offers a look at the Photoshop Elements Camera Raw converter. This process takes some time but gives the photographer the ultimate control over how the picture ingredients are baked into an image pie.

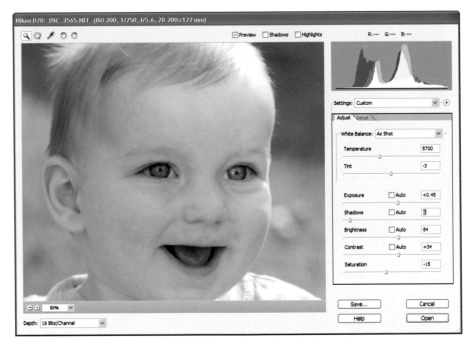

Figure 1-10: Photoshop Elements offers its own tool for processing Camera Raw files.

One other important distinction exists between Camera Raw and JPEG: JPEG uses a process known as *lossy compression,* in which some image data is dumped in the name of creating smaller files. Shrunken files are good because they eat up less space on your camera memory card. But when too much compression is applied, so much image data can be lost that you can wind up with an ugly, blocky-looking image like the one you see in Figure 1-11.

Heavy JPEG compression

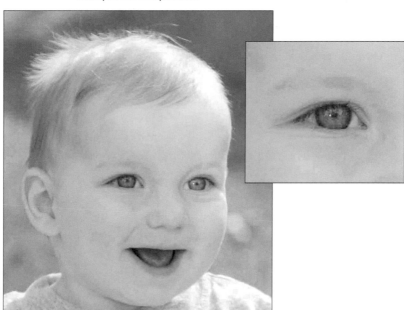

Figure 1-11: Heavy JPEG compression results in a small image file, but horrible picture quality.

Don't panic and assume that you must have Raw capture to get good digital images, though. All cameras that record JPEG photos offer a high-quality JPEG option. At this setting, the camera applies a minimum amount of compression, providing a good trade-off between image quality and file size.

Whether your eyes can tell the difference between a lightly compressed JPEG and a Raw image depends on the image, how much you enlarge the photo, and of course, how well you see. For snapshots, you're not likely to be able to tell the two apart. In fact, even when enlarged, you may not be able to spot any quality loss in the JPEG version. As proof, Figure 1-12 shows a lightly compressed JPEG image together with an uncompressed version created from a Raw capture; Figure 1-13 offers a closer inspection of both images.

Uncompressed Light compression

Figure 1-12: Most people can't see a quality difference between a lightly compressed JPEG image and an uncompressed Raw image.

My take: If you answered "yes" to the two questions posed at the start of this section, Raw capture is a worthwhile feature, assuming that you're willing to put in the extra time to process all your Raw files. Otherwise, you'll be perfectly happy with JPEG. (And don't listen to the photo snobs who insist that Raw is the only way to go.)

A few other points on the issue:

- Each manufacturer has its own flavor of the Raw format, so the file formats have different names. Nikon Raw files go by the moniker NEF; Canon, CRW; and so forth.

- As an alternative to Raw capture, some cameras offer a third format option, called TIFF (*tiff,* as in a little spat). In this format, the data goes through the in-camera picture processing like a JPEG photo, but lossy compression isn't applied. So there's no possibility of JPEG compression defects, and you don't have to run your files through a Raw converter but your picture files are much larger.

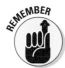

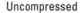

✔ Before you can share a Raw or TIFF file online, whether via e-mail or on a Web site, you must convert it to a JPEG file. Chapter 3 shows you how.

✔ You can, however, immediately use TIFF files in word-processing programs, publishing programs, and so on. (In fact, TIFF is the preferred format for pictures destined for publication.)

✔ Some high-end cameras offer a handy option known as JPEG+Raw. In this mode, the camera creates both a JPEG file and a Raw file every time you press the shutter button. This option is a nice convenience; you can share your JPEG files online immediately and then process your Raw files when you have time. Of course, saving two copies of each image requires more storage space on your camera memory card, but the JPEG files don't create a huge burden because of their small size.

Uncompressed

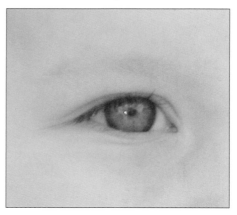

Light compression

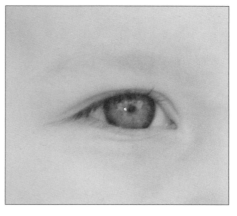

Viewfinder, monitor, or both?

Many digital cameras sold today don't have a viewfinder; instead, you frame your picture by using the camera's monitor.

Figure 1-13: Here you can see a close-up comparison of the images in Figure 1-12.

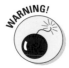

Using the monitor to compose your pictures can present two problems. First, you have to hold the camera away from your body to take the picture, as shown on the left side of Figure 1-14. This posture increases the odds that your hands — and, by extension, the camera — may move slightly during the exposure, which leads to blurry photos. With a viewfinder, you can brace the camera against your face and tuck your elbows into your sides to steady the camera, as shown in the right image in the figure.

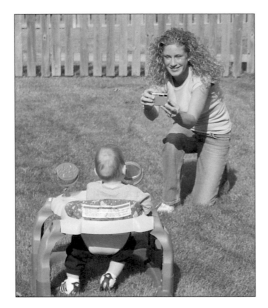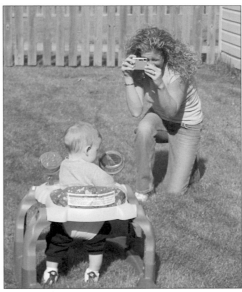

Figure 1-14: Framing shots via a monitor (left) can lead to camera shake; using a viewfinder enables you to brace the camera against your face (right).

What's more, some monitors wash out in bright light. So if you're considering a viewfinder-less camera, take the camera outside for a test run so that you know that composing pictures in bright sunlight won't be too much of a challenge. If you do decide you want a viewfinder — which is my recommendation, in case you couldn't guess — be aware that viewfinders come in two forms, optical and electronic. Here's the scoop:

- **Optical viewfinder:** An optical viewfinder is a standard viewfinder, the kind you have on your old film camera. On most point-and-shoot cameras, an optical viewfinder doesn't show you exactly what the lens is seeing. Instead, the viewfinder's perspective is slightly above and to the left of the lens. So the image that the camera records doesn't exactly match what you see through the viewfinder.

 To deal with this issue — called *parallax error* — you can look for a *through-the-lens* (TTL) viewfinder, which puts viewfinder and lens much more in sync, although no optical viewfinder is 100 percent accurate. Note that the camera monitor *does* provide an accurate preview, which is the one upside of using it to frame your shots. Most digital SLRs, however, do not enable you to frame shots via the monitor; the monitor is for reviewing pictures only.

✔ **Electronic viewfinder:** An electronic viewfinder is like a miniature monitor; it displays the current camera settings along with the scene in front of the lens. In other words, you see everything you would if you were using the monitor to compose your shot. Unfortunately, the clarity of the display on some electronic viewfinders isn't so hot; all cameras are not created equal in this regard. In addition, you can't see anything through an electronic viewfinder while the camera is powered off. For this reason, I prefer optical viewfinders, but this is a personal choice.

One final note about viewfinders: Be sure that the viewfinder isn't so tiny that you have to work hard to even see through it. On cameras that have tiny bodies, I find that the viewfinders are often way too small for easy viewing.

Still more features to consider

After sorting through the camera qualities covered so far, use the following feature list to narrow down your camera choices even more. These features, presented in no particular order, may seem insignificant now but can play a big role in your long-term satisfaction:

✔ **Physical fit:** Hold the camera and take some test shots to try out the position of the shutter button, viewfinder, and so on. Also be sure that the camera is a comfortable size and weight. Those pocket-sized cameras are great for portability, but if they're *too* small, using them can be difficult. The dials and buttons are by necessity also small, and it's easy to inadvertently cover a bit of the lens or flash with your finger. On the other hand, some models are so bulky and heavy that you wouldn't want to carry them around on a long day of sightseeing.

✔ **Ease of use:** Are the controls that you're likely to use most often easily accessible? Having a bunch of buttons and dials on the outside of the camera seems intimidating at first, but they actually make life simpler in the long run. Features accessible only via menus take more time to implement, which means that you're less likely to use them.

✔ **Image stabilization:** This feature, which goes by different names depending on the manufacturer, is designed to eliminate the blur that can occur if you move the camera slightly during the image exposure. If you choose a camera without a viewfinder, this feature is especially helpful; see my earlier rant about this issue in the "Viewfinder, monitor, or both?" section. But find out how the manufacturer implements the feature. In some cases, turning on image stabilization simply shifts the camera to a faster shutter speed, which shortens the time you need to keep the camera still.

Memory cards: "Film" for the digital age

Instead of recording images on film, digital cameras store your picture data on small cards known generically as *memory cards* or *picture cards*. Here are a few important factoids about your so-called "digital film":

↘ **Type:** Cards come in several flavors: CompactFlash (CF), Secure Digital (SD), Memory Stick, and xD are the most common. No one type is better than the other — they're all based pretty much on the same concept. But most cameras can accept only one type of card, so check your camera manual before buying more cards. Note, too, that if you own a media player or other device that uses the same type of card as your camera, you can use your cards for both purposes.

↘ **Capacity:** Cards also come in different capacities, with the most common sizes ranging from 512MB (megabytes) to 2GB (gigabytes). How many pictures you can store on a particular size of memory card depends on the size of the picture file, which in turn is dependent on the file format (JPEG, TIFF, or Camera Raw) and image resolution (pixel count) that you use when you take the picture. See Chapter 2 for more details about these settings.

↘ **Speed:** Some cards are advertised as *high-speed cards,* which means that they enable your camera to record and access picture data more quickly. However, before you pay more for a high-speed card, be sure that your camera can take advantage of this feature; many can't.

↘ **Speed:** Some cameras take several seconds to come to life after you press the power button. Others are slow to record an image to the memory card, requiring you to wait several seconds after you take one shot before you can take another. And on some cameras, the autofocus and autoexposure mechanisms are slow operators. Take some test shots at various picture settings, with and without the flash, to be sure that you won't be frustrated with the camera's speed, especially if you enjoy sports or action photography.

↘ **Battery type:** Some cameras use proprietary batteries, whereas others accept standard, rechargeable AA- or AAA-size batteries. Either is fine, but with a proprietary battery, you can't carry spare batteries with you (unless, of course, you buy a second battery from the manufacturer, which can be expensive).

Checking Your Computer Setup

You don't need the latest greatest computer to do the kind of projects presented in this book. But you do need a relatively fast processor, a healthy

supply of system memory (RAM), and a hard drive that has plenty of free storage space. Otherwise, your computer may run your photo software at a pace that's frustratingly slow or, if you're working with very large digital files, be unable to handle the load at all.

Here are my recommendations for the minimum computer requirements:

- **Processor:** The processor, or CPU (central processing unit), is the part of your computer that does the, er, computing. The faster the processor, the better. If you run Windows, I suggest a Pentium 4 or Celeron 1.3 Ghz processor or better; on the Mac side, a PowerPC G3 or better.

- **System operating software (OS):** To work on a Windows-based machine, most new photo programs require Windows XP (with Service Pack 2) or later. On a Mac, most programs require OS 10.4 or later. Again, check the system requirements for the software you want to use, especially if your computer runs the very latest operating system; some software may not yet be fully compatible with Windows Vista, for example.

- **System memory (RAM):** At a bare minimum, you need 512MB of RAM. The more, the merrier; adding RAM typically increases the speed of all your programs.

- **Hard drive:** The hard drive is the internal storage device that holds your programs and data files. The computer also needs some empty hard drive space to use as a temporary data-storage tank when you work on your pictures.

If you see an alert box saying that your *scratch disk* is full, as shown in Figure 1-15, you don't have enough free hard drive space. You'll need to delete some files or programs in order to go forward. (You may see the term *virtual memory* instead of *scratch disk* depending on the program you're using.)

Figure 1-15: The scratch disk is empty space on your hard drive that your software needs to operate properly.

If needed, you can add a second hard drive to your system. Adding an internal drive isn't hard, but if you're squeamish about opening up your computer case, you can get an external drive that connects via a USB or FireWire cable.

I do *not* recommend using a hard drive, either internal or external, for long-term archiving of your important picture files. Hard drives do fail, and when they do, your data is usually lost. Instead, look at your hard drive as temporary storage for your working files; back up important pictures to a CD or DVD (see next bullet).

✔ **CD or DVD burner:** At present, the best way to safeguard your image files is to "burn them" — that is, record them — to a CD or DVD. My personal preference is CD because the jury is still out on which DVD-recording format will be around ten years from now. However, a CD-ROM holds only 650MB of data, which isn't very much in the modern era of high-resolution digital photos, whereas a DVD holds about 4.7GB.

The good news is that most computers now ship with a DVD burner, which can produce either DVDs or CDs, so you have choice. Personally, I burn my most precious family pictures to a CD-ROM and copy my other photos to a DVD.

Chapter 3 offers more tips on protecting your picture files.

Selecting a Photo Printer

In the market for a new printer? As with cameras, you have a wide range of choices. Your first decision relates to the print technology. You have three options: dye-sub, laser, and inkjet. Here's my take on each:

✔ **Dye-sub:** Most dye-sub (short for *dye sublimation*) printers can produce only snapshot-size prints. More important, you must use special, dye-sub compatible paper, usually sold together with the actual dye ribbons or cartridges. You can't print on plain paper, textured photo papers, and other specialty papers, as you can with a laser or inkjet printer. So if you want to print greeting cards, advertising flyers, and the like, a dye-sub printer isn't a good solution.

✔ **Laser:** If you need to print large volumes of regular documents as well as photos, a laser printer is a good choice. For plain-paper printing, laser printers usually are cheaper and faster than inkjets. On the down-side, laser printers tend to be bulkier than inkjets, and you need to read reviews carefully because not all lasers do a great job with photos.

No fuss, no muss: Retail photo printing

When you have more than a few images to print, consider letting the local photo pros do the job. You can drop off your camera memory card at any retail photo lab and pick up your prints as soon as an hour later, just as you used to do with your film pictures. In most cases, you'll get better prints than you can make at home, with less hassle, less time, and for less money.

If you have a high-speed Internet connection and are computer-comfortable, you can even send your image files directly to the lab via the Web, and then pick up your prints when you're ready. To find a lab in your area, check out the Web site www.prints-are-memories.com. You just enter the zip code where you want the prints made, and the site returns a list of all the area labs. This is a great way to get prints to far-off friends and relatives, too; you can have prints made at labs near their homes.

✔ **Inkjet:** Inkjet printers are the best all-around choice for most digital photographers, offering excellent photo printing and the capability for printing on a wide variety of paper stocks. The printers themselves are usually inexpensive, but you need to factor the cost of ink into your purchase decision. You can save money by choosing a model that has separate ink cartridges for each color. With models that use a single cartridge, you often wind up throwing away ink because not all colors are depleted at the same rate.

Whichever print technology you choose, give extra points to models that offer slots that can read your camera memory cards, as shown in Figure 1-16, which features a model from HP. This feature gives you the option of printing directly from the card; you don't even have to fire up your computer. In addition, you can transfer image files to your computer via the card slot instead of cabling the camera to the computer. See Chapter 3 for more on this topic.

If you need a scanner as well as a printer, look at an all-in-one inkjet or laser machine. In the old days — a few years ago — all-in-ones didn't do a great job on photos, but now many manufacturers use the same print heads in their all-in-one machines as in their photo printers. (Again, it pays to read reviews to ensure top quality.) Check out the next section, which offers scanner-buying tips, to make sure that both the printer and scanner part of the machine offer the specs you need.

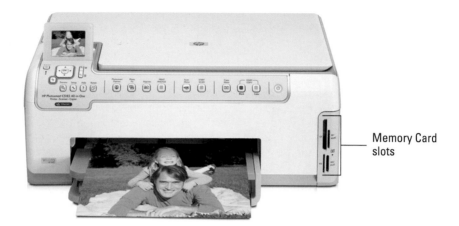

Memory Card
slots

Courtesy HP

Figure 1-16: A printer with memory card slots offers the choice of computer-free printing.

Considering Your Scanning Options

Before you can work with your existing film prints or slides, you need to have them digitized, or, in layman's terms, *scanned*. You can go about this in two ways: You can take your prints, slides, or negatives to a local lab for scanning, or you can buy a scanner and do the job yourself.

If you're new to the whole imaging game, to computers, or both, I *highly* recommend letting a professional handle the job. Yes, you'll pay for the service, but the results are likely to be much better than you can produce yourself because the equipment is better than what's found in home scanners. Most labs also do the job of cleaning your originals before scanning, which is essential to a good result. In most cases, your scanned images are put on an archival CD or DVD.

If you want to tackle the job yourself, Chapter 6 has scanning guidelines, and the following tips will help you buy a good scanner:

> ✔ **Flatbed versus sheetfed scanners:** For scanning prints, get a flatbed scanner rather than a sheetfed scanner. The latter takes your original on a curved path past the scanner head, which can damage photographic prints. With a flatbed, you lay the original on a flat sheet of glass, and the scanner head moves underneath the print.

✔ **Film scanners:** To scan film negatives, slides, or transparencies, you have two choices. You can get a flatbed scanner that offers an adapter for those originals, or you can get a dedicated film scanner. Film scanners typically produce better results than the flatbed-with-adapter setup, but they're pricey and can't scan prints.

✔ **Optical resolution:** Like a digital camera, a scanner creates pixel-based images. And just as with a digital camera, pixel count determines how large you'll be able to print your scanned image and still enjoy good image quality. To determine the pixel capabilities of a scanner, look for a specification called *optical resolution.*

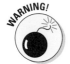

Most scanners state resolution using two numbers, such as 2400 x 1200. Without going into detail, the "real" resolution number is the lower of the two. All other things being equal, higher is better. But again, be sure that you pay attention only to the optical resolution; claims such as "maximum resolution *up to* 9600" usually indicate a resolution that's achievable only through a software process called *interpolation,* which doesn't add to image quality.

✔ **Bit depth:** One other scanner spec to consider is *bit depth,* which determines how many possible colors the scanner can reproduce. Look for a model that delivers between 36 and 48 bits. Technically, 48 is better, but you're not likely to see a difference with most pictures, and your photo software may not be able to open 48-bit files. See Chapter 6 for more details on bit depth.

As with buying a printer or digital camera, you should check out print and online reviews of the scanner models you're considering. Image quality varies greatly, and just knowing the resolution and bit depth isn't enough to ensure that you're buying a good machine.

Choosing Photo Software

To complete your digital darkroom, you need some capable photo software. This book features the leading consumer photo software, Adobe Photoshop Elements. I chose this program because it's reasonably priced, it's one of the few options available for both Windows and Mac computers, and it offers all the tools that most digital photographers need. Elements also has a user-friendly interface, offering you on-screen guidance, as shown in Figure 1-17. The figure shows you Elements 5.0 for Windows; if you use another version of the program, it appears much the same. (As I write this, the most current version available for Mac users is 4.0.)

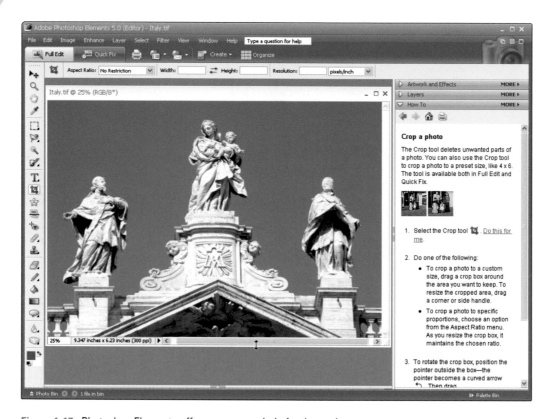

Figure 1-17: Photoshop Elements offers on-screen help for the novice.

Elements isn't the only good product on the market, however. If you haven't yet invested in photo software, you may also want to consider programs such as Corel Snapfire Plus and ArcSoft PhotoImpression. Like Elements, these programs are aimed at the novice user and offer lots of on-screen help. If you watch the sale ads, you can get any of them for under $100.

What about that granddaddy of all photo programs, Adobe Photoshop? It's the program the pros use, so shouldn't you? Well, assume for a moment that price is no object: Your budget can easily handle the $650 price tag. (Will you adopt me?) I still encourage you to start your photoediting career with something a little less intense. As you can see from Figure 1-18, Photoshop isn't designed for beginners — you won't find the friendly, helpful interface you get in Elements and other entry-level programs. In addition, you'll likely be paying for a lot of high-end features that you'll never use: tools for creating CMYK separations, manipulating image channels, drawing clipping paths, and so on. Wait, you say that you don't know what any of that means? Now you get my point.

Figure 1-18: Photoshop is a great program, but it's not designed for beginners.

So that you can do your own software evaluations, the DVD that comes with this book offers tryout versions of a variety of photo-editing programs.

Getting Help from the Experts

In this chapter, I have room to give you only a starting point for buying digital photography equipment and software. For in-depth reviews and additional tips, visit your local bookstore and pick up the latest photography magazines. Also check out the following Web sites, all of which offer reviews as well as problem-solving advice and tips for taking better pictures:

- ✔ www.imaging-resource.com
- ✔ www.dpreview.com

- ✔ www.photographyreview.com
- ✔ www.cnet.com
- ✔ www.scantips.com

Finally, after buying, don't forget to check the Web site of your equipment manufacturer for updated software, technical support, electronic copies of user manuals, and other helpful content.

The Digital Photographer's Troubleshooting Guide

In This Chapter

▶ Choosing the right resolution (pixel count) and file format for top image quality

▶ Ignoring digital zoom

▶ Silencing noise with ISO

▶ Using automatic exposure and focus to your best advantage

▶ Tweaking exposure with EV compensation and metering modes

▶ Seeing flash in a new light (har har)

▶ Manipulating focus

▶ Adjusting white balance to solve color problems

*W*hen you first unpacked your new digital camera, you no doubt sat right down and read the manual. So you know, for example, that you're using the correct batteries, that you have the memory card inserted properly, and that you understand the basics of how to snap and review your pictures.

But even after your best efforts, many of your pictures aren't so great. Maybe they're a little blurry. Maybe they're underexposed or overexposed or slightly off in the color department. Or maybe the sharpness and clarity of your images is disappointing.

Projects in later chapters show you how to correct these and other issues in your photo editor. But I'm guessing that you'd just as soon *avoid* problems in the first place and spend less time cleaning up your pictures after the fact. To that end, this chapter helps you troubleshoot the most common photographic problems encountered by digital photographers.

What's that? You say you *haven't* read your camera manual? Well, I can't encourage such behavior, but given the miniscule type and dry prose found in most manuals, I can't blame you, either. So I'll make you a deal: Just get the manual now, and as you read this chapter, tab the pages that tell you how to access the features I mention. Unfortunately, all cameras are different in this regard, so I can't give you the specifics. (If you lost the manual, most manufacturers offer downloadable versions on their Web sites.)

Also check out Chapter 10, which offers some additional tips for improving your digital photos.

Improving Picture Quality

First, a definition: by *picture quality,* I don't mean the artistic composition, color, exposure, or focus, but rather how finely the camera renders the image.

The quality of the camera lens plays a large role in determining the clarity and sharpness of the photo, of course. But three digital camera settings — resolution (pixel count), file format, and ISO — also impact picture quality. If you choose the wrong settings, your pictures may be grainy, exhibit odd color defects, or appear jagged or blocky. The following sections tell you what camera settings to use to avoid these problems.

Preventing pixel pitfalls

Most cameras enable you to choose from several *resolution* settings. As I describe in Chapter 1, this setting determines how many pixels the camera uses to record the image. *Pixels* are the tiny squares of color from which digital images are built.

Depending on the camera, you may specify resolution through a single control, or you may select a resolution and file format in combination. Cameras that offer a single setting may name the control *picture size* or something similar; models that lump resolution and format together often name the setting *picture quality.* Check your manual for specifics.

Regardless of how your camera handles the matter, pixel count is critical to the quality of printed digital photos. In short, the number of pixels determines how large you can print your photo without your image becoming a mess.

Figures 2-1 and 2-2 offer an illustration of the impact resolution makes. In the first image, a healthy pixel population results in a great-looking picture. But in the pixel-poor second photo, details aren't clear, color transitions are choppy, and diagonal and curved lines have a stair-stepped appearance — a problem that imaging pros refer to as *the jaggies*.

300 ppi

Figure 2-1: An adequate pixel supply ensures that details are finely rendered.

The number of pixels required to produce an optimal print varies depending on the printer. Figure 2-1 has a resolution of 300 pixels per linear inch, or *ppi,* which is the norm for commercial printers like those used to produce this book. Figure 2-2 has a resolution of just 50 ppi, which might be appropriate for printing bird-cage liners, but only for undiscriminating birds.

I suggest that you aim for at least 200 ppi. Remember, that's pixels per *linear* inch, not square inch. Table 2-1 lists the approximate pixel count needed to meet the 200 ppi threshold for standard print sizes. Some printers may need more pixels — even as many as 360 ppi — so check the manual for the manufacturer's recommendation or make some test prints to experiment. Most retail and online photo labs offer guidance as to the recommended print size indicated by the pixel count of your image file, too.

50 ppi

Figure 2-2: Details are gummy and curved and diagonal lines appear jagged in a low-resolution image.

Table 2-1	Minimum Resolution for Quality Prints*	
Print Size	*Pixel Dimensions*	*Megapixels (approximate)*
4 x 6 inches	800 x 1200	1 mp
5 x 7 inches	1000 x 1400	1.5 mp
8 x 10 inches	1600 x 2000	3 mp
11 x 14 inches	2200 x 2800	6 mp

** Based on 200 ppi*

Of course, most people don't know at the time they take a picture how large they'll wind up printing it. So should you just max out your camera's resolution setting and leave it there? Well, that depends. First, understand that a very high-resolution setting does have some disadvantages:

> ✓ **The higher the resolution, the fewer pictures you can store on a camera memory card.** File size increases as the pixel count grows, so each picture takes up more storage space. Your manual should offer a chart that shows you how many pictures you can fit on a given capacity memory card at each resolution setting.

> ✓ **High-resolution pictures take longer to record to memory.** Your camera needs more time to process a larger image file than a smaller one.

> ✓ **High-resolution pictures are *too* large for on-screen use.** Chapter 3 explains the details, but for now, just understand that for on-screen pictures, pixel count doesn't affect image quality, only the size at which the picture appears. For e-mail picture sharing, anything larger than about 450 pixels wide or 400 pixels tall is too large to allow the entire picture to be viewed without scrolling the display on most monitors. (Keep in mind that the e-mail browser eats up a good portion of the monitor space.)

So here's my best advice: A maximum resolution setting is appropriate if your main concern is being able to make large prints or substantially crop your images.

On the other hand, dial down resolution if

> ✓ You're running out of memory card space.

> ✓ You're trying to shoot action pictures and the speed at which the camera is recording images is hampering your efforts.

> ✓ You know without a doubt that the picture is solely for on-screen use and you'll never print it.

Note, however, that even if you capture an image at the camera's lowest resolution, you still may need to dump some pixels to size the picture appropriately for on-screen use. Chapter 3 shows you how.

One last critical note: Although you can easily dump excess pixels in your photo program, don't expect to be able to add pixels after the fact. Doing so doesn't improve the photo quality and in fact can degrade it, as illustrated by Figure 2-3. I added enough pixels in my photo editor to bring the picture resolution up to 300 ppi, and as you can see, the quality is nowhere near that of the 300 ppi original shown in Figure 2-1.

Digital gurus refer to the process of adding or deleting pixels as *resampling*, by the way. Adding pixels is also sometimes called *upsampling*, and deleting pixels is called *downsampling*.

Resampled from 50 ppi to 300 ppi

Figure 2-3: Adding pixels in my photo editor raised the resolution to 300 ppi, but did not improve picture quality.

The evil truth about digital zoom

Most digital cameras offer a feature known as *digital zoom,* and many manufacturers make a big deal about it, highlighting the digital zoom power in camera advertisements. But In fact, digital zoom does nothing but crop away the perimeter of your picture and enlarge the remaining area. Usually, pixels are then added to the image to make it appear as though the scene was recorded at the original pixel count.

The end result is the same as enlarging and resampling a low-resolution picture: reduced image quality. Also, digital zoom doesn't offer the same shift in perspective and depth of field as a real, or *optical* zoom lens. For more on that subject, see the Chapter 1 section related to focal length. In the meantime, disable digital zoom on your camera if possible. Otherwise, check the manual to find out whether the camera alerts you when digital zoom kicks in so that you can avoid shifting into that mode. And if you're shopping for a new camera, pay attention only to the specifications related to optical zoom — that's the feature that matters.

Avoiding JPEG artifacts

By default, most digital cameras record picture files using the JPEG (*jay-peg*) file format. You typically can choose from two or more JPEG capture settings, each of which results in a different image quality. Often, the setting names are vague, such as *Basic, Fine,* and *Superfine* or *Low, Normal,* and *High.*

As Chapter 1 explains, the JPEG format creates smaller files by applying *lossy compression,* a process that eliminates some picture data. At the lower-quality JPEG settings, file sizes are very small, so you can fit more pictures on your camera memory card but so much data gets dumped that those pictures look awful.

Symptoms of a highly compressed JPEG include random color defects and an overall blocky or tiled appearance – problems that imaging pros refer to collectively as *JPEG artifacts.* Figure 2-4, which shows a portion of architectural photo featured in the resolution discussion, offers an example. The left image was produced using minimal JPEG compression; the right example, extreme compression.

Minimum JPEG compression Heavy JPEG compression

Figure 2-4: For best results, stick with the highest-quality JPEG setting.

At the size shown in Figure 2-4, the difference between the two images appears minimal, although you can see some odd color artifacting in the heavily compressed version, and details aren't as sharp. But as the print size increases, compression artifacts become more apparent, as illustrated by the enlarged examples shown in Figure 2-5.

Minimum compression

 Notice that the tiled look that you get from heavy JPEG compression appears slightly different from the blocky appearance that's caused by too few pixels. Because of the way that JPEG processes images, your entire photo appears to have been divided into equal blocks. With low resolution, the blockiness typically occurs along diagonal and curved lines. Keep that difference in mind if you have trouble deciding whether your quality problems stem from too few pixels or too much compression.

Maximum compression

 JPEG artifacts are extremely difficult to remove or even diminish in a photo editor, so always stick with your camera's highest-quality JPEG setting for important pictures. Stock up on additional memory cards if needed to accommodate the larger file sizes. And of course, remember that if you combine heavy compression — your camera's lowest-quality JPEG setting — with low resolution, your quality problems are multiplied.

Figure 2-5: JPEG defects become more apparent when you enlarge your image.

To avoid any possibility of artifacting, you also can consider shooting in the TIFF or Camera Raw format, if your camera offers those options. See Chapter 1 for more information on the pros and cons of those formats as compared to JPEG.

Deadening noise

Your digital camera likely offers an *ISO* control, which adjusts the camera's sensitivity to light — and, in turn, determines how much light is needed to expose a picture. At a high ISO setting, the camera is more sensitive, so you can capture an image with less light.

Film is also assigned an ISO rating based on its light sensitivity. The ISO rating, sometimes referred to as the *film speed,* is marked on the film box. Consumer film usually comes in ISO 200, 400, 800, and 1600; the range of ISO settings on digital cameras varies.

Although raising the ISO enables you to capture a brighter image, it has a pretty serious downside. At higher ISO settings, digital pictures often exhibit a defect known as *noise,* which makes your photo look as though it was sprinkled with sand. You usually get a similar defect, called *grain,* when you shoot with high-speed film.

Figure 2-6 illustrates the pros and cons of raising the ISO on a digital camera. I shot this little guy inside a dimly lit nature museum. I used the same aperture and shutter speed — which control how much light can strike the camera's image sensor — for each exposure. (See the upcoming section, "Understanding exposure," for more about aperture and shutter speed.) At a low ISO, the image quality is superb, but the exposure is too dark. Raising the ISO produced a brighter exposure but at the cost of increased noise, which is especially visible in areas that contain little detail, such as the background in this photo. Figure 2-7 offers a close-up comparison of all three images.

The amount of noise produced at a given ISO setting depends on the camera, so experiment to find the acceptable noise threshold on your model. And whenever possible, keep the ISO at its lowest setting for pictures where image quality is critical.

In very dark lighting, you may not be able to capture the image without raising the ISO, but know that you do so at a price. Usually, in fact, you're better off keeping the ISO down and then brightening the image in your photo editor if needed. See Chapter 4 for a look at this process.

If your camera offers an Auto ISO setting, which allows the camera to adjust the ISO as needed based on the light conditions, I suggest that you disable the feature. Because of the impact of ISO on image quality, you should be the one to control it.

ISO 200

ISO 500

ISO 1000

Figure 2-6: Raising the ISO makes the camera more light sensitive but also increases noise.

Note, too, that noise also tends to increase as you reduce the shutter speed, which results in a longer exposure time. Balancing ISO and shutter speed can be tricky because a low ISO often means that you need a longer exposure — so the noise reduction you get from a lower ISO can be offset by that longer exposure. When all is said and done, simply adding more light to the scene is the best solution. With more light, you can use a lower ISO, a faster shutter, or both. Again, see the upcoming discussion about exposure if you're new to the concept of shutter speed.

ISO 200 ISO 500 ISO 1000

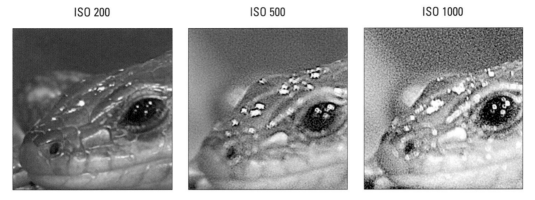

Figure 2-7: Here you see a close-up view of the images from Figure 2-6.

Getting Good Results in Automatic Mode

Your camera probably arrived from the factory set to fully automatic mode. All you have to do is frame the shot and press the shutter button, and the camera automatically sets the focus and selects the right exposure settings.

Because today's autoexposure and autofocus systems are so refined, they produce good results in most photographic situations. However, the auto-everything systems can't do their jobs unless you use the proper shutter-button technique.

Yes, you read that correctly. How you press the shutter button determines whether the camera can accurately set both focus and exposure. You need to take the following approach, illustrated in Figure 2-8:

1. **Frame the picture and then press and hold the shutter button halfway down.**

 You may hear the camera innards whirring or buzzing as the autofocus and exposure mechanisms do their thing.

2. **Wait for the signal that the focus and exposure are set.**

 On some cameras, a small light appears near the viewfinder. On others, the camera emits a beep. And some models give you both a light and a beep.

3. **Press the shutter button the rest of the way down.**

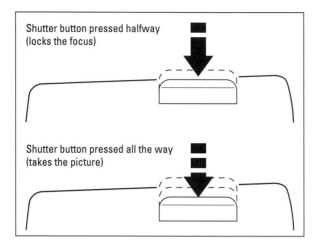

Shutter button pressed halfway
(locks the focus)

Shutter button pressed all the way
(takes the picture)

Figure 2-8: Depress the shutter button halfway, wait for the "okay" signal, and then press the button the rest of the way to capture the image.

One note on this process: It's critical that you frame your shot so that your main subject is within the frame area that your camera considers when setting exposure and focus. Most cameras base their calculations either on the center of the frame or on the entire frame, for example. And many cameras use one frame zone for setting focus and another for setting exposure. Your manual should offer a diagram indicating the available focus and exposure zones, as well as information about whether you can select a different zone from the camera's default.

If your camera bases focus or exposure on the center of the frame and you want to compose the picture so that your subject is off-center, use this technique, illustrated in Figure 2-9: Frame the picture so that your subject *is* within the center of the frame. Press and hold the shutter button halfway to lock the focus and exposure on your subject. After you get the "go ahead" signal from the camera, reframe the picture to the composition you want — don't let up on the shutter button — and then press the shutter button the rest of the way down.

Figure 2-9: After locking the focus and exposure on your main subject, you can reframe the picture before pressing the shutter button the rest of the way down.

Solving Exposure Problems

Even if you use the picture-taking technique outlined in the preceding section, some subjects and lighting situations can give your camera's autoexposure system fits. In fact, even in manual mode, which gives you complete control over the exposure settings, getting a proper exposure isn't always easy.

When your camera monitor indicates that your picture is *overexposed* (too bright) or *underexposed* (too dark), the next sections offer ways to correct the problem.

Understanding exposure

To better grasp the troubleshooting techniques offered in the following section and elsewhere in the book, you need a brief primer on exposure.

A photograph is created when light is gathered by a lens and then is allowed to strike a light-sensitive recording medium. Whether that medium is a film negative or a digital camera's image sensor, the brightness, or exposure, of the picture depends on three factors:

- ✔ The light sensitivity of the film or image sensor
- ✔ The size of the beam of light that strikes the negative or image sensor
- ✔ The duration of the light

On your digital camera, these factors are determined by the following controls:

- ✔ **ISO (light sensitivity):** The section "Deadening noise," earlier in this chapter, introduces ISO ratings, which indicate the light sensitivity of film and digital image sensors. As ISO goes up, so does light sensitivity.

- ✔ **Aperture (size of light beam):** The *aperture* is a hole in an adjustable diaphragm that lies between the lens and the shutter, as illustrated in Figure 2-10. Adjusting the aperture size controls the size of the light beam that can strike the recording medium.

Aperture size is measured in *f-numbers,* more commonly referred to as *f-stops,* and stated as f/2, f/5.4, and so on. The higher the f-stop number, the *smaller* the aperture. For example, an aperture setting of f/2 allows more light to enter the camera than an aperture of f/8.

Figure 2-10: Aperture and shutter speed together control the amount of light that strikes the image sensor (or film).

- ✔ **Shutter speed (duration of light):** The *shutter* is positioned between the aperture and the recording medium, as indicated by Figure 2-10. When you press the shutter button on your camera, the shutter opens so that the light that funnels through the aperture can strike the film or image sensor.

The *shutter speed* control determines how long the shutter remains open, typically for a fraction of a second. Shutter speeds are expressed in seconds, as in 1 second, 1/400 second, and so on.

So, in theory, you can tackle an exposure problem by adjusting the three settings either alone or in combination, as follows:

✏ **For a brighter exposure:** Select a lower f-stop number *(open the aperture),* choose a slower shutter speed, or raise the ISO.

✏ **For a darker exposure:** Select a higher f-stop number *(stop down the aperture),* choose a faster shutter speed, or lower the ISO.

I say "in theory" for a few reasons:

✏ Because raising the ISO often has the side effect of creating noise, a defect introduced earlier in this chapter, I suggest that you avoid that option and rely on aperture and shutter speed to adjust exposure.

✏ If your model offers only autoexposure, you can't specify an aperture or shutter speed. You can, however, tweak exposure by using the alternative techniques outlined in the upcoming section, "Tweaking exposure in automatic mode."

✏ Some cameras offer one or both of two semi-automatic autoexposure (AE) modes, aperture-priority AE and shutter-priority AE. In aperture-priority mode, you select the f-stop, and the camera sets the appropriate shutter speed to produce a good exposure. In shutter-priority mode, you set the shutter speed, and the camera selects the f-stop.

Although these modes enable you to select a specific aperture or shutter speed, changing either control doesn't result in a different exposure. Instead, the camera simply adjusts the other setting to produce whatever exposure it thought was correct in the first place. For example, if you open the aperture, the camera increases the shutter speed to compensate. Again, use the workarounds presented in "Tweaking exposure in automatic mode" to solve your exposure problems.

✏ Changing the aperture also affects *depth of field,* or the range of sharp focus in the image. And the shutter speed determines whether moving objects appear blurry or sharply focused (and whether any small camera movements result in a blurry image). For these reasons, changing the aperture may not be as appropriate in some situations as adjusting shutter speed, and vice versa. Read the next section for a more thorough explanation.

Affecting focus with aperture and shutter speed

Technically, I probably shouldn't say that you can affect focus by adjusting aperture or shutter speed. Without going into the science, changing either setting doesn't actually shift focus in the purest sense of the word. But you can manipulate the *apparent* focus of the image — in other words, what most ordinary folks would describe as focus.

Here's the scoop:

✏ **Aperture (f-stop) also affects depth of field.** *Depth of field* refers to the distance range within which objects are sharply focused. A photo in which the main subject is sharply focused, but distant objects are not, has a shallow depth of field. Pictures in which both near and distant objects are sharply focused have a large depth of field.

Opening the aperture — that is, choosing a *lower* f-stop number — decreases depth of field. Stopping down the aperture — selecting a higher f-stop number — increases depth of field. Experienced photographers typically open the aperture when shooting portraits so that the background is diminished, as illustrated in Figure 2-11. But for landscapes or other shots in which you want to keep a greater area in sharp focus, a higher f-stop usually works better.

f/22 f/4

Figure 2-11: Opening the aperture from f/22 to f/4 softened the focus of the background, making it less distracting.

✏ **Shutter speed also affects the appearance of moving objects.** At slow shutter speeds, moving objects appear blurry; fast shutter speeds can "freeze" motion. How high a shutter speed you need depends on how fast the object is moving. In Figure 1-7 in Chapter 1, for example, I needed a shutter speed of 1/500 second to catch my flying furball in midstride. A slower shutter speed left him blurry.

That's not to imply, however, that a faster shutter speed is always desirable. Sometimes, blurring a moving object can create a heightened sense of motion or other special effect. For example, many photographers shoot waterfalls using a slower shutter speed to blur the water, which gives it that soft, misty look. I took that approach to capture the right image in Figure 2-12, slowing the shutter speed to 1/15 second. Using a tripod is critical for slow-shutter shooting, however; otherwise, camera shake is likely, making the entire scene blurry.

Whatever your creative goals, keep these side effects in mind when you decide whether to tackle an exposure problem by adjusting aperture, shutter speed, or both. Then pick the path that delivers both the exposure you want and the focusing effects that best suit your subject.

1/125 second 1/15 second

Figure 2-12: A slow shutter speed gives the waterfall that romantic, misty look.

Also note that aperture and shutter speed aren't the only ways to manipulate focus; for other possibilities, see the upcoming section, "Fixing Focus Flubs."

Tweaking exposure in automatic mode

Even if you're shooting in autoexposure mode or the two semi-automatic modes (aperture-priority and shutter-priority AE), you have some control over image brightness. You can tweak exposure using a feature called EV compensation and, on some cameras, by changing the camera's autoexposure metering mode. The next two sections discuss these controls.

Adjusting exposure with EV compensation

Almost all digital cameras offer an EV compensation setting, which enables you to tell your camera that the exposure it produced is out of line. (*EV* stands for *exposure value.*) Usually, you can increase or decrease the EV setting in increments of one-half or one-third step: EV +0.3, +0.7, +0.1, and so on.

A setting of EV 0.0 is the default and results in no exposure adjustment. Raise the value for a brighter exposure; lower it for a darker exposure. In Figure 2-13, the original exposure produced in autoexposure mode left the statue too dark, so I raised the EV setting to +0.7.

EV 0.0 EV +0.7

Figure 2-13: Use EV compensation to adjust exposure when you shoot in autoexposure mode.

Changing the autoexposure metering mode

The autoexposure *metering mode* refers to the method that the camera uses to calculate the proper exposure. Some cameras offer a choice of modes; the three most common work as follows:

- **Full-frame metering:** Referred to by many names, including *matrix, average, multispot,* and *pattern,* this mode sets exposure based on the average brightness of the entire frame. This mode typically is used by cameras that don't offer adjustable metering modes.

- **Center-spot metering:** In this mode, exposure is based on the center of the frame.

- **Center-weighted metering:** This mode calculates exposure based on the entire frame but gives added emphasis to the center.

Full-frame metering is typically the default setting and works well for most pictures. But if your subject is significantly darker or lighter than the background, switching to center-spot or center-weighted metering may produce better results because the camera then assigns less importance to the background when calculating exposure.

In Figure 2-14, I switched to center-weighted metering because I wanted the camera to pay more attention to the fountain than to the sky. Because the fountain was darker, the camera increased the exposure accordingly. The result is a brighter image that makes the figures at the bottom of the fountain more visible.

Full-frame metering Center-weighted metering

Figure 2-14: Switching from full-frame metering (left) to center-spot metering (right) brightened the exposure.

If you want to use center-spot or center-weighted metering but you don't want your subject to be in the middle of the frame, use the workaround suggested earlier: Frame the shot so that the subject is in the center of the frame, lock in exposure by depressing the shutter button halfway, reframe the picture, and then press the button the rest of the way. However, you also may find it just as easy and efficient to instead use EV compensation to alter the exposure.

Adding flash: Use it outdoors, too!

Sometimes, you can't get a bright enough exposure no matter how much you fiddle with your camera's exposure controls. In dim lighting, you simply may need to add artificial light, which makes the built-in flash found on most cameras such a helpful feature.

Most cameras offer at least three flash settings: automatic mode, which fires the flash when the camera thinks the light is inadequate; *fill flash*, also known as *force flash*, which fires the flash no matter what; and no flash, which disables the flash. Some cameras also offer a *red-eye reduction* mode, which is designed to reduce the chances of that all-too-familiar problem in portraits taken with a flash. Table 2-2 offers a look at the symbols that typically indicate these flash modes.

Table 2-2		Standard Flash Modes
Symbol	*Mode*	*What It Does*
⚡ AUTO	Auto	Fires flash when camera thinks more light is needed.
⚡	Fill or Force	Fires flash regardless of available light.
⚡⃠	No flash	Disables flash regardless of available light.
👁	Red-eye reduction	Emits preflash before primary flash to reduce red-eye.

Evaluating exposure on your camera monitor

Many digital cameras enable you to adjust the brightness of the camera monitor. If you do, keep that adjustment in mind when you evaluate exposure on the monitor. For example, if you set the monitor to a very bright setting, a picture that's actually underexposed may look just fine on the monitor. The reverse is also true.

Some cameras offer a _histogram display,_ a feature that provides a more accurate reflection of exposure. A _histogram_ is a graph that plots out the brightness values in the image, from white to black. (You can read more about histograms in the Chapter 4 discussion about exposure correction.) If your camera doesn't offer a histogram, take some test shots and then compare the brightness of the images on your camera monitor with what you see on your computer monitor. Then you'll better know how to interpret exposure when reviewing pictures on your camera. Of course, this assumes that your computer monitor is properly calibrated, too. Chapter 10 talks more about this issue.

Automatic flash mode works fine in many situations, but in some scenarios you can get better results by taking the flash reins yourself. Here are my tips for when to shift to manual:

- **Use fill flash for better outdoor portraits and close-ups.** Even when skies are very bright, a flash makes a dramatic difference, as illustrated by Figures 2-15 and 2-16. I took the first picture using autoflash mode, and the camera didn't fire the flash because it sensed enough ambient light to expose the image. The background is fine, but the subject is too dark because the strong overhead light cast shadows on the face. Adding the small pop of light from the flash solved the problem while keeping the background properly exposed. Adding flash can also improve close-ups of flowers and other small subjects.

- **Disable the flash for indoor portraits whenever possible.** I know, this advice seems backwards: Use flash in bright sunlight, but turn it off inside? But you probably already know the usual result when you take indoor portraits with a flash: red-eye. So if possible, position your subject near a sunny window, turn on as many room lights as you can find, and try to work without flash. Not only do you eliminate the chance of red-eye, you get softer, more even light than a built-in flash typically produces.

Figure 2-15: In autoflash mode, the flash didn't fire because of bright ambient light, leaving the subject underexposed.

Figure 2-16: Setting the flash to fill (or force) flash mode adds just the right pop of light to illuminate the face.

✔ **Switch to red-eye reduction mode when using flash is unavoidable.**
Red-eye occurs when the light from the flash is reflected back from the
subject's retinas. In red-eye reduction mode, the camera emits a small
burst of light prior to firing the real flash. The idea is that the subject's
pupils constrict in reaction to the prelight, lessening the amount of
light that can enter said pupils and then be reflected by the main
flash. (Now you know why you rarely get red-eye when using flash
outdoors — the pupils are already constricted to accommodate the
ambient daylight.)

A couple of comments about red-eye flash mode: First and foremost,
warn your subjects not to move or stop smiling until after the *second*
flash of light. Most people see the preflash and think that the picture
has just been taken. Second, don't expect this mode to eliminate all red-
eye; it just can't. If you do get red-eye, see Chapter 5 to find out how to
quickly eradicate it in your photo editor.

Fixing Focus Flubs

Poorly focused pictures can occur for a number of reasons. The following
section offers solutions for the most common causes of the blurs. After that,
you can find out how to manipulate depth of field to bring more or less of
your scene into sharp focus.

Shooting sharper pictures

You can capture a sharper image by using the following strategies:

✔ **Lock in autofocus correctly.** Frame the picture and depress the shutter
button halfway, wait for the camera to signal that focus has been set,
and then depress the shutter button the rest of the way. (For more
details about this technique, see the earlier section, "Getting Good
Results in Automatic Mode.")

Also be sure that your subject is within the selected focusing zone. Your
camera manual should illustrate all the focus-zone options that are avail-
able on your model.

✔ **Stay within the camera-to-subject focusing distance.** Every lens has a
certain focusing limit. Your manual should tell you the minimum dis-
tance at which you can focus on your subject. Most point-and-shoot
camera lenses are limited only at the close-focusing range — meaning
that they're designed to focus on anything from a short distance away
to infinity.

For close-up shots, you may need to switch your camera to *macro* mode, which is usually indicated by a little flower symbol. Again, check your manual for the specifics on using this mode.

✓ **Keep the camera still during the entire exposure.** Any camera movement during the time that the shutter is open may result in a blurred image. When you shoot at a slow shutter speed, use a tripod or some other method to steady the camera to avoid camera shake.

If you don't want to carry a full-size tripod with you, consider one of the more portable solutions shown in Figure 2-17. The left image shows the Gorillapod (www.joby.com), which has twisty legs that can wrap around almost any surface; and The Pod (www.bogen.com), a beanbag-like device that can steady the camera even on non-level surfaces.

✓ **Enable image stabilization, if available.** Some cameras offer this feature, which is designed to compensate for small amounts of camera shake. This feature is also known as *anti-shake, steady shot,* and other such names depending on the manufacturer. Be sure to read your manual to find out how the feature is implemented. With some cameras, turning on this feature simply increases the shutter speed so that you need to hold the camera still for a shorter period of time. Depending on your subject matter, a faster shutter may or may not be appropriate. And on some cameras, turning on image stabilization may increase the possibility of noise because the camera automatically raises the ISO setting to allow for that faster shutter. (See the earlier section "Deadening noise" for more details on this image defect.)

Courtesy Joby *Courtesy Bogen Imaging, Inc.*

Figure 2-17: Small, portable gadgets like the Gorillapod (left) and The Pod (right) provide convenient alternatives to a full-size tripod.

✔ **Press, don't jab, the shutter button.** A jerky shutter-button press can create just enough shake to cause image blur. If you want to avoid this possibility altogether, you can set the camera to self-timer mode, which enables you to take a hands-free picture. Some cameras also offer a remote shutter-button release that serves the same purpose.

✔ **Increase the shutter speed if the subject is moving.** As illustrated in the earlier section, "Affecting focus with aperture and shutter speed," you need a fast shutter speed to freeze a moving subject in place.

If your camera doesn't offer manual shutter control or shutter-priority autoexposure, look for a sports or action creative scene mode. This mode is designed to produce the camera's fastest shutter speed.

Controlling the range of focus

Expert photographers work not just to keep their subjects in focus, but also to manipulate depth of field to their creative advantage. Depth of field, again, refers to the range of distance that is sharply focused.

You can manipulate depth of field in three ways:

✔ **Adjust the aperture (f-stop).** As illustrated earlier, in Figure 2-11, a smaller aperture — higher f-stop number — produces a greater depth of field, bringing more of the scene into focus.

Don't have an aperture control on your camera? Try using the portrait scene mode, if available, when you want a short depth of field. And switch to landscape mode for a long depth of field.

✔ **Zoom in or out.** With an optical zoom lens — *not* a digital zoom — zooming in increases the lens focal length, which shortens the apparent depth of field. (Chapter 1 introduces you to focal length.) So if you want more of your scene to be in focus, zoom out. Of course, changing the focal length also affects the angle of view and the size relationship of objects in the scene.

✔ **Change the camera-to-subject distance.** The closer you get to your subject, the shallower the depth of field. In Figure 2-18, I used the same focal length (zoom setting) and aperture for both images; I simply got closer to the water lily to capture the second photo. Notice that the red stems behind the flower appear much more softly focused in the close-range photo.

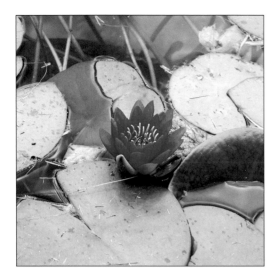 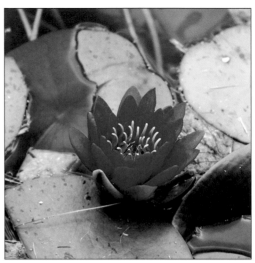

Figure 2-18: For the right picture, I moved closer to the water lily to shorten depth of field.

Putting it all together, then — and believe me, I know this is all overwhelming at first, but pretty soon it'll be second nature:

- ✔ **To maximize depth of field:** Zoom out, move farther from your subject, and choose a higher f-stop (smaller aperture).

- ✔ **To minimize depth of field:** Zoom in, get closer, and open the aperture by choosing a smaller f-stop number.

Solving Color Miscues

Are your whites looking dingy yellow — or maybe an odd shade of blue, green, or pink? Well, assuming that we're talking about your digital photos and not your should-be-tidy whities, the problem is related to a feature known as *white balancing*.

Like video cameras, digital cameras use a white-balancing system to compensate for the color tints that are emitted by various light sources. Fluorescent light emits a bluish cast, for example, and incandescent bulbs create a slightly warm cast. Without white balancing, your image colors would be influenced by the color tendencies of the light source.

Usually, the automatic white balance setting on your camera handles its task well, keeping your whites white and all your other colors true as well. But some light situations can confuse the camera.

A subject that is lit by multiple types of lights is probably the most common white-balance culprit. For example, when I shoot still-life pictures in my studio, I light the scene with photography lamps that use tungsten bulbs (similar to incandescent bulbs). But enough daylight filters through the windows to throw the camera off. As a result, the automatic white-balance setting results in a yellowish cast to my pictures, as shown in the left example in Figure 2-19.

For times when automatic white balancing doesn't work, most cameras enable you to select from several manual settings, each designed for a specific type of light. Check your manual to discover the white-balance options available to you and how to implement them. In my case, changing the white-balance control to the Incandescent setting removed the yellowish color cast.

Figure 2-19: Multiple light sources confused the white-balance system in automatic mode (left); manually setting the white balance fixed the problem (right).

Working with Your Picture Files

*E*very creative endeavor involves a little less-than-exciting prep work. Before you can cook a gourmet vegetable stir fry, for example, you have to stand in line at the grocery store, clean and chop the vegetables, and measure out all the herbs and spices.

Likewise, you need to take some preliminary steps to prepare your digital picture files for the various creative uses you have in mind. First, of course, you have to get those picture files off of your digital camera memory card and into the computer — probably one of the more confusing aspects of digital photography. Then you need to open the photos in a photo editor and set their print dimensions and resolution or, if the images are destined for the Web, their display size. Finally, you must save your edited files in the appropriate image format.

Just as mindlessly adding cayenne pepper instead of paprika can ruin a stir-fry, inattention to detail during this picture-prep process can affect the quality of your finished project, so this chapter walks you through each of the critical steps. In addition, the pages to come offer some advice about the best ways to archive your digital pictures to ensure that they survive for generations.

Transferring Pictures to Your Computer

Getting pictures from a digital camera to a computer isn't difficult, but the software tools for the job vary so widely that it's impossible for me to provide you with very specific instructions on what to click and when to click it. However, I can give you a generic overview of the two main options for photo transfer: connecting your camera directly to your computer and using a memory-card reader. My hope is that this background will enable you to adapt these steps to whatever transfer software you use.

Linking camera and computer via USB

All digital cameras sold today ship with a USB cable, shown in Figure 3-1, and all computers sold within the past few years have at least one USB *port* (the slot where you insert the end of the cable).

USB stands for *Universal Serial Bus.* You don't really need to know that, but you can drop it into a conversation with your computer-geek friends if you want to impress them.

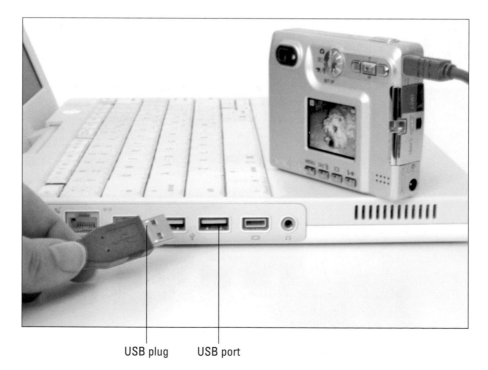

USB plug USB port

Figure 3-1: You can connect the camera to the computer via a USB cable.

When those geek friends aren't around, dig out your camera manual if you plan to use this method of image transfer. (Really, you'll save time and frustration in the long run if you don't just wing it.) Look for specifics on the following:

 ✔ **Camera software installation:** You may need to install software that shipped with the camera before the computer and camera can communicate. The piece of software in question is sometimes referred to as a TWAIN driver. Note that the driver usually is provided as an independent installation option, so you don't have to install any photo-editing software that also shipped with the camera if you don't want to.

 ✔ **Transfer setting:** You must set the camera to the computer-transfer function, typically accessed via a camera dial and often indicated by the little two-way arrow icon you see in Figure 3-2. After you select this setting, the camera menus may display further options for transfer.

Computer transfer setting

 ✔ **Connection order:** Usually, you plug the cable into the camera, turn on the camera, and then plug the other end of the cable into the computer. But this step varies, so double-check.

Figure 3-2: The image-transfer setting is often represented by this double-arrow icon.

 To save battery life, power the camera via an AC adapter, if your camera came with one.

After you connect the camera to the computer, a window may pop up automatically, providing you with tools and options for transferring your photos. This offer to help may come from your photo editor, your camera's software, or a utility provided with your computer's operating system.

For example, if you use Photoshop Elements for Windows, you may see the window shown in Figure 3-3. Windows users may instead see the window shown in Figure 3-4, from which you can access the Windows Camera and Scanner Wizard. (A *wizard,* for the uninitiated, is a little program that walks you step by step through a particular process.) On the Mac side, a program called iPhoto usually comes to life and offers to handle your picture downloads.

With any of these programs, you typically just specify where you want your picture files stored (write down the folder you choose so you can find it later), and the software takes things from there. Be on the alert for these two additional options, though:

 ✔ **Delete after downloading:** If the software asks whether you want to delete pictures from your memory card after downloading, say no. Always check to make sure that the pictures have made it to your computer in good shape before dumping them from your memory card.

And delete files by using the camera, not your computer, which sometimes can mess things up.

✔ **Automatic red-eye correction:** The Adobe Photo Downloader, for one, offers this option. Automated red-eye fixers work fine sometimes, but other times they mess up your image. So instead, use the technique discussed in Chapter 5 to remove red-eye in your photo editor.

Don't panic if nothing happens after you connect your camera. Your computer just may not be set up to let you know automatically that it found your camera. Move on to the next section and follow the same steps but look for your camera to appear as a drive or drive icon instead of the card reader in Step 3. If the camera doesn't show up, something's amiss with your connection, camera setting, or both; double-check the manual for troubleshooting ideas.

If you don't want Elements to pop up the photo downloader automatically, you can disable this feature. Open the Elements Organizer window and then choose Edit⇨Preferences⇨Camera or Card Reader. In the dialog box that appears, you can find options that both turn off the autolaunch and the automatic red-eye fix.

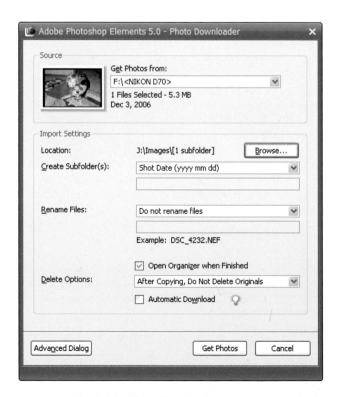

Figure 3-3: The Adobe Photo Downloader appears automatically if you use Photoshop Elements for Windows.

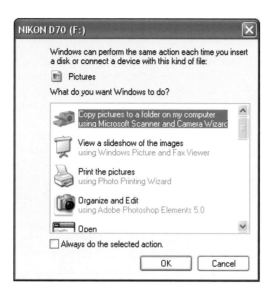

Figure 3-4: Windows may display this list of options when you attach your camera to a computer.

Using a card reader

The main drawback to transferring pictures directly from your camera is that you consume battery power because the camera must be turned on during the entire transfer process. As an alternative, you can buy a memory-card reader and attach *it* to your computer via a USB connection. When you want to transfer pictures, you take your memory card out of the camera and pop it into the slot in the card reader. Then you just drag and drop the files from the card to your hard drive, much like you may have done eons ago to transfer files from a floppy disk.

Card readers are inexpensive; you can buy a reader that accepts multiple types of memory cards, such as the SanDisk model shown in Figure 3-5, for about $30, or a single-format reader for about $10. But if your computer is fairly new, you may not need to spend anything — many systems now offer built-in card readers. Many photo printers

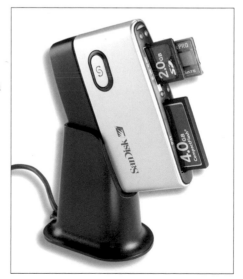

Photo courtesy SanDisk Corporation

Figure 3-5: This SanDisk card reader accepts several types of camera memory.

also offer this convenience. Just be sure that the built-in readers accept the type of memory card that your camera uses (SD, CompactFlash, and so on).

To transfer pictures using a card reader, first install whatever software came with the reader. Then take these steps:

1. **Start your computer.**

2. **Insert the memory card into the card reader.**

 Be gentle! Jamming or forcing the card into the slot can damage both the card and the reader. Check the instruction manual to make sure that the card is oriented in the proper direction.

 Depending on what software is installed on your computer, inserting a memory card may launch a picture-transfer wizard; see the preceding section to find out what to do next. If you don't see a wizard, move on to Step 3.

3. **Using Windows Explorer or the Mac Finder, locate the card reader's drive (or drives).**

 Your computer considers your card reader to be just another drive on your system. (If your camera is connected to the computer, it should also appear as a drive.) To locate the drive, take these steps:

 • *Windows:* Click the Windows Start button and then choose All Programs⇨Accessories⇨Windows Explorer. Or, if you see a My Computer icon on your desktop, right-click the icon and choose Explore from the pop-up menu. You should see a window that looks something like the one in Figure 3-6. A drive letter appears for each of the card reader's slots. For example, my reader has four slots, and Explorer displays them as drives F, G, H, and I. (The drive letters vary depending on how many other drives exist on your computer.) You may or may not see the camera name displayed with the drive as in Figure 3-6.

 If you don't see the window in Figure 3-6, be sure that you launched Windows Explorer and not Microsoft Internet Explorer, which you use to browse the Web. Hey, you wouldn't want them to make things so obvious that you could do without my help, would you? (Be kind.)

 • *Mac:* Navigate to the Finder level. Your memory card should appear as an icon on the desktop, as shown in Figure 3-7. The drive may or may not be assigned a specific name or show your camera name, depending on the reader and camera.

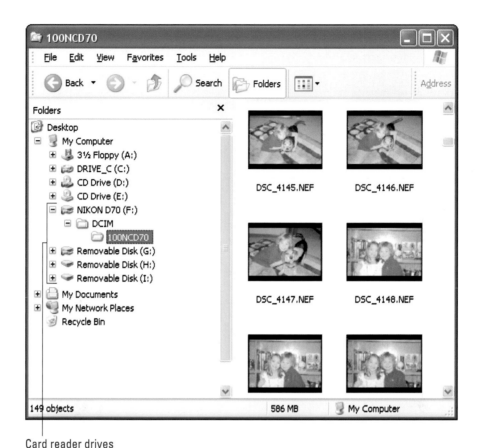

Card reader drives

Figure 3-6: Windows Explorer displays a drive letter for each slot on the card reader.

4. **Navigate to the folder on the reader drive that holds your images and then open that folder.**

Normally, the images are stored inside a folder labeled DCIM, as shown in Figures 3-6 and 3-7.

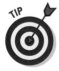

In Windows, choose View➪Thumbnails to display thumbnails of your image files, as you see them in Figure 3-6.

Card reader icon

Figure 3-7: On a Mac, the card reader appears as a drive icon on the Finder desktop.

5. **Drag and drop the image files to a folder on your hard drive, as shown in Figure 3-8.**

 Where you store your picture files is completely up to you. I created a folder called Images on my main hard drive to hold all my pictures. I then created subfolders to hold different types of pictures, as you see in Figure 3-8. Windows users may instead prefer to use the My Pictures folder, which is where most photo-editing programs look first to locate image files. But it really doesn't matter, so use the organization system that makes sense to you.

TIP

 To select all files on the memory card, click in the list of image files and then press Ctrl+A (Windows) or ⌘+A (Mac). To select several, but not all files, click the first file and then Ctrl-click (Windows) or ⌘-click (Mac) the other files one by one.

 When you drag your files, you should see a little plus sign next to your cursor, as shown in Figure 3-8. The plus sign indicates that you're copying your files, not moving them — which means that the originals will remain on your memory card.

Figure 3-8: Select the files you want to copy and drag them to the folder where you want to store them.

6. **In Windows, shut down Explorer and then remove the memory card from the card reader.**

 Removing the card while Explorer is still running sometimes causes the program to crash.

 On a Mac, drag the card icon to the Trash icon to eject the drive and then remove the memory card from the reader.

 If you don't, your Mac will chastise you for not following the ejecting procedure.

Never remove the memory card while the computer is still accessing it. Doing so can ruin the card and destroy any files on it. The same applies to disconnecting your camera from the computer, if you go that route.

Opening Picture Files

To open a digital photo in most photo-editing programs, you choose the Open command, usually found on the File menu. This command displays the Open dialog box, which, again, looks and works the same as all the other Open dialog boxes you've probably encountered. Figure 3-9 shows the Windows XP version of this dialog box. Click the name of the picture you want to open and then click the Open button.

In some photo programs, however, the Open command may instead be named something such as Get Photos. Or, you may need to navigate to a secondary menu off the File⇨Open command to access pictures. Check your software's Help system for details if you can't find the right command.

If you're brand new to computers as well as to digital imaging, the whole topic of opening, moving, and managing files can be pretty confusing. Unfortunately, that's a subject beyond the scope of this book, so I highly recommend that you get a beginner's guide to your operating system (Windows or Mac) so that you can get a better understanding of how your computer thinks.

Figure 3-9: You open picture files just as you do any computer file.

In the meantime, here are a few additional file-opening tips that relate just to opening pictures in a photo program:

- ✐ **Helping your computer work faster:** You can open pictures directly from your camera, a memory-card reader, or a CD. However, if you plan to edit your photos, copy the pictures to your computer's main hard drive and work on those copies instead. A computer usually can process files located on an internal hard drive more quickly than it can work with files on an external drive or storage device. Follow the instructions in the preceding sections to copy the files to your hard drive.

- ✐ **Linking your photo organizer program and editing program:** While browsing your pictures in most photo-organizing programs, you can instruct the organizer program to open a selected picture in your photo editor. In the Organizer program provided with the Windows version of Photoshop Elements, for example, you can click the Edit button on the toolbar and then choose Go to Full Edit to open the photo in the Elements workspace, as shown in Figure 3-10. Depending on the organizer, you may need to specify in the program preferences which program you want to use to edit your photos.

Figure 3-10: In Elements, you can send a picture from the Organizer to the editing workspace by choosing Go to Full Edit.

✔ **Converting Camera Raw files:** If you set your digital camera to capture images in the Camera Raw format, clicking the Open button in the Open dialog box takes you to an intermediate file-opening step. You must use a *Raw converter* utility to specify how you want to translate the Raw image data into a common picture-file format. (See Chapter 1 for an introduction to Camera Raw.) Some photo programs provide their own Raw converter; Figure 3-11 shows the Photoshop Elements version. You can also use the camera manufacturer's own converter, usually provided on the software CD that ships in the camera box.

The DVD included at the back of this book contains a QuickTime tutorial that explains how to use the Adobe Camera Raw converter provided with Photoshop Elements.

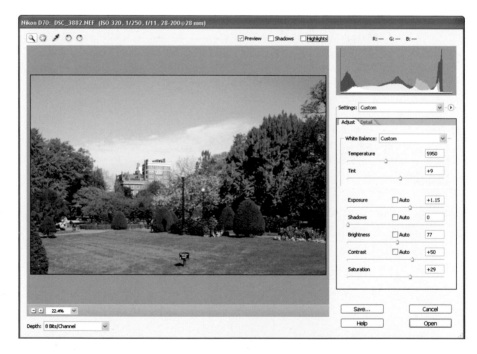

Figure 3-11: Opening a Camera Raw file in Elements takes you to the Adobe Camera Raw converter window.

Protecting Your Digital Images

The preservation of digital files is a hot topic in the photo industry these days. Many experts are concerned that because of the fast-changing nature of technology, the imaging equipment of the future may not be able to open the picture files that digital photographers create today. (Think Betamax video-tapes and 8-track audio cassettes.)

What's usually overlooked in this discussion is that film photography presents just as much, if not more, risk to the lifespan of a picture. After all, most people aren't exactly careful about how they store photos and negatives — can you even *find* the negatives of your most precious pictures? And do you have all your family photographs archivally framed and hung in a light-controlled environment to guard against fading?

That's not to suggest, however, that you don't need to take steps to protect your digital image files. The following sections tell you how to ensure the long life of your digital originals as well as how to save any changes you make to those pictures in your photo editor.

Archiving your picture files

Let me start by warning you away from data-storage devices that are *not* reliable for long-term safekeeping of your picture files:

- Your camera's memory card (or any memory card)
- A removable flash drive, like those tiny USB key drives that are all the rage today
- Your computer's hard drive
- An external hard drive
- A multimedia player such as one of those flashy portable devices that can play movies, MP3 audio files, and pictures
- Zip disks, a Microdrive, or any of the other high-capacity removable storage drives and disks that may be hanging around your office

All these devices use storage technology that is simply too prone to failure, breakage, and accidental erasure to provide long-term protection for your important pictures.

So what's the solution? Here's my best advice:

- For picture files that you absolutely, positively want to give the best chance of survival, go with non-rewritable CD-ROMs. They're labeled CD-R, not CD-RW. (The RW means that you can overwrite the files on the disc with other files.) And buy high-quality, gold-coated discs, not the cheapo store brands. Yes, there is a difference, and it's worth paying for.

- For all your other picture files, you can also copy the pictures to a DVD. Again, a non-rewritable DVD (that's either DVD-R or DVD+R) ensures that you don't accidentally erase the pictures on the disc.

I don't recommend DVD yet for critical-image storage because the industry hasn't settled on a single DVD format. So there's a chance that the DVDs you burn on your current computer may not play on next year's model. When a clear winner emerges, however, DVDs probably will replace CDs as the media of choice because they offer a much greater storage capacity. The good news is that most DVD players can play CDs as well as DVDs.

If you don't want to mess with burning your own CDs or DVDs, most retail photo labs and online photo services can do it for you.

Saving works in progress

When you make changes to your pictures in a photo editor, you must remember to save the altered file before closing the image. (Most programs prompt you do to so.) If you're making a lot of changes, you should also save the file periodically so that if your system crashes, you don't lose your work.

Here are the critical facts to know about saving your photo files:

- **Save versus Save As:** Both commands are typically found on the File menu, but they approach the save process differently. With File⇨Save, you overwrite the open picture file, usually without being presented with any dialog box or other message. (This assumes that you're working with an existing file rather than one you just created anew or scanned into your photo editor.)

 With Save As, the program opens a dialog box in which you can specify a new name, file format, storage location, and so on. Figure 3-12 shows the Save As dialog box that appears when you use the Windows version of Photoshop Elements.

- **File format:** You can save a picture file in many different formats, but you should always save your works-in-progress in the TIFF format or, if you use Elements (or Photoshop), the Photoshop format, PSD. Both formats are *lossless*, which means that they preserve all your picture data.

Never resave an edited photo in the JPEG format because doing so results in data loss that can damage your image. (Merely opening, viewing, and closing the file doesn't do any harm, however.) If you need a JPEG file for online use, create a copy of your finished image by following the instructions later in this chapter.

✔ **Program-specific save options:** Your Save As dialog box may contain some options that relate just to your photo software. In Elements, for example, you see the Layers check box as well as a few additional options, as shown in Figure 3-12. Because the options vary widely among photo software, I must direct you to your program's Help system for details on these options. For Elements users, Chapter 5 contains some information about the Layers option, however.

Figure 3-12: Some file-saving options are specific to the photo software.

Undoing mistakes

Up to the time that you save or close an edited picture, you can undo almost any change you made. Use these go-back options:

- ✓ **Edit⇨Undo:** This command takes you back one step in time, undoing whatever you just did to your picture. In many programs, including Elements, you can keep choosing the command to undo a series of bad moves. For times when you change your mind about your undo, Elements and most other programs offer an Edit⇨Redo command, which restores the most recent change that you reversed.

- ✓ **Revert:** This command, found on the Edit menu in Elements and sometimes on the File command in other programs, restores the picture to the way it appeared immediately after you last saved it.

- ✓ **Close without saving:** If you simply close the image and don't save your changes, you undo any changes made since the last time you saved the file. In other words, this step does the same thing as Revert except that Revert leaves your picture file open.

If you use Elements, also check out the Undo History palette, where you can view a list of your most recent changes and then undo multiple steps more quickly than you can by choosing the Undo command repeatedly. The Elements Help System tells you what you need to know to take advantage of this feature.

Preparing a Picture for Print

Whether you need to take any preparatory steps before printing your pictures depends on how you plan to put those puppies on paper. No prep work is necessary if you're taking your files to a retail photo lab for printing; just be sure that you follow the lab's recommendations for how large you can print your photo, given the number of pixels in the image file. (See Chapter 1 for an introduction to pixels and their relationship to print quality and size.)

If you want to print your own photos or use them in a print publishing program, however, prepare the files as outlined in the next two sections.

Setting print dimensions and resolution

Before you choose the Print command in your photo-editing program, you should set the output dimensions and resolution (pixels per inch) of your image. To do so in Photoshop Elements, take these steps:

1. **Choose Image⇨Resize⇨Image Size.**

 You see the Image Size dialog box, shown in Figure 3-13.

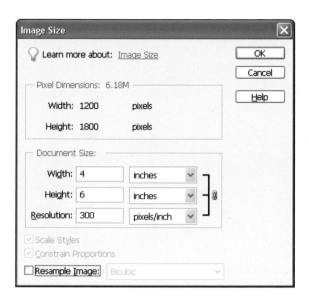

Figure 3-13: To avoid degrading your image, turn off resampling.

2. **Turn off the Resample Image check box.**

 This step prevents you from adding or deleting pixels to or from your photo, a dangerous option that you can explore in Chapter 2.

3. **Enter your desired print height or width.**

 When you type a value in the Width box, the Height value changes automatically, and vice versa. This restriction maintains the original proportions of your photo.

 Additionally, you see the Resolution value change as you adjust the width or height because changing the dimensions of the photo changes the number of pixels per inch. Remember, for a good quality print, you should aim for at least 200 pixels per inch (ppi).

 What if the Resolution value is lower than 200 ppi at your desired print dimensions? Unfortunately, there is no magic fix. You simply have to decide whether print size or quality is more critical to your project. *Don't* try to add pixels to make up the difference — as illustrated in Chapter 2, you don't gain anything and you may make the picture quality worse.

4. **Click OK to close the dialog box.**

Now you're ready to ship that picture file off to the printer, which you can do by choosing the Print command, usually found on the File menu. The dialog box that appears next varies depending on what photo software you use and whether your computer is a PC or a Mac, so again, I must refer you to your program's Help system for detailed explanations.

Whatever software you use, *don't* take advantage of any options that *scale* your photo — change the print size, in everyday lingo. Otherwise, you change the output resolution of the photo, undoing all the work you did in the preceding steps. Whether the resolution change resamples the image depends on the photo software.

Saving a TIFF copy for publication

When you're asked to submit a photo for use in a newsletter, magazine, or other print publication, you may be required to provide the image file in the TIFF format. You also need to create a TIFF copy of your image to use it in most desktop publishing programs (such as Microsoft Publisher).

To do so, use the File⇨Save As command that I explain in the "Saving works in process" section, earlier in this chapter. When you save the file, you may see a second dialog box similar to the one shown in Figure 3-14.

Some TIFF options can affect the file's compatibility with some publishing programs. So follow these guidelines:

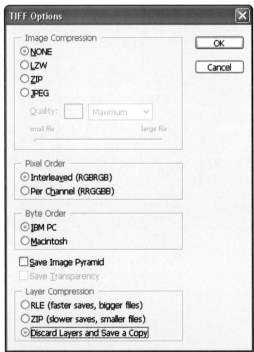

Figure 3-14: Save TIFF files with no compression and no layers to avoid conflicts with some publishing programs.

✔ Turn off file compression, if available.

✔ For Pixel Order, choose Interleaved. Trust me, you don't want to know the details.

✔ Set the Byte Order according to whether the person who requested the file uses a Windows PC or a Mac computer. If you don't know, stick with the one that matches your operating system.

✔ If your picture contains layers, also choose the option that merges all the layers into one. (In Elements, choose Discard Layers and Save a Copy.) Many publishing programs can't open layered TIFF files.

Preparing Photos for the Web

Getting pictures ready for online use — or for any on-screen use, really — involves two steps: setting the picture display size and saving the resized file in the Web-friendly JPEG format. The next section explains some background about sizing pictures for screen display; following that, I show you how to use a tool called a *JPEG optimizer* to set the picture size and create your JPEG file at the same time.

Understanding screen display size

A computer monitor can display a limited number of pixels. For most monitors, the maximum screen display size is around 1600 x 1200 pixels — and that's much higher than most people use. I run my 19-inch monitor at a setting that displays 1024 x 768 pixels, for example. (As you lower the display setting, text and other on-screen objects get larger and easier to view.)

Unless you're dealing with a very low-resolution original, you probably need to dump pixels to properly size the photo for screen display. For example, Figure 3-15 shows you how a 6-megapixel image appears when attached to an e-mail message and viewed on a monitor set to the 1024 x 768 display. The picture, which has a pixel count of more than 3000 x 2000 pixels, is much too large to be viewed without scrolling. In addition, all those pixels make for a large file and a long download time.

To stay within safe viewing limits, follow these size guidelines:

✔ **E-mail photos:** For pictures that you want to share via e-mail, use a maximum size of 450 pixels wide and 400 pixels tall. This size ensures that the entire image can be viewed without scrolling, as shown in Figure 3-16, and also significantly reduces the time required to download the picture.

✔ **Web site photos:** For a picture that you plan to use on a Web site, size the picture according to the page layout. If you aren't the one designing and maintaining the page, call the person who plays that role to find out what size to use.

✔ **Presentation photos:** If you're preparing a picture for a multimedia presentation that will be given via a digital projector, find out the resolution of the projector. Then set the image display size accordingly. For example, if the projector has a resolution of 1280 x 1024 and you want your picture to fill the entire screen, set the picture size to 1280 x 1024 pixels.

Finally, remember that pixel count has *no* effect on the quality of on-screen pictures, only on the size at which the image appears on-screen. In other words, the rules are different for screen images than they are for prints.

However — and this is an important however — if you're sending a picture file to someone who needs to produce a good print from the file, size the photo according to the print guidelines I provide earlier in the chapter, in the section "Setting print dimensions and resolution." The same holds true if you're uploading pictures to an online album site from which you want to order prints.

Figure 3-15: This 6-megapixel image is much too large for on-screen viewing.

Figure 3-16: I reduced the pixel count significantly so that the entire picture is visible in the e-mail window.

Saving your JPEG copies

Many photo programs offer something that geeks like me refer to as a *JPEG optimizer.* With this tool, you can set your image display size and make a JPEG copy of the image all at once. But the more important benefit of a JPEG optimizer is that it contains previews that enable you to see how your image will appear at different JPEG quality settings.

Chapters 1 and 2 explain the JPEG format fully so I won't go into it all again here. Just remember that saving a picture in the JPEG format results in some of your picture data being dumped in order to create smaller files. This process is called *lossy compression.* And if you toss lots of picture data, your image quality becomes, well, stinky. So your goal when preparing Web images is to find the optimum balance between file size and image quality — hence, the term JPEG *optimizer.*

The following steps show you how to use the Photoshop Elements version of this tool. If you don't use Elements, the controls in your optimizer should be very much the same, although how you access them may vary.

1. **Open the picture that you want to prepare for the Web.**

2. **If you made changes to the image that you haven't yet saved, do so now.**

 Save the file in a lossless format such as TIFF or, in Elements, PSD.

3. **Choose File⇨Save for Web.**

 You see the Save for Web dialog box shown in Figure 3-17. The dialog box contains two previews: On the left, you see the original image, and on the right, you see how the image will appear if you save it at the current dialog box settings. Below the second preview, you see the approximate file size and download time for the "after" images.

Figure 3-17: The Save for Web tool enables you to preview your image at different JPEG quality settings.

You can adjust the preview setup as follows:

- *Adjust the preview magnification:* Click either preview with the Zoom tool, labeled in Figure 3-17. To zoom out, hold down the Alt key (Windows) or the Option key (Mac) as you click with the Zoom tool.

- *Scroll the preview display:* Drag inside either preview with the Hand tool, also labeled in Figure 3-17.

- *Adjust the modem speed for the download time preview:* The download speed value shown beneath the right preview relates to a specific modem speed. By clicking the little triangle button labeled in Figure 3-17, you open a menu from which you can select a different modem speed.

Unless you're preparing a picture that you plan to share only with people who have a high-speed Internet connection, set the preview to a modem speed of 56.6 Kbps (kilobytes per second). Currently, this is the slowest modem speed of most dial-up connections — the lowest common denominator, if math terms help.

4. Set the image display size in the New Size area of the dialog box, featured in Figure 3-18.

Before you do anything else, turn on the Constrain Proportions box so that you retain the original proportions of the image when you resize it.

Then enter either the new width or height — measured in pixels — into the Width or Height box. When you enter either value, the other updates automatically to keep the image proportional.

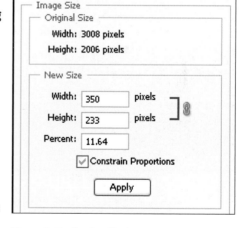

Figure 3-18: Set the display size and then click the Apply button.

5. Click the Apply button underneath the Width and Height boxes to make the change in pixel count official.

After you click the button, the file size and download time shown for the after preview should both go down. If they don't, you forgot to click that Apply button. (I do it all the time, which is why I bring it up.)

6. Select JPEG from the format drop-down list highlighted in Figure 3-19.

The list contains choices of all the available Web image formats; JPEG is the best option, so don't stray from the plan.

7. Set the image quality by using the two controls shown in Figure 3-19.

You can either select a quality range from the drop-down list on the left or select a specific quality value from the Quality option to the right. As you adjust the quality settings, the image preview updates to show you the effect on file size and picture quality. You may want to zoom in on the image so that you can spot any serious degradation, which may not be visible at a long view.

Format

Quality settings

Figure 3-19: When you use a low pixel count, you can use the top quality settings and still create a very small file.

8. Deselect the Progressive and ICC Profile boxes.

Both options can cause problems for certain browsers and don't offer benefits worth the risk.

The Matte setting has no impact unless the bottom layer of your photo contains transparent pixels. That's an advanced option that I don't cover in this book, but if your photo *does* have transparent pixels, use the Matte option to select a color to fill the transparent areas. The JPEG format can't handle transparency.

9. Click OK to close the Save for Web dialog box.

You see a standard Save As dialog box.

10. Choose a filename and storage location as usual.

The format, JPEG, is already selected for you.

If your original image is also in the JPEG format, be careful not to use the same name, or you will overwrite that original. I add the word *Web* to the end of my filenames so that I know that a picture file has been prepared for online use.

11. Click Save to close the dialog box.

You return to the Elements main window, where your original picture remains on-screen. Close the picture without saving it (assuming that you saved the image in Step 2, as instructed). To view your JPEG copy, open it from the location where you just stored it.

Part II
Easy Digital Darkroom Repairs

The 5th Wave By Rich Tennant

©RICHTENNANT

"Well, well! Guess who just lost 9 pixels?"

*I*f a soufflé falls before you get it to the table, there's nothing much you can do. Knock an antique vase onto a hardwood floor, and, well, that heirloom's a goner. But with the right computer hardware and software, you can repair almost any photographic flub, whether you need to tweak a picture from your digital camera or repair years of damage to an old image from your family album. The chapters in this part of the book show you how.

Performing Photo First Aid

*I*t never fails: All the pictures on your memory card or roll of film turn out perfectly focused, exposed, and composed *except* the must-have image — the once-in-a-lifetime moment when your spouse receives the employee-of-the-year plaque, your college grad accepts a diploma, your two-year-old blows out the birthday-cake candles. Call it Murphy's Law, Photography Edition.

When such photographic disasters occur, don't panic. And whatever you do, don't delete that picture from your memory card or throw away the negative or print, because the image may be salvageable. This chapter's projects walk you through simple steps for correcting exposure, focus, and even composition. (I cover color correction in Chapter 6.)

In addition, the beginning of the chapter explains *selecting,* which is a step you can take to limit the effects of any corrective filters or tools to a specific part of your image.

Selecting the Area to Alter

All the examples in upcoming sections of this chapter assume that your entire photo needs adjusting. But often, you need to correct only a portion of your picture. To apply a correction filter or tool just to that area, leaving the rest of the image untouched, you must perform a preliminary step called *selecting*.

This process is similar to using your cursor to highlight a word you want to edit in a word-processing program. But in photo-editing programs, you use a *selection tool* to draw a dotted *selection outline* around the pixels you want to alter.

Photoshop Elements, like most photo-editing programs, offers you a variety of tools for creating a selection outline. The following steps show you how to use the most flexible and capable of these tools, the Selection Brush. (Don't be intimidated by the length of the steps; it takes lots of words to fully describe this tool, but it's actually very easy to use.)

1. **Choose the Selection Brush, as shown in Figure 4-1.**

Flyout menu triangle Mode control

Figure 4-1: To open a tool flyout menu, press and hold on the little triangle.

The tool shares a toolbox slot with the Magic Selection Brush. If you see the Magic Selection Brush instead of the Selection Brush in the toolbox, put your cursor over the little black triangle in the lower-right corner of the tool icon and then hold down your mouse button. This action reveals a flyout menu. Click the Selection Brush as shown in Figure 4-1 to make it the active tool.

2. **On the options bar, set the Mode control to Selection, as shown in Figure 4-1.**

The Selection Brush offers two modes, Selection and Mask. I suggest that you start in Selection mode to draw a rough outline (as explained in Steps 3 through 5) and then switch to Mask mode to refine the outline if you need to precisely select an object or area. (See Steps 6 through 9.)

3. **Open the Brushes palette and choose any round brush.**

To open the palette, labeled in Figure 4-2, click the brush icon on the options bar, also labeled in the figure. Inside the palette, make sure that the Default Brushes option is selected from the Brushes drop-down list. Then click any of the first several brushes in the palette, as shown in the figure. You don't need to worry about a specific brush size or hardness yet; just be sure to select a round brush and not one of the specialty brushes found near the end of the brush list.

The figure shows the default palette display. If you changed the display, your brush icons may look different from what you see in the figures in this book.

Figure 4-2: Start by selecting a basic round brush from the Brushes palette.

4. **Adjust the Hardness control on the options bar if necessary.**

 When you work with the Selection Brush, the Hardness control determines whether the edges of the selection outline you create are *feathered,* which in turn impacts the results of the filter or other change you then apply to the selected area. Here's the scoop:

 - *Use a low Hardness value for a feathered outline.* With a *feathered outline,* pixels become only partially selected near the edges of the outline. When you then apply your correction filter or other change to the image, that alteration fades out gradually at the edges of the selected area. A Hardness value of 0 gives you the most feathering.

 - *Set the Hardness value to 100 for a non-feathered outline.* Now when you apply your filter to the selected area, all pixels within the selection outline receive the full impact of the change.

 What Hardness value you should use depends on what you're trying to accomplish. For example, to apply a blur just to the background of the example photo, use a non-feathered, or fully hard, outline so that no part of the flower or butterfly receives the blur. But to apply an exposure filter to brighten the center of the image more than the outside edges, a feathered outline creates a more natural result because there is no abrupt transition between the lightened and non-lightened areas.

 When you use a feathered outline, you may need to experiment to find the right feathering amount; no one value works for all projects and images. Note that the selection outline appears the same whether you use a feathered or unfeathered outline; you can't see the difference until you apply your subsequent filter or other correction.

5. **Drag over the area you want to select.**

 As you drag, a dotted outline emerges from your cursor, as shown in Figure 4-3. You don't have to complete the entire outline in one drag — you can stop and start as needed. You also can use the Size control on the options bar to adjust the brush size as needed.

 Keep dragging with the Selection Brush until the area you want to select is entirely enclosed by the outline. In Figure 4-3, I drew a rough selection outline around the flower and the butterfly.

 If you need just a rough selection outline, you're done. But if you need a very precise outline, move on to Step 6.

6. **To refine the outline, switch the tool's Mode control to Mask.**

 This mode enables you to more precisely place the edges of the selection outline than the Selection mode.

Figure 4-3: Anything inside the dotted selection outline is selected and ready for editing.

As soon as you switch to Mask mode, your selection outline disappears, and the options bar controls change to those you see in Figure 4-4. Anything that was formerly outside the selection outline you created is covered by a red, translucent overlay, or *mask*. Think of this overlay like the masking tape you put down over your baseboards before painting your walls — it protects the pixels it covers from being changed.

If the color or opacity of the mask makes it difficult for you to distinguish the mask from your image pixels, use the Overlay Color and Overlay Opacity controls on the options bar to adjust the mask appearance.

Erase Paint

Apply Paint

Mask

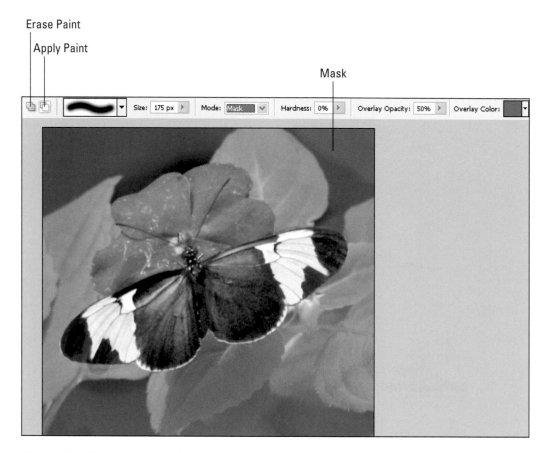

Figure 4-4: In Mask mode, you paint a red mask over areas that you *don't* want to select.

7. Paint with the Selection Brush to perfect the mask.

Your goal is to extend the red mask over the pixels that you don't want to select and to remove it from those you do. You do this by painting with your tool brush, as follows:

- *To apply the mask paint:* Click the Apply Paint icon labeled in Figure 4-4 and then drag over areas that aren't covered by the mask.

- *To remove the mask paint:* Click the Erase Paint icon and drag over the masked areas.

Anything that's covered by the red mask becomes deselected — or, more accurately, *will* become deselected when you complete this process in Step 9. And remember that you don't see the dotted selection outline in this mode.

8. **When painting the borders of the mask, adjust the Hardness value if needed.**

The Hardness value that you set while painting the borders of your mask determines whether you create a feathered or nonfeathered outline. As with Selection mode, use a value of 100% if you want a non-feathered outline; a lower value produces a feathered outline. You can adjust the Hardness for different parts of the outline; in this way, you can create a selection outline that's feathered in some areas and not in others. In Figure 4-5, you can see me painting the border using a fully hard brush.

I recommend that you paint the interior areas of your mask with the Hardness value set to 100%, however; using a feathered brush tends to leave some stray pixels selected even if they appear to be masked.

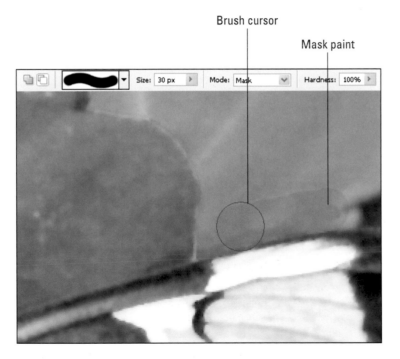

Figure 4-5: For a nonfeathered mask, paint the mask borders with the Hardness value set to 100%.

Keep painting until you've applied the mask over all the areas that you don't want to select. Zoom in to paint the boundaries between the object you want to select and the background, as shown in Figure 4-5. If needed, you can adjust the brush size between strokes to get into all the little nooks and crannies along the border. Figure 4-6 shows my finished mask.

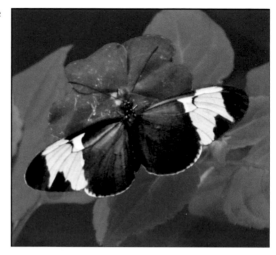

Figure 4-6: My finished mask precisely covers only the photo background, leaving the flower and butterfly unmasked.

9. **When you're happy with the mask, set the Mode control on the options bar back to Selection.**

Now the mask disappears and the blinking selection outline reappears, as shown in Figure 4-7. Anything that was formerly covered by the red mask is outside the selection outline; anything that was formerly unmasked appears inside the selection outline and is then ready for your next edit.

If the selection outline doesn't look quite right, however, you can switch back to Mask mode to further refine the mask. Keep switching between the two modes until you're sure the outline is where you want it.

TIP

Customizing your Elements tool cursor

By default, the cursors for Photoshop Elements tools resemble the tools' icons in the toolbox. You see a little paint brush when you work with the Brush tool, for example. These cursors don't offer any indication of the brush size and shape, so you don't know what pixels your next brush stroke will affect.

For a better option, visit the Display & Cursors panel of the Preferences dialog box. In Windows, open the dialog box by choosing Edit➪Preferences➪Display & Cursors. On a Mac, choose Photoshop Elements➪Preferences➪ Display & Cursors. Then set the Painting Cursors option to Full Size Brush tip. Now your tool cursor reflects the actual size and shape of your brush.

I also set the Other Cursors option, found on the same dialog box panel, to Precise. With this setting, tools that don't have adjustable brushes display a simple crosshair cursor instead of the icon-based cursor. Again, the crosshair cursor makes it easier to see exactly what area you're about to alter with your tool.

All the figures in this book feature these cursor display settings.

Selection outline

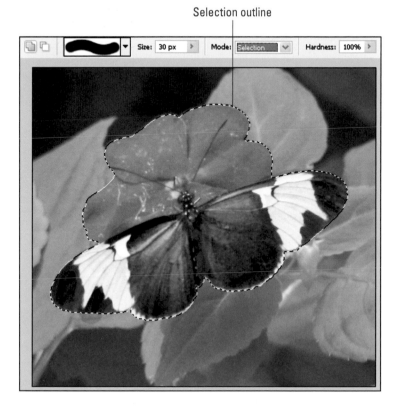

Figure 4-7: When you switch from Mask mode to Selection mode, everything that wasn't covered by the red mask becomes selected.

Again, the Selection Brush is much easier to understand when you try it for yourself, so don't worry if reading these instructions left you a little baffled. Just work through the steps one or two times using the sample image on the DVD, and all should become clear.

In addition to the sample images, the DVD that comes with this book contains QuickTime movies that show you how to use the Selection Brush and some of the other Elements selection tools. The movie titled "Selection Basics" also talks more about selection feathering and explains how to adjust an existing selection outline.

Straightening a Crooked Photo

If you've ever traveled to Venice, Italy, you probably shot your first pictures of that canal-laced city while riding in a water taxi to your hotel, as I did when shooting the scene in Figure 4-8. And so you can appreciate my excuse for the

tilting horizon line in that picture — it's not easy to keep the camera and horizon level while bobbing along the waves.

Whether you have a good excuse or not, you can easily straighten your image by rotating it slightly in your photo editor. Here's how to do it in Photoshop Elements:

1. **Choose Select➪All to select your entire image.**

 You see the blinking selection outline around your picture.

2. **Choose Image➪Rotate➪Free Rotate Selection.**

 The blinking outline is replaced by a solid outline that has little boxes, called *handles,* around the perimeter, as shown in Figure 4-9. (If you don't see the outline or handles, maximize your image window or zoom out by choosing View➪Zoom Out.) The options bar also changes to show you the controls you see in the figure.

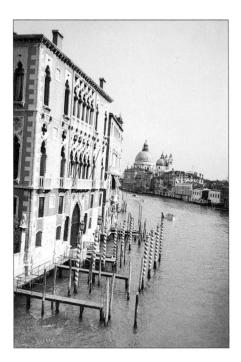 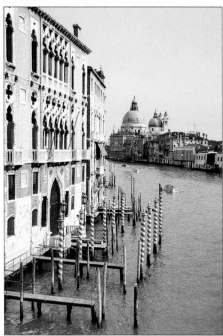

Figure 4-8: A crooked horizon line ruins my original Venice shot (left) but is easily repaired (right).

Handle Rotate cursor

Figure 4-9: Drag outside a corner handle to rotate the photo.

3. Place your cursor outside one of the corner handles, as shown in Figure 4-9.

The cursor should change into a curved, double-arrow handle, as you see in the figure.

4. Drag up or down to rotate the picture until the horizon is level.

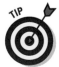

If you have trouble getting the rotation right, try this trick: Double-click inside the Rotate box on the options bar (labeled in Figure 4-10). Then press the up-arrow key to nudge the picture clockwise; press the down-arrow key to nudge it counter-clockwise.

As you rotate the image, you reveal parts of the image *canvas* — the virtual background on which every photo rests in Elements. In Figure 4-10, the canvas is white.

Rotate box

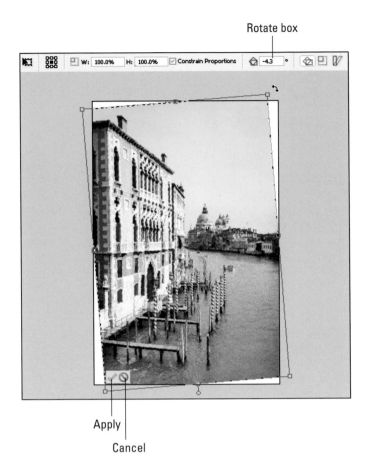

Apply

Cancel

Figure 4-10: Rotating the image reveals empty canvas areas that must be cropped away.

5. **Click the green Apply check mark, labeled in Figure 4-10, to apply the crop.**

 If you instead want to escape the crop operation, click the adjacent red cancel button.

6. **Crop the image to remove the now-empty canvas areas.**

 The next section explains cropping. You can see my final, cropped Venice image on the right in Figure 4-8, shown earlier.

Cropping to a Better Composition

Trimming away excess background can dramatically improve many pictures. Figure 4-11 offers an example: The bright blue pool water in the background distracts the eye from the subject, as does that turquoise frozen-treat thing she has in her hand. Cropping the image tightly eliminates those flaws and restores emphasis to the face, where it should be.

Before you crop, however, check your original pixel count and be sure that you have enough pixels to even allow the crop. If you plan to print the image, you need at least 200 pixels per linear inch of your print to get good print quality. So if you start with a low-resolution image and then crop it to a small area, you're going to be disappointed with the resulting print. Chapter 3 shows you how to set print output size and pixels per inch (resolution).

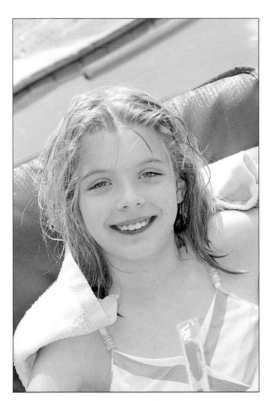
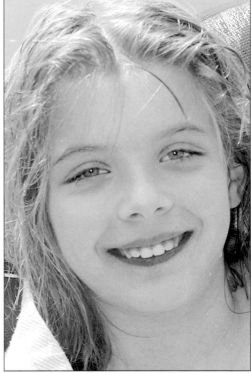

Figure 4-11: Cropping can improve your image by eliminating distracting background elements.

If you also need to straighten the horizon line in your photo, tackle that job first. (See the preceding section.) You lose some of your original image area in the process of straightening the horizon, so you want to start that task with an uncropped photo to give yourself the most flexibility.

With those caveats in mind, follow these steps to crop your picture in Elements:

1. **Grab the Crop tool, labeled in Figure 4-12.**

2. **On the options bar, set the Crop tool behavior by choosing an option from the Aspect Ratio drop-down list, as shown in Figure 4-12.**

Crop tool Swap

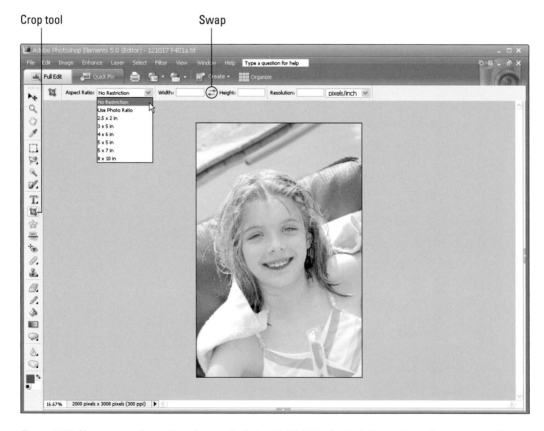

Figure 4-12: You can use the options bar controls to establish the desired dimensions of your cropped image.

These options enable you to crop your photo to a specific size or to specific proportions, as follows:

- *No Restriction:* Choose this option if you don't care whether your cropped image has specific proportions. You then can crop the image to any width or height you choose.

- *Use Photo Ratio:* Avoid this option. It crops your image in a way that retains the original proportions of your photo; for example, if your original was 3 units wide by 4 units tall, your cropped image will also take on those proportions. The problem is that the program then adds as many pixels as needed to take you back to the picture's original pixel count. Adding pixels, or *resampling,* nearly always reduces picture quality. If you need to crop to a specific proportion, use either of the next two options instead.

- *Standard Frame Size (4 x 6, 5 x 7, and so on):* If you want your cropped photo to fit a specific frame size, select that size from the menu. Leave the Resolution box empty; if you enter a value, the program resamples the image.

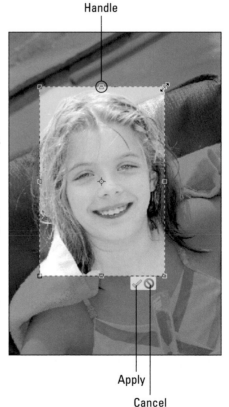

Handle

- *Custom Size:* If you don't see the size you want on the menu, select No Restriction and then type the dimensions into the neighboring Width and Height boxes. Enter the unit of measurement after the values you type: For example, type **5 inches** or **10 picas** in the box. Again, leave the Resolution box empty.

I chose the 4 x 6 option for my image.

3. **Drag with the Crop tool to create an initial crop boundary, as shown in Figure 4-13.**

After you complete your drag and let up on the mouse button, the area outside the crop boundary appears dimmed, as shown in Figure 4-13. You also see two buttons beneath the boundary: a green check mark and a red cancel sign.

Apply

Cancel

Figure 4-13: Drag to enclose the area you want to keep in a crop boundary.

4. **Adjust the crop boundary if needed.**

 You can resize and relocate the boundary as follows:

 - *Resize the boundary:* Drag one of the square boxes that appear around the perimeter of the boundary. (These boxes are known as *handles.*) Elements restricts the boundary to maintain the proportions you set in Step 2.

 - *Move the boundary:* Place your cursor inside the boundary and drag it. Or, for precision moves, press the arrow keys on your keyboard: Press the up arrow to nudge the boundary up, the right arrow to nudge the boundary to the right, and so on.

 - *Change the boundary orientation:* Here's a cool one: Want to see how the picture would crop using a horizontal orientation instead of a vertical, or vice versa? Click the Swap arrows between the Width and Height boxes on the options bar. (See Figure 4-12.) Now, instead of a crop boundary that's, say, 4 inches wide by 6 inches tall, you get a boundary that's 6 inches wide by 4 inches tall.

 Should you need to get rid of the boundary altogether and start over, click the red cancel button, labeled in Figure 4-13.

5. **Click the green Apply check mark underneath the crop boundary to crop the image.**

 I labeled the check mark in Figure 4-13. (Exactly where the check mark appears depends on the size of your photo.) My cropped portrait appears on the right in Figure 4-11.

Adjusting Exposure

Achieving the right exposure is one of the trickiest aspects of photography, which is why entire books have been written on the subject. The good news is that because it is so easy to wind up with a photo that's too dark or too light, most photo-editing programs offer several tools for correcting exposure.

The next sections show you how to use the best of these tools to brighten an underexposed photo, darken an overexposed image, and add impact by adjusting contrast.

Which exposure tool is best?

Photoshop Elements, like many photo-editing programs, offers a number of tools for correcting exposure. I address just two of these tools, the Levels filter and the Shadows/Highlights filter, both found on the Enhance⇨Adjust Lighting menu. I picked these two filters because they offer the best combination of good results and ease of use.

Before I explain these filters, a little lingo lesson is needed to help you better understand the filter options and exposure correction in general. Photographers describe exposure in the following terms:

- **Highlights** are the brightest areas in the image. The term *blown highlights* refers to areas that should contain a range of light colors but are instead completely white because of overexposure.

- **Shadows** are the darkest areas of a photo. Photographers often discuss *hidden shadow detail* or *blocked shadows* when referring to photo details that are severely underexposed and thus obscured.

- **Midtones** are areas of medium brightness.

- **Contrast** refers to the range of brightness values in an image, from shadows to midtones to highlights. A high-contrast image consists mainly of strong shadows and highlights, with few midtones. In a low-contrast image, the range of brightness values is limited; for example, everything is of medium brightness, with few shadows or highlights.

Now that you have the basic terminology sorted out, look at Table 4-1, which suggests the appropriate filter for the exposure problem you're facing. Some pictures, by the way, may need an application of both Levels and Shadows/Highlights. (Remember, if you use software other than Elements, you likely can find similar tools in your program, but the names may vary.) For specifics on how to use these filters, read the next two sections.

Also check out the DVD that accompanies this book. It contains a QuickTime movie titled "Adjusting Exposure and Focus," in which I demonstrate the Levels and Shadows/Highlights filters.

Table 4-1	Choosing the Right Exposure-Correction Filter
If You Want to Do This . . .	*Use This Filter*
Lighten shadows	Shadows/Highlights
Lighten highlights	Levels
Darken shadows	Levels
Darken highlights	Shadows/Highlights
Lighten or darken midtones	Levels
Increase contrast	Levels
Decrease contrast	Shadows/Highlights

Applying the Shadows/Highlights filter

At first glance, the photo in Figure 4-14 appears to be a throw-away. The left side of the image is way too dark, whereas the clouds and buildings on the right are overexposed.

Figure 4-14: Details are lost in too-dark shadows and too-bright highlights.

But not so fast: You may be surprised at just how much you can tweak this kind of lopsided exposure. In Elements, for example, the Shadows/Highlights filter does an amazing job of revealing details formerly lost in the shadows and toning down too-bright highlights.

Before I show you how to use this filter, though, I want to point out that it doesn't affect any areas that are absolute black or absolute white. It works only on shadows and highlights that are *almost* black or *almost* white. No correction filter, in fact, can create highlight or shadow detail out of fully white or black pixels — the filter can't simply make up those details out of thin air.

That said, I still think the Shadows/Highlights filter will quickly become one of your favorites. Here's how to use it:

1. **Choose Enhance⇨Adjust Lighting⇨Shadows/Highlights.**

 The Shadows/Highlights filter dialog box opens.

2. **Select the Preview check box, as shown in Figure 4-15, so that you can see the results of the filter in your image.**

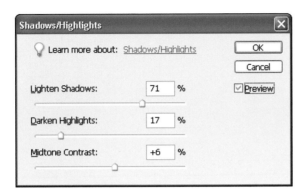

Figure 4-15: The Shadows/Highlights filter automatically brightens shadows by 25%.

3. **Brighten shadows by dragging the Shadows slider to the right.**

 When you first open the filter, Elements automatically lightens the darkest parts of your image by 25%. To brighten shadows more, drag the slider farther to the right; to darken shadow areas, drag the slider to the left. I set the slider to 71% for my image.

4. **Darken highlights by dragging the Highlights slider to the right.**

 For my image, I uncovered a little additional highlight detail by setting the slider to 17%. Notice, again, though, that the filter doesn't alter areas that are completely white — in my image, the brightest cloud areas.

5. **Adjust midtone contrast by dragging the Midtones slider.**

 Drag the slider to the right to increase contrast; drag left to decrease contrast.

6. **Click OK to close the filter dialog box and apply the changes to your photo.**

Figure 4-16 shows you my final filter settings along with my corrected image. The picture still has some blown highlights and blocked shadows, but it's greatly improved from the original.

Figure 4-16: I used the filter settings shown in Figure 4-15 to produce this improved version of the image in Figure 4-14.

So what do you do about those highlight and shadow areas the filter can't fix? Well, you have two options. You can either use your paint brush to simply paint in the correct colors, or you can *clone* (copy and paste) properly exposed areas over the bad spots. Chapter 5 gives you an introduction to painting; Chapter 6 explains cloning.

Adjusting exposure and contrast with Levels

Think of the Levels filter as the opposite of the Shadows/Highlights filter — sort of. With Shadows/Highlights, you can brighten shadows and darken highlights. In addition, you can increase or decrease contrast in the midtones.

With Levels, you can deepen shadows and brighten highlights. When you do so, you also increase overall image contrast. In addition, you can make midtones either brighter or darker.

To recap, turn to the Levels filter if you want to

- Adjust the brightness of midtones.
- Add "pop" by increasing contrast.
- Darken the darkest areas of your picture.
- Lighten the lightest areas of your picture.

(Don't worry; all this begins to become second nature after you get some experience evaluating and repairing your photos.)

The image in Figure 4-17 offers a good example of an image that can be improved by the Levels filter. Most of the picture is of medium brightness, and there aren't any deep, rich blacks or bright whites. In other words, it just doesn't have any "oomph," if you want my professional term. On top of that, the midtones are a little too dark overall.

Figure 4-17: This fall scene is underexposed in the midtones and also lacks contrast, with no strong highlights or shadows.

To correct images that suffer from one or all of these issues, apply the Levels filter like so:

1. **Choose Enhance⇨Adjust Lighting⇨Levels.**

 You see the Levels dialog box, shown in Figure 4-18. Don't freak out — I know it's initially overwhelming, but you really need to worry only about the area enclosed in the red box in the figure. Also turn on the Preview check box so that you can preview the filter changes on your image. (Any time you want to compare your "before" and "after" image while the dialog box is open, just click the check box on and off.)

Histogram

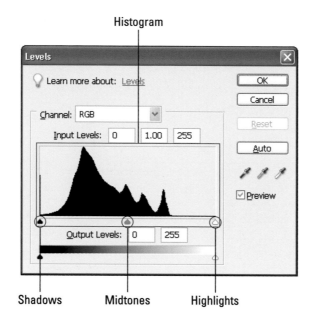

Shadows Midtones Highlights

Figure 4-18: Drag the sliders to adjust the brightness of shadows, highlights, and midtones separately.

That graph in the middle of the dialog box is called a *histogram*. A histogram plots out the brightness values of all the pixels in your image, with absolute black at the left end of the graph and absolute white at the right end. The height of the graph at any one spot reflects how many pixels you have at that brightness value.

For example, the histogram you see in Figure 4-18 shows that my original park image has almost no pixels that are very light or white, and only a smattering that are pure black. The big hill indicates that most of the pixels are clustered toward the darker side of the midtones range.

2. **To darken shadows, drag the Shadows slider, labeled in Figure 4-19, to the right.**

 Elements takes all the pixels at the new position of the Shadows slider and makes them black. Then it reassigns other pixels accordingly along the brightness spectrum.

 Notice that as you move the Shadows slider, the Midtones slider moves in tandem. You can adjust the midtones values later if needed.

3. **To brighten highlights, drag the Highlights slider to the left.**

Now Elements finds all the pixels at the new position of the Highlights slider and makes them white. Then it redistributes the other image pixels along the brightness spectrum as needed. Again, the Midtones slider moves in tandem when you drag the Highlights slider.

4. **Drag the Midtones slider as needed to tweak midtone brightness.**

 Drag the slider to the right to darken midtones; drag it to the left to lighten midtones.

5. **Click OK to apply the filter and close the dialog box.**

 I dragged the sliders to the position you see in Figure 4-19 to achieve the corrected image.

Adjusting exposure sometimes creates an apparent loss of color vibrancy. If this happens, you can bump up color saturation with the Hue/Saturation filter. See Chapter 6 for details.

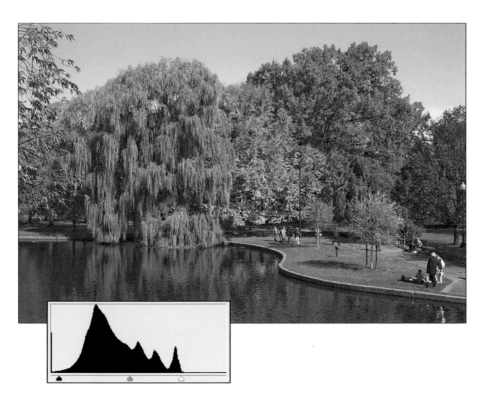

Figure 4-19: Increasing contrast and lightening midtones with Levels did this photo a world of good.

Sharpening Focus

Those high-tech spy-thriller movies and TV shows are starting to annoy me. For one thing, I don't believe that in real life, a size two beauty wearing a leather bustier and high-heeled boots kicks the stuffing out of the bad guys on a weekly basis and that she emerges from these battles with lipstick and mascara unsmudged.

More to the point of this chapter, I especially hate it when the techies in the spy guy's imaging lab take a totally out-of-focus photo and magically transform it into a picture that's so sharply focused that you can read the license plate number on a car that was a block away from the photographer. I'm sorry to disappoint you, but that kind of focus correction simply isn't possible.

You can, however, take an image that's slightly soft, like the left portrait in Figure 4-20, and create the illusion of sharper focus, as I did for the right portrait. And just so you know, even removing the amount of blur you see in the original portrait is pushing the limits of focus-sharpening.

Figure 4-20: Applying the Unsharp Mask filter to a slightly blurry photo (left) creates the illusion of sharper focus (right).

Why do I say *illusion* of sharper focus? Because a sharpening filter doesn't really change the focus of your picture. What it does is increase contrast along the boundaries where light areas meet darker areas. To do that, the filter creates *sharpening halos* along those boundaries, as shown in the close-ups in Figure 4-21. The light side of a color boundary gets lighter, and the dark side gets darker. From a distance, this contrast shift tricks the eye into thinking that the picture is more sharply focused.

Unsharpened

Sharpened

In Elements, the sharpening filter I prefer is called the Unsharp Mask filter. (The name stems from an old darkroom technique that involves using a blurry negative to create sharpening halos, if you care.) Follow these steps to apply it:

1. **Set the output size and resolution of your image, following the Chapter 3 instructions.**

 You should always take this step first because changing the size and resolution can affect how much sharpening an image needs.

Figure 4-21: Sharpening tricks the eye by increasing contrast along the border between areas where light meets dark.

2. **Select the area you want to sharpen.**

 The section at the beginning of this chapter shows you how. If your whole image needs help, as mine does, skip this step.

3. **Choose Enhance⇨Unsharp Mask (Elements 5.0 only).**

 If you use an earlier version of Elements, choose Filter⇨Sharpen⇨Unsharp Mask instead. The filter is the same; Adobe just moved it to another menu in Version 5.0.

Either way, you next see the Unsharp Mask dialog box, which is shown in Figure 4-22.

4. **Adjust the dialog box preview if needed.**

Select the Preview check box so that you can see the effects of the sharpening filter both in the image window and in the smaller preview window inside the dialog box.

To zoom the preview in the dialog box, click the plus and minus buttons underneath the preview. To display another area of the image in the preview, place your cursor in the preview and then drag when you see the cursor change to a little hand icon.

Figure 4-22: Click the plus and minus buttons to zoom the dialog box preview.

Try keeping your image window preview zoomed out so that you can see the entire image. Then zoom in on the most critical areas of your image inside the dialog box preview. This way, you can monitor the sharpening effect both at a distant and close-up view.

5. **Adjust the sharpening effect by using the three dialog box sliders.**

Each slider affects the sharpening effect in a different way:

- *Amount* controls the overall strength of the effect; the higher the value, the more intense the sharpening halos become.

- *Radius* controls the width of the sharpening halos. Typically, I use a value below 0.5 for on-screen images — pictures destined for the Web or a multimedia presentation — and between 0.5 and 2.0 for print images. Print images usually require more sharpening than on-screen images, especially if you print on textured paper.

- *Threshold* controls whether the halos appear along every color boundary in your image or just along boundaries where very-bright pixels meet very dark pixels — in other words, high-contrast areas. Digital imaging gurus refer to those high-contrast boundaries as *edges*. At a value of 0, all boundaries get the sharpening halos; raise the value to limit the effect to just the image edges.

I usually raise the Threshold value to anywhere from 1 to 5 when retouching portraits. This setting helps to keep the sharpening effect from making skin texture look rough.

6. **Click OK to apply the filter and close the dialog box.**

 For my sharpened image, I used the following filter settings: Amount, 150; Radius, 1.3; Threshold, 1.0.

Be careful not to oversharpen your images. If you do, your picture can take on a sandpaper-like texture, with visible sharpening halos along image edges. Figure 4-23 shows an example of an oversharpened picture. The larger you print your photo, the more subtle you need to be with sharpening, as halos and texturing become more apparent at large print sizes.

Figure 4-23: Oversharpening leads to grainy images and distracting sharpening halos.

Watch the QuickTime movie titled "Adjusting Exposure and Focus," found on the DVD accompanying this book, for a look at the Unsharp Mask filter in action and for some additional sharpening tips.

Blurring a Busy Background

A good photographer makes sure that the picture background doesn't distract from the subject. But sometimes, posing a subject against a good background just isn't possible. Try as I might, for example, I couldn't convince the giraffe you see in Figure 4-24 to move to a better spot for his portrait. And as a result, the animal is almost lost amidst the tree branches and flowering trees in the background.

When you face a similar situation, you can downplay a distracting background by throwing it into soft focus. You can do this in two ways: First, when taking the picture, use camera settings that result in a short depth of field, or range of sharp focus. Chapter 2 explains this technique.

Figure 4-24: The trees in the background distract from the subject (left); blurring the background in my photo editor improved the image (right).

If you need to blur the background even more, you can do so easily in just about any photo editor. Here's how to do it in Photoshop Elements:

1. **Select the area that you want to blur.**

 The first section in this chapter shows you how. For my picture, I selected everything but the giraffe.

 Be very careful when creating your selection outline; otherwise, you may wind up with a noticeable border of unblurred pixels around your subject.

2. **Choose Filter➪Blur➪Blur More.**

 This filter has no user-controlled options — just choosing the command applies a small amount of blur to the selected area. If you want more blur, just keep choosing the command until you get the effect you want. I applied the filter about ten times to produce the "after" image on the right in Figure 4-24.

 In Elements, you can quickly reapply the last filter you used by selecting it from the top of the Filter menu. Or just press Ctrl+F (Windows) or ⌘+F (Mac).

5

Retouching Portraits

*E*ver notice how many infomercials and TV-shopping shows feature beauty products these days? Gone are the days of Ginsu knives and the Popeil Pocket Fisherman. Now the screen is filled with celebrities hawking products that promise to erase all blemishes, turn teeth blindingly white, and generally morph ordinary humans into the perfect specimens shown on the pages of the fashion magazines.

I've never bought any of these miracle gels and goos, so I can't say that none of them live up to their claims. But I can tell you with some assurance that the flawless models/movie stars/heiresses you see on magazine covers owe their perfect appearance not to the latest beauty product, but to the skills of a talented photo retoucher who has carefully eradicated every zit, wrinkle, and age spot.

Well, I see no reason why everyone else shouldn't benefit from the same helping hand, so this chapter shows you how to remove all sorts of portrait flaws, including red-eye. In addition, the first section of this chapter introduces you to layers, a feature that's essential to getting good retouching results.

For a "live look" at techniques presented in this chapter, grab the DVD that accompanies this book and watch the QuickTime movies titled "Retouching Eyes and Teeth," "Repairing Skin," and "Introduction to Layers."

Discovering Layers: Don't Retouch without Them!

As you explore this chapter, you may notice that many projects involve a feature known as *layers*. The next several sections introduce you to this important photo-retouching tool. Layers aren't just a Photoshop Elements feature, by the way. If you don't use Elements, check your software's Help system to find out whether the program offers layers and, if so, how you access them. Generally, programs that offer layers offer similar layer features to those found in Elements.

What are layers, anyway?

Image layers have no real-life equivalent, but you can start by thinking of them as the sheets of clear plastic, similar to the transparencies used with overhead projectors, if you're old enough to remember that presentation technology. Your virtual transparencies, however, hold image pixels, those squares of color that make up a digital photo.

All images in Elements begin life with one layer, which is called the *Background* layer and holds all your original image pixels. The Background layer is fully opaque throughout.

On top of the Background layer, you can stack new layers, which I refer to as *editing layers*. Pixels on an editing layer can be opaque, transparent, or somewhere in between (translucent, in technical terms). Wherever an editing layer is transparent, you see the pixels on the underlying layer. In areas where a layer is translucent, the underlying pixels are partially visible.

For an example of how layers work, take a look at my original, unretouched photo in Figure 5-1. Next to the photo, you see the Layers palette, which is command central for layers in Elements. The palette displays thumbnail views of all the layers in your photo and also contains controls that offer the quickest ways to accomplish most layer tasks. To open the palette, choose Window⇨Layers.

When retouching my photo, I added four layers atop my Background layer:

- First, I added a layer on which I used the Clone tool, described in Chapter 6, to remove the chocolate stain near the neckline of the shirt.

- Next, I created another new layer on which I cloned away the necklace, which I thought was a little distracting.

- To quiet my inner perfectionist's voice, I added another layer on which I painted the phone with a new color that didn't clash as much with the subject's lips.

- On the top layer, I created a digital frame using the technique outlined in Chapter 8.

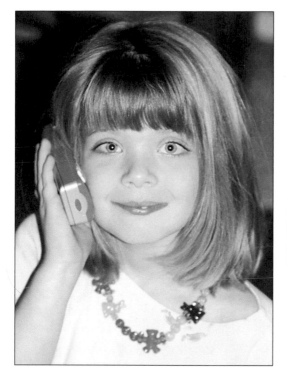

Figure 5-1: Every image starts life with one layer, called the *Background* layer.

Figure 5-2 shows you the final, retouched image. To the right of the photo, the Layers palette shows the order of the retouching layers.

In the Elements Layers palette, transparent areas of a layer are represented by the gray-and-white checkerboard pattern you see in Figure 5-2.

Of course, I could have done all this work directly on the Background layer. But keeping each change on a separate layer makes life easier. The next two sections spell out the main benefits of retouching with layers.

One quick side note: In this book, I show the Layers palette as an individual window. By default, it is instead part of the Palette Bin. If you want to take your Layers palette out of the Palette Bin — which frees up additional screen space for working on your photo — see the QuickTime movie "Getting Started with Photoshop Elements," on the DVD that accompanies this book. You can also find a QuickTime movie that provides an on-screen introduction of basic layer concepts.

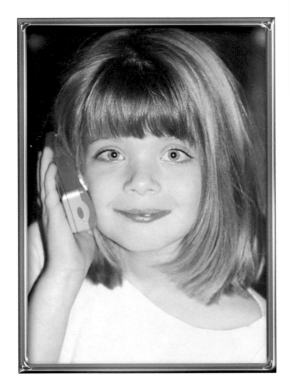

Figure 5-2: I did each step in retouching the portrait on a separate layer.

Use layers for safer, easier retouching

If you make your changes on an editing layer and then mess up or later change your mind about what you've done, you can simply remove the editing layer. This makes experimenting both easier and safer. For example, when I finished my picture, I decided that I liked the necklace after all. So I just trashed the layer that held the pixels I used to cover it up, as shown in Figure 5-3. If I worked solely on the Background layer, I could get the necklace back only by choosing Edit⇨Undo, and I first would have to undo all the changes I made after I removed the necklace.

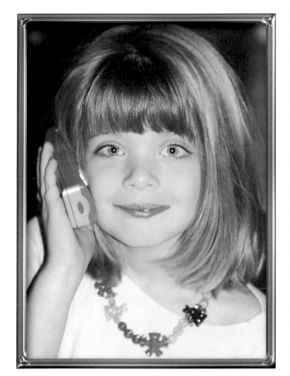

Figure 5-3: To restore the necklace, I just removed the layer that contained the patch I made to cover it up.

Alternatively, you can make the offending editing-layer pixels transparent — invisible, if you prefer — by dragging over them with the Eraser tool. For example, when painting the phone, I spilled paint onto the surrounding area. So I just dragged over the spilled paint with the Eraser, as shown in Figure 5-4. You also can make layer pixels transparent by selecting them and deleting them.

You can't, however, erase *or* delete pixels on the Background layer. The Background layer can contain only opaque pixels, so any pixels that you try to erase or delete instead take on the background paint color. In Figure 5-5, the background paint color was set to white, so my attempt to erase the spilled paint just resulted in replacing the colored pixels with white ones.

Here's one more way that layers give you an editing safety net: Most tools and filters affect only the currently selected layer, so you can't accidentally alter an element on another layer. (You select a layer by clicking it in the Layers palette.)

Figure 5-4: You can use the Eraser tool on an editing layer to rub away mistakes.

Figure 5-5: Erasing on the Background layer applies the background paint color (white, in this example).

Gain more creative control with layers

By using the Opacity and Blending mode controls in the Layers palette, you gain a great deal of control over how the pixels on your editing layers blend with the pixels on layers below, as follows:

- **Layer opacity:** This setting controls whether your layer pixels completely obscure the pixels below. At 100 percent opacity, the editing pixels completely cover pixels on the layer below. At a lower opacity, your original image pixels remain partially visible. For example, I often paint at a lowered opacity when covering up blown highlights, a topic explored near the end of this chapter. That way, instead of completely eliminating the highlights, which would reduce contrast, I can simply tone them down.

- **Layer blending mode:** This setting enables you to mix editing pixels and original pixels in special ways. Some blending modes create special effects, but others are useful in the retouching room. For example, when painting the phone in my image, I set the blending mode for the paint layer to Color. This mode retains the natural shadows and highlights of the original pixels but uses the color data from the editing layer, producing a natural result.

Some tools, such as the Brush tool, also offer opacity and blending mode controls, so you *could* accomplish the same results by working directly on the Background layer. But again, doing so makes changing your mind difficult — you have to undo all your work and start again. With editing layers, you can change the blending mode or opacity any time the mood strikes.

In addition, you can use the Move tool to relocate, rotate, and otherwise manipulate anything on an editing layer. This benefit is especially helpful when building collages or otherwise combining photos. You can experiment freely until you arrive at a composition you like. If you instead paste all the elements onto your Background layer, you lose that flexibility because moving an object on the Background layer produces the same result as using the Eraser tool — you get a hole that's filled with the background paint color. For more on collage building, see Chapter 7.

Layer control 101

You can explore a variety of layer techniques throughout this book. But so that you have a one-stop reference as well, the following list explains how to accomplish the most common layer tasks in Photoshop Elements:

- **Display and hide the Layers palette:** Choose Window➪Layers.

- **Add a new, empty layer:** In the Layers palette, click the layer that's directly below where you want to put the new layer. (You can skip this step if your image contains only the Background layer.) Then click the New Layer icon in the Layers palette, labeled in Figure 5-6.

Elements automatically assigns your new layers the names Layer 1, Layer 2, Layer 3, and so on. If you want to rename a layer to remind you what it holds, double-click the layer name, type the new name, and press Enter.

New Layer icon

Blending Mode control

Trash icon

Eyeball icon

- ✔ **Copy part of an image onto a new layer:** Select the area you want to copy and then choose Layer➪ New➪Layer via Copy. (Chapter 4 introduces the selection process.)

Use this command only for copying selections within the same image. If you copy and paste an object from another photo into the image, Elements automatically places the pasted object onto a new layer.

- ✔ **Duplicate an entire layer:** In the Layers palette, drag the layer name to the New Layer icon.

Figure 5-6: To add a new, empty layer, just click the New Layer icon.

- ✔ **Hide/display a layer:** Click the little eyeball icon to the left of the layer thumbnail to hide the layer. Click in the now-empty eyeball column to redisplay the eyeball and the layer contents.

- ✔ **Select a layer:** Just click the layer name in the palette.

- ✔ **Select a portion of a layer:** If you want to select only some pixels on the layer, click the layer name and then create your selection outline.

You can quickly select all the nontransparent areas of a layer — in other words, the parts of the layer that contain visible pixels — by Ctrl-clicking (Windows) or ⌘-clicking (Mac) the layer thumbnail.

- ✔ **Delete a layer:** Click the layer name in the palette and then click the Trash icon, also labeled in the figure. Or just drag the layer to the Trash icon.

- ✔ **Erase part of a layer:** To erase a large area — or, to be technically accurate, to make the layer pixels transparent — select the area and then press Delete.

For smaller areas, select the Eraser tool, labeled in Figure 5-7. Choose Brush from the Mode menu, adjust the brush size and shape as needed, and then drag over the area you want to erase. If you set the Opacity control on the options bar to 100%, the tool completely erases the pixels it touches, as illustrated in Figure 5-4, in the preceding section. At a lower opacity, the Eraser makes pixels translucent.

Click to open Brushes palette

Eraser tool

Background paint color

Figure 5-7: To fully erase pixels on an editing layer, set the Eraser tool's Opacity value to 100 percent.

Don't try to erase or delete pixels on the Background layer. If you do, the pixels don't become transparent; instead, they take on the background paint color.

✔ **Adjust layer opacity:** Drag the Opacity slider located near the top of the Layers palette.

✔ **Adjust layer blending mode:** Select the mode from the Blending Mode drop-down list, labeled in Figure 5-6.

✔ **Shuffle the order of editing layers:** You can change the *stacking order* of your editing layers — that is, the order in which they appear in the layer list — by simply dragging a layer up or down in the palette. You cannot move the Background layer, however.

✔ **Combine layers:** To fuse one layer with the layer directly beneath it, click the uppermost layer of the two in the layers palette. Then choose Layer➪ Merge Down. To combine all layers in the image, choose Layer➪Flatten.

Why merge layers? Because every layer adds to the image file size, which puts more strain on your computer. So whenever possible, you should merge layers. Just remember, after you do so, you can no longer manipulate the layer pixels independently.

✔ **Preserve layers when saving your image:** In Elements, you must save
your photo in either the PSD (Photoshop) or TIFF file format *and* you
must select the Layers check box in the Save As dialog box, as shown in
Figure 5-8. Otherwise, all your layers are merged when you save the photo.

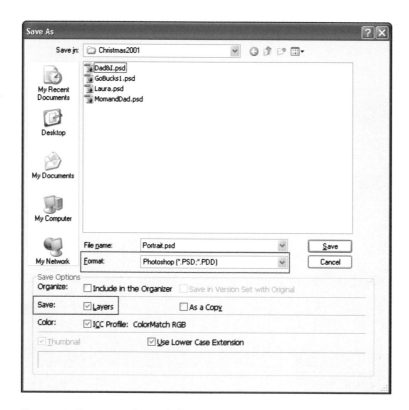

Figure 5-8: To preserve layers in Elements, save your image in the TIFF or PSD
format and select the Layers check box.

Removing Red-Eye

Even if you take advantage of your camera's red-eye reduction flash mode,
some of your portrait subjects will wind up with red-eye. Fortunately, this
phenomenon, which lends a gleaming red tint to the eyes, is usually easy to
remove.

The next section explains how to use the type of automated red-eye removal
tool found in many photo-editing programs. For eyes that don't respond to an
automated tool, the second section offers an alternative technique.

I demonstrate both processes in the QuickTime movie titled "Repairing Eyes and Teeth," included on the DVD that accompanies this book.

Using automated red-eye removal

Most photo editors offer a red-eye removal tool, and the one in Photoshop Elements is particularly adept. I was able to repair the red-eye problem you see in the left image in Figure 5-9 in just a few seconds, in fact.

Figure 5-9: Using a flash often causes red-eye (left); you can fix the problem easily in your photo editor (right).

You apply the tool as follows:

1. **Using the Zoom tool, magnify the image so that you get a close-up view of the first eye you want to repair.**

 The Zoom tool is labeled in Figure 5-10. Just drag around the eye area to fill the screen with that portion of the image.

2. **Select the Red-Eye Removal tool, also labeled in Figure 5-10.**

 When you select the tool, the options bar offers two controls — Pupil Size and Darken Amount — plus an Auto button.

Zoom tool

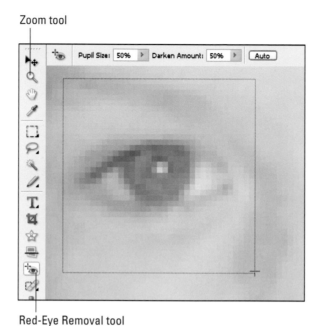

Red-Eye Removal tool

Figure 5-10: Drag around the eye with the Red-Eye Removal tool.

3. **Set the Pupil Size and Darken Amount options both to 50%.**

 These are the default settings, so this step may be unnecessary.

4. **Click the Auto button on the options bar.**

 When you click the button, Elements tries to locate and repair the offending red-eye pixels. But you need to be careful, because the tool sometimes replaces red pixels that aren't actually in the eyes.

 If you get good results, great — you're done! If not, choose Edit⇨Undo and move on to Step 5.

5. **Drag with the Red-Eye Removal tool to enclose the eye plus some surrounding area in a selection outline, as illustrated in Figure 5-10.**

 After you release the mouse button, Elements again attempts to replace the red-eye pixels with properly colored pixels. In the case of my example image, the tool worked well; the results appear in the right photo in Figure 5-9.

Usually, if the Elements Red-Eye Removal tool is going to work, it does so on your first or second try. But if you still don't get results, you can undo your initial attempts by choosing Edit⇨Undo and then adjusting the tool's performance as follows:

✔ **Affect a larger or smaller area.** To alter a larger area of eye pixels, raise the Pupil Size value and drag around the eye again. Or, to affect a smaller range of pixels, lower the value.

✔ **Make the replacement pixels darker or lighter.** Raise the Darken Amount value if you want the replacement pixels to be darker. Lower the value if the replacement pixels are too dark.

You must adjust the tool settings before dragging; neither the Pupil Size nor Darken Amount option have any effect after the fact.

✔ **Click instead of drag in Step 5.** Instead of dragging around the entire eye, try simply clicking on one of the red-eye pixels. Sometimes, this technique produces better results than dragging.

Still no luck? Don't waste any more time on the automated tool. Instead, use the eye-repair technique outlined in the next section.

Painting out red-eye (and glowing animal eyes)

Not all red-eye removers are as adept as the one in Elements. And if the red pixels are very bright, even the Elements version of the tool may not fully eliminate the problem.

In addition, no red-eye removal tool works on animal eyes. Red-eye tools know how to replace only red pixels, and animal eyes usually take on a yellow, white, or green glow in response to a flash, as shown in the left photo in Figure 5-11.

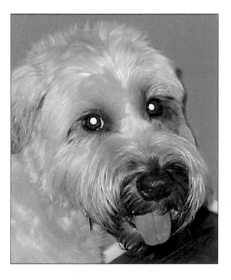

Figure 5-11: Red-eye removal tools can't fix most animal eyes, but you can simply paint in the correct eye colors.

You can approach the problem in a number of ways, but the easiest solution is simply to paint in the new eye colors, as outlined in the following steps. (It's not as hard as the length of the steps makes it appear — I just need to spell out some brush settings in detail.)

New Layer icon

Figure 5-12: Create a new layer to hold the eye paint.

1. **Open the Layers palette by choosing Window⇨Layers.**

2. **Create a new empty layer by clicking the New Layer icon, labeled in Figure 5-12.**

3. **Press D to set the foreground paint color to black.**

 Or click the Default Colors swatch, labeled together with the foreground paint color swatch in Figure 5-13.

Brush tool

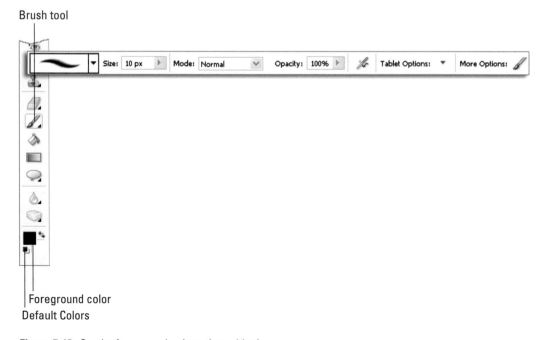

Foreground color
Default Colors

Figure 5-13: Set the foreground paint color to black.

4. **Select the Brush tool, labeled in Figure 5-13.**

 If the Brush tool isn't visible, click and hold on the little black triangle in the lower-right corner of the visible tool's icon to display a menu of related tools. Then click the Brush tool's icon to choose it.

5. **Select a round brush from the Brushes palette.**

 To open the palette, just click where indicated in Figure 5-14. Then click any of the first several brushes. Any brush size will do for now; just be sure to select a round brush.

 If your cursor looks like a little paint brush icon, visit the program's Preferences dialog box to change it to a cursor that reflects the actual brush size and shape. See Chapter 4 for details.

6. **Open the More Options palette and set the Hardness value to 0, as shown in Figure 5-14.**

 A low Hardness value causes your paint to fade out at the edges of your brush stroke.

7. **Using the Size control on the options bar, set the brush size to about one tenth the size of the area you need to paint.**

Click to open palette Click to open palette

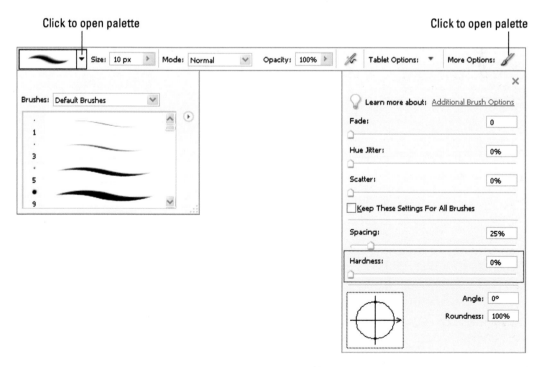

Figure 5-14: Select a round brush and set the Hardness value to 0.

8. Set the other tool options as shown in Figure 5-14.

Set the Mode to Normal; Opacity to 100 percent; Airbrush, off (the icon should appear as in the figure); and all Tablet Options, off.

9. Using small, swirling strokes, paint over the damaged eye area, as shown in Figure 5-15.

Try to avoid painting the same pixels repeatedly. That way, the fuzziness of your brush creates some tonal variations, as shown in Figure 5-15, because the paint fades at the edges of the cursor. Keep painting until all the problem pixels are replaced. (If the problem pixels are very saturated and using the feather-painting technique doesn't fully cover them, just go ahead and keep swabbing them until the color is hidden. You can paint some tonal variations back in later if needed.)

Figure 5-15: Use small, circular strokes to cover the bad pixels.

10. Create another new layer.

Your next task is to recreate the natural white highlights that appear in the eye — assuming that you covered them in Step 9. (If not, move on to Step 14.) Your second new layer will hold the paint you use to create the highlights.

11. Press X to swap the foreground and background paint colors, so that white is the foreground color.

Or click the Swap Colors icon in the toolbox, labeled in Figure 5-16.

12. Reduce the brush size if needed to match the size of the highlight you want to create.

Swap Colors

Figure 5-16: Add a few dots of white to recreate the specular highlights in the eye.

13. Click in each eye to add the highlights.

For this step, I like to zoom out so that I can see both eyes and the face, as shown in Figure 5-16; the wider view gives me a better idea of the right size and placement of the highlights.

If the highlights appear too bright, lower the Opacity value for the highlight-paint layer in the Layers palette. For my dog image, an Opacity value of 68 percent created a better result than full-on white. (Of course, you can always just repaint the highlights using a light gray instead of white.)

14. View the eyes at the size you plan to print or display the finished image.

At this point, you may want to use the Brush tool to create some additional tones or colors to the eye. If you do so, create a third new layer to hold your new paint. But don't sweat this step too much — unless you're going to print or display the image at a very large size, no one is likely to be able to notice the difference.

15. When you're happy with the eyes, choose Layers⇨Flatten Image to merge the paint layer with the original image.

You can see my repaired dog eyes on the right side of Figure 5-11.

Whitening Teeth

Every time I teach portrait retouching, I have to fight the urge to "forget" to bring up the subject of teeth whitening. Personally, I think the whole obsession with bleaching our choppers is a little bizarre — I mean, the expression is *pearly* whites, not glow-in-the-dark whites, yes?

But of course, I, too, have succumbed to the pressure and even have touched up my own teeth in pictures now and again. So it would be unfair not to share the secret with you, I guess. Just promise that you'll go for a subtle effect like

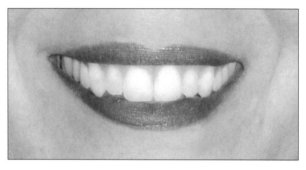

Figure 5-17: When whitening teeth, aim for a subtle effect!

what you see in the lower image in Figure 5-17. As a rule, if the first thing you notice when you look at a portrait is teeth, you've gone too far.

Alright, I'll step down off my bleach box now and explain how the process works:

1. **Choose Window⇨Layers to open the Layers palette.**

2. **Create a rough selection outline around the teeth.**

 The Selection Brush works great for this task. Chapter 4 offers specifics if you need help, but don't worry about getting the selection outline perfect. Just make sure to include all the teeth in the outline.

3. **Choose Layer⇨New⇨Layer via Copy to copy the selected teeth area to a new layer.**

4. **Zoom in for a close view of the teeth.**

 Just drag around the mouth area with the Zoom tool (refer to Figure 5-10 to see the tool).

5. **Select the Dodge tool, labeled in Figure 5-18.**

 The Dodge tool, which both lightens and desaturates colors, shares a toolbox slot with the Burn and Sponge tools.

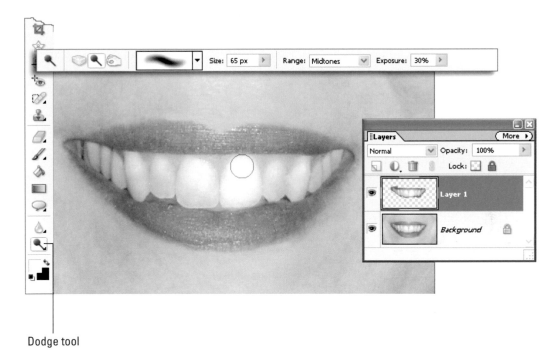

Dodge tool

Figure 5-18: The secret to whitening teeth is the Dodge tool.

6. **Select a soft, round brush from the Brushes palette.**

 See the preceding section if you need help using the Brushes palette.

7. **Adjust the Size value until the brush cursor is slightly smaller than the smallest tooth.**

8. **Set the Range value to Midtones and the Exposure value to 30%.**

 With the Dodge tool, you can lighten shadows, midtones, and highlights independently. For tooth whitening, start with the midtones.

 The Exposure value affects how much change you get with a single swipe of the tool. The results you get from the default value, 50%, usually are too intense, so lower the value to at least 30%.

9. **Drag over the surface of each tooth once or twice.**

 Each time you pass over the same area, the pixels get progressively whiter and brighter. Remember that teeth toward the back of the mouth would naturally be darker than those in front.

To remove dark stains between teeth, change the Range value to Shadows, reduce the brush size, and drag once or twice over the stained areas.

Don't select Highlights as the Range value. Dodging the highlights in teeth nearly always produces unrealistic results.

To watch me perform this dental magic on-screen, see the QuickTime movie titled "Retouching Eyes and Teeth," included on the DVD that ships with this book. That same movie also demonstrates the technique covered in the next section, which features the Dodge tool's cousin, the Burn tool.

10. **When you're happy with the teeth, choose Layer⇨Flatten to merge the whitening layer with the Background layer.**

Emphasizing Eyes

In the preceding section, I show you how to use the Dodge tool to whiten teeth. The Dodge tool's opposite, the Burn tool, also comes in handy in portrait retouching. This tool both darkens and desaturates colors and, when applied with a light touch, can give the eyes additional impact. You can see the difference the tool can make in Figure 5-19. The left image shows the unretouched portrait; the right image, the results of applying the Burn tool.

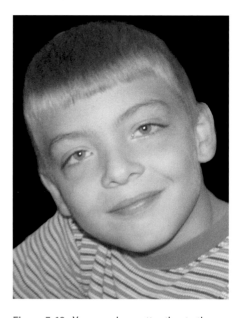
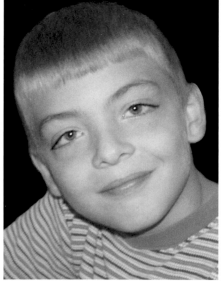

Figure 5-19: You can draw attention to the eyes and make a subject appear more sharply focused by applying the Burn tool to the lashes and pupils.

Notice that in my before and after portraits, the change I made is very subtle, yet it not only draws more attention to the eyes but also makes the whole image appear more sharply focused. Making the dark areas of the eye darker increases contrast, and adding contrast creates the illusion of sharper focus — a fact you can explore in the focus-correction section of Chapter 4. So if your portrait suffers from soft focus, try the following burning technique *before* you apply a sharpening filter. That way, you can avoid adding unwanted texture to the skin, which is often a side effect of sharpening filters.

Here's how to perform this trick:

1. **Copy the eye area to a new layer.**

 Just create a rough selection outline around the eyes by using the Selection Brush or any other selection tool you prefer. Then choose Layer➪New➪Layer via Copy.

2. **Select the Burn tool, labeled in Figure 5-20.**

 The tool shares a toolbox slot with the Dodge tool, covered in the preceding section.

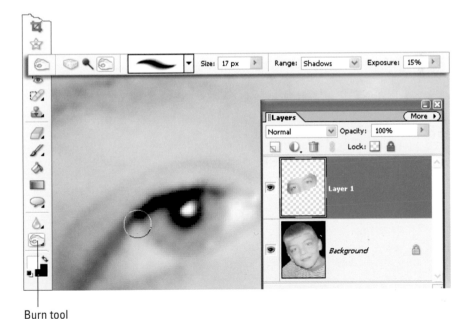

Burn tool

Figure 5-20: The Burn tool darkens and desaturates the pixels it touches.

3. **Select a small, soft brush from the Brushes palette on the options bar.**

4. **Set the Range value to Shadows and the Exposure value to 15%.**

 The Exposure value determines how much change the tool produces each time you click or drag. It's best to use a low value and then apply the tool multiple times if necessary; at the default value, 50%, you can easily produce garish results with just one stroke.

5. **Drag over the pupils and along the lash line.**

 Be careful about burning the iris of the eye — the Burn tool also desaturates colors, so you run the risk of making a blue-eyed somebody a gray-eyed somebody. And if you're retouching a male portrait, don't go overboard with the lashes, either, unless you want that male to be a little annoyed with you.

6. **Also apply the tool to darken the eyebrows if desired.**

 For this step, you may need to switch the Range value to Highlights or Midtones, depending on the color of the subject's brows. Experiment to find the best setting.

7. **Choose Layer⇨Flatten to merge the burned layer with the original.**

The Burn and Dodge tools are named after traditional darkroom tools that are used to selectively lighten and darken areas of a photograph. If you've never worked in a darkroom and have trouble remembering which tool does what, just remember that when toast *burns,* it gets darker.

Repairing Skin

Retouching skin is one of the most difficult tasks you can tackle in the digital darkroom. You can easily destroy the skin's natural texture and color variations in the process of covering up blemishes, boo-boos, and other flaws. So take your time and don't be surprised if you need to try several different tools or approaches to find one that works.

The next two sections explain how to remove small blemishes and cover up shiny spots on the skin. For larger repairs, you may need to use the alternative retouching techniques explored in Chapter 6. In particular, you should investigate *cloning,* a process that comes in handy for some skin repairs as well as for the photo-restoration projects covered in Chapter 6.

In addition, see the QuickTime movie "Repairing Skin," on the DVD that ships with this book, for a demonstration of the techniques in this section as well as information on how to give skin a sun-kissed glow.

Healing blemishes

For tiny blemishes like the one you see in the top image in Figure 5-21, you can simply copy and paste a bit of surrounding skin over the flaw. Chapter 7 explains the copy/paste routine in detail, but in brief, you simply select the pixels you want to use as a patch, choose Edit⇨Copy, and then choose Edit⇨Paste. Then you just use the Move tool to drag the patch over the flaw.

If you use Photoshop Elements (or Photoshop), however, you have an easier and faster option: You can cover up the flaw using the Spot Healing brush. This tool hides flaws by automatically replacing the pixels under your cursor with pixels that blend with the surrounding area. I used the tool to repair the skin in Figure 5-21.

You apply the Spot Healing Brush like so:

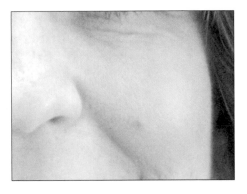

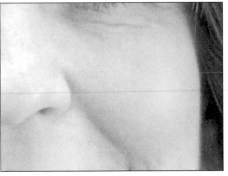

Figure 5-21: You can apply digital cover-up cream to hide small blemishes.

1. **Select the Spot Healing Brush, labeled in Figure 5-22.**

 The Spot Healing Brush shares a toolbox slot with the Healing Brush, so be sure to select the correct tool. The options bar should show the controls you see in Figure 5-22 when the Spot Healing Brush is active.

2. **Select any soft brush from the Brushes palette, as shown in Figure 5-22.**

 A soft brush helps the repaired pixels blend in better with the surrounding area. Remember that the fuzzy brush icons in the palette represent a soft brush.

3. **Set the Type control on the options bar to Proximity Match.**

4. **Select the Sample All Layers box on the options bar.**

5. **Open the Layers palette and create a new layer to hold your repair.**

 With the Sample All Layers option turned on, the Spot Healing Brush can see through layers. So you don't need to copy the blemish to a new layer, as you do with most of the other projects in this chapter. Just create a new, empty layer by clicking the New Layer icon in the Layers palette (see Figure 5-23).

Click to open palette

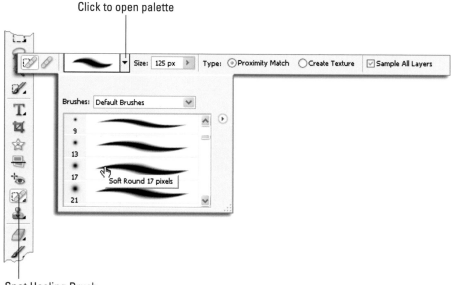

Spot Healing Brush

Figure 5-22: Select a soft brush so that your repair pixels blend more naturally with the surrounding area.

New Layer icon

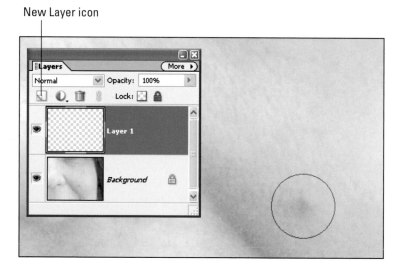

Figure 5-23: Create a new layer, center the Spot Healing Brush over the blemish, and click.

6. **Using the Size control, adjust the brush size until your cursor is slightly larger than the blemish.**

 The tool works best when you include a little margin of "good" skin around the edges of the cursor, as shown in Figure 5-23.

7. **Click to heal the spot.**

 After you click, Elements attempts to replace the blemish pixels with good skin pixels. If the entire blemish isn't repaired on your first click, either click again or drag over the remaining area that needs help.

8. **When you finish your repairs, merge the repair layer with the Background layer by choosing Layer⇔Flatten Image.**

This tool can work magic when the blemish is surrounded by a perimeter of pixels that are pretty similar in color. But if the blemish is bordered by a variety of different shades, you're not likely to get good results because Elements doesn't know exactly what color to make the repair pixels.

If you can't get a natural repair after one or two tries, undo your work (choose Edit⇔Undo) and then rely on the Clone tool, covered in Chapter 6, to do the job.

The Spot Healing Brush isn't just for skin retouching. You can also use it to remove almost any tiny flaw, from stray bits of lint on clothing to dust specks on scanned photos.

Painting over shiny spots

When you shoot portraits with a flash or in very bright sunlight, light reflecting off the skin can cause overexposed areas — *blown highlights,* in technical terms, or just *shiny spots,* if you prefer plain talk. You can see an example in the forehead area of Figure 5-24.

If the spots are small enough, you can cover them using the Spot Healing Brush, described in the preceding section. The Clone tool, discussed in Chapter 6, is another possibility; that tool simplifies the job of patching an area using pixels from another part of your photo. Of course, cloning requires that you have some good, matte skin areas to use as a patch.

In my experience, however, the easiest fix is simply to paint over the shiny spots. But you have to use a special technique for the repair to look natural. I used this approach to produce the retouched portrait you see in Figure 5-25.

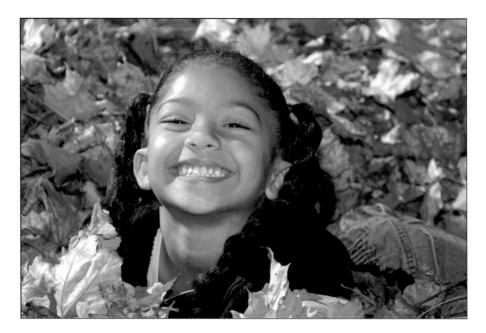

Figure 5-24: Light bouncing off the skin can create shiny spots.

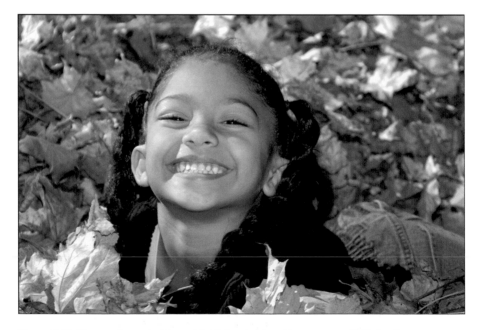

Figure 5-25: To tone down the blown highlights, I painted in some new "skin" using low-opacity paint and a texture filter.

Here's the drill:

1. **Open the Layers palette and create a new, empty layer.**

 Choose Window➪Layers to open the palette, and click the New Layer icon to create your empty layer. (Refer to Figure 5-23, in the preceding section.)

2. **Select the Eyedropper tool, labeled in Figure 5-26.**

 Set the tool mode to Point Sample, as shown in the figure.

3. **Click on a "good" skin pixel in the area surrounding the shiny spot, as shown in Figure 5-26.**

 Your click establishes the color you click as the foreground paint color — the color you apply with the Brush tool.

Eyedropper

Eyedropper cursor

Figure 5-26: Click with the Eyedropper to match the foreground paint color to the surrounding skin color.

4. **Select the Brush tool, labeled in Figure 5-27.**

5. **Open the More Options palette and set the Hardness value to 0.**

 Click where indicated in Figure 5-27 to open the palette.

6. **Set the other options bar controls as shown in Figure 5-27.**

 Set the Mode control to Normal, set the Opacity in the neighborhood of 20–30%, and make sure that the Airbrush option is turned off.

Brush tool Click to open palette

Figure 5-27: Set the tool's Opacity value low so that you tone down highlights but don't completely destroy them.

7. Paint over the shiny spot, as shown in Figure 5-27.

As you work, vary the paint color as needed to create a natural blend. Depending on the brightness of the skin, you may need to swab repeatedly over the same area until you get a good color match.

Don't try to completely lose the shiny spot — your goal is just to tone it down. Otherwise, you eradicate the natural mix of shadows, midtones, and highlights that should be present.

Also, don't worry that your new skin looks flat at this point. The next step takes care of that problem, so just work on getting the skin tones correct for now.

If you spill paint where you don't want it to go, remember that you can use the Eraser tool, introduced at the beginning of this chapter, to wipe away the mess.

8. When you finish painting, choose Filter➪Texture➪Grain.

This special effects filter adds back the texture that you eliminated by painting over the skin. When you choose the command, you see the Filter Gallery dialog box, shown in Figure 5-28.

The preview on the left side of the dialog box shows you only the contents of your paint layer, as shown in the figure. (Remember, in Elements, the checkerboard pattern indicates empty areas of the layer.) You can use the controls at the bottom of the preview to zoom the display if needed; drag inside the preview to scroll the display.

Figure 5-28: Use the Grain filter to add a bit of texture to the painted areas.

9. **Select Enlarged from the Grain Type drop-down list.**

 You can experiment with other options, but this one typically produces the best results for me.

10. **On the right side of the dialog box, set the Intensity and Contrast sliders to 10.**

 The sliders control the look of the grain texture; the higher the values, the more dramatic the result. Because you can't see the textured pixels atop the underlying image in the preview, it's best to start with low values at first.

11. **Click OK to close the dialog box and then evaluate the results.**

 If the grain effect is too strong, choose Edit⇨Undo. Then reapply the filter, this time using even lower Intensity and Contrast settings.

 If the effect isn't strong enough, just keep reapplying the filter until you build up the texture you want.

12. **Merge the paint layer with the Background layer by choosing Layer⇨ Flatten Image.**

You can use this same technique to cover up any blown highlights, by the way. And don't worry if the texture produced by the Grain filter isn't a 100-percent match for the surrounding area — unless you're printing the photo very large, the discrepancy shouldn't be noticeable.

Tackling Other Portrait Problems

In addition to the techniques I cover in this chapter, some tools covered elsewhere in the book come in handy for certain portrait-retouching tasks. So here's a handy quick-reference guide to help you find the right tools to solve other common portrait problems:

- ✒ **Diminishing a distracting background:** Use the technique explained in Chapter 4 to blur the background so that it takes less attention away from your subject.

- ✒ **Enhancing or adjusting skin tones:** Try the color correction techniques explored in Chapter 6.

 Also take a gander at the QuickTime movie titled "Repairing Skin," on this book's bonus DVD, for a look at another option for refining skin tones.

- ✒ **Removing clothing stains, tattoos, and other large flaws:** Head to Chapter 6 for these problems, too. See the section related to the Clone tool, with which you can hide almost any unwanted object in a photo.

- ✒ **Adjusting exposure and focus:** Chapter 4 covers these topics. Don't forget, though, that using the eye enhancement technique discussed in this chapter can make a slightly soft portrait appear in sharper focus.

- ✒ **Opening closed eyes:** Oh, boy, do I wish I had a good, automatic solution for this one. Unfortunately, the only answer is to find a picture in which the subject's eyes are open and then copy and paste those eyes onto the closed eyes. See the section on collage building in Chapter 7 to find out how to copy and paste the eyes and also how to position and size the pasted eyes.

Bringing Back Lost Memories

*H*ere's a tip you can use the next time conversation lags at a family gathering: Just dig out the old photo albums. Before long, everyone will be sharing stories about the people and places in those pictures. "Remember how wonderful that rose garden smelled?" "That was the day that we found out we were pregnant with you!" And, of course, "Hey, nice mullet, dork!"

When you finish mocking each other's style gaffes and speculating about whatever happened to the crazy cousin who convinced you to get that mullet, don't just put those family photos away. Instead, work through the projects in this chapter, which show you how to get your photos into digital form and then use your photo editor's tools to solve the problems that are likely to plague old photos.

Among other things, this chapter shows you how to restore faded photos, correct colors, and remove dust, stains, and other flaws. (For tips on sharpening focus and adjusting exposure, see Chapter 4.) I also explain what steps to take to create the best possible digital originals of your film slides, prints, and negatives.

While you're at it, go ahead and digitize important images that are still in good shape, too. Those pictures *will* deteriorate sooner or later, so scanning them now saves you the trouble of having to restore them later.

Scanning Your Photos

How well you can restore an old photo depends largely on the quality of the original. You can't make a silk purse out of a sow's ear, as they say. But you can produce the best *possible* purse by following the guidelines in the next two sections, which explain how to create high-quality scans of your original photos.

Go pro or scan it yourself?

For the most painfree way to a good scan, I recommend taking your pictures to a photo lab for scanning. The lab will scan your photos and put the resulting digital image files on a CD or DVD.

Professional scanning offers a couple of advantages:

- ✔ **Time savings:** Do-it-yourself scanning can be a time-consuming process, with each scan taking several minutes — not a big deal if you're scanning only one or two photos, but a huge chore if you're digitizing a whole shoebox full of memories.

- ✔ **Better scanning equipment:** The equipment at professional labs typically is of higher quality than what you and I can buy for home or office use, so the scans tend to be better. (This presumes that the person running the equipment is a qualified technician, which you're more likely to find at a pro imaging lab than at your local drugstore's photo counter.)

Of course, the downside is cost. Depending on the type of scan you need, you can pay anywhere from $1 to $8 a photo. When you're placing your order, talk with the lab technician about the ultimate print size, image file format, and scan quality you want to ensure that you get the type of scan that works for your intended use.

If you already own a scanner, you may want to order a few test scans from the lab to determine whether the time and quality difference you gain from professional scanning is worth the price. The next section offers tips to help you get the best results for those times when you do tackle the job yourself.

Getting a good scan

The quality of consumer-level scanners varies widely, so if you're in the market for a new model, search out reviews before you buy. Photography magazines and Web sites offer the best evaluations of a scanner's abilities; computer and electronics magazines sometimes worry more about scan speed and other business-related functions than image quality.

Whatever scanner you buy, follow the guidelines laid out in the next few sections to generate the best possible digital originals from your prints, slides, and negatives.

In addition, dig out your scanner manual and give it a read. No two scanners work the same way, so only your manual can provide specifics on critical topics such as orienting your originals and setting up your system for the fastest, best scans.

Cleaning your originals

Before scanning, make sure that your print, slide, or negative is as free of dust and other dirt as possible. Use a soft, dry cloth or brush to *gently* clean the original. Even better, visit your local camera store, where you can find cloths, cleaning sprays, and other supplies specially made for this purpose. If you're using a flatbed scanner, make sure that the scanner bed is clean, too.

Don't try to clean your prints, slides, or negatives with water, window cleaner, or anything else not specifically designed for working with photographic media. Also, wear a pair of white, cotton gloves to avoid getting fingerprints and skin oils on your originals.

Calculating the scan resolution

This option, which you set via your scanner software, determines how many pixels your original scan contains. Chapter 2 explains resolution, but in short, a good print requires at least 200 pixels per inch (ppi). However, 200 is a minimum, and because most scanners can deliver more pixels, I suggest that you aim higher and use 300 ppi as your scan resolution.

Scanner software varies in terms of how you specify resolution. Most scanners enable you to select a print size plus an output resolution, but some offer only a resolution setting. In the latter case, you need to do some math if your original photo size is different than your intended print size. For example, to scan a 4 x 6-inch print and print it at double that size, set the scan resolution at 600 ppi, not 300 ppi. (If you're scanning a very tiny original and have a very large print size in mind, you may have to compromise on resolution.)

One more note about resolution: Every scanner has a stated *optical* resolution, which is its true resolution capability. Most scanners enable you to go beyond that optical resolution, however. When you do so, the software *interpolates* — makes up — additional pixels after scanning and adds them to the scan file. This process is the same thing as *resampling,* which is the term more commonly used when discussing changing the pixel count in your photo software. Whatever you call it, adding pixels after an image is scanned or captured by a digital camera diminishes picture quality.

Choosing the bit depth setting

Most scanners offer a choice of *bit depth* settings. Here's the scoop on this setting, also controlled via your scanner software:

- ✓ **More bits means more colors.** A *bit* is a unit of computer data; *bit depth* refers to how many units are available for storing color information in an image file. The more bits, the more colors your scan can contain.

- ✓ **More bits also result in larger image files and longer scan times.** The scanner simply needs more time to capture all those bits. And the larger the image file becomes, the more time and power your computer and photo software need to process your pictures.

- ✓ **Scan color photos at 24 bits (or 8 bits per channel).** Most scanners offer you a choice of bit depth settings; common options are 8 bits, 24 bits, and 48 bits. With 8 bits, your scan can contain only 256 colors, which typically creates the blotchy, unacceptable result you see in the top example in Figure 6-1. Moving up to 24 bits gives you more than 16.7 million colors, which is more than enough for most color photos, as illustrated by the middle example.

Note that some scanner and photo-editing programs — including Photoshop Elements — designate bit depth in terms of *bits per channel* instead of total bits. In an RGB (red-green-blue) digital image, which contains three channels, a bit depth of 8 bits per channel is the same thing as 24 bits.

8-bit

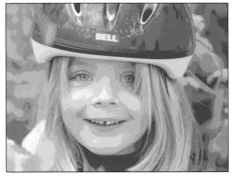

24-bit

48-bit

Figure 6-1: Bit depth determines how many colors a scanned image can contain.

✔ **More than 24 bits is probably overkill.** Many scanners can scan at a bit depth higher than 24 bits, but whether you gain anything from so-called *high-bit* scanning is questionable. In most cases, you won't see any difference in your photo, as illustrated by the 24- and 48-bit examples in Figure 6-1. See the sidebar "Should you go high bit?" for information about when high-bit scanning can come in handy and the price you pay for those added bits.

✔ **For black-and-white photos, 8 bits is fine.** A black-and-white image contains only one color channel, and the 256 shades you get with an 8-bit image are sufficient. See the next section for more on this topic.

Scanning black-and-white photos

In digital imaging, what most of us know as a black-and-white photo is called a *grayscale image.* A grayscale image can contain 256 colors — black, white, plus shades of gray. A *true* black-and-white image, on the other hand, can contain only two colors: black and white. Figure 6-2 shows you the difference.

Refer to your scanner manual to find out how it deals with this issue. On some models, choosing the black-and-white scan setting produces a 2-bit scan; on other models, a setting with the same name produces an 8-bit scan. Remember: The bit setting determines how many colors the scan can generate. With 2 bits, you can have only two colors (black and white); with 8 bits, you get 256 colors, which, again, works just fine for black-and-white photos.

Saving your scan files

When you scan directly into Photoshop Elements, the first thing to do after the scan is created is to save the new file; Elements doesn't do it automatically for you. When you save, set the file format either to the Photoshop format (PSD) or TIFF. These two formats are the only

8 bit

2 bit

Figure 6-2: An 8-bit scan produces a good grayscale image; a 2-bit scan contains only black and white, with no shades of gray.

standard formats that retain all your original image data. Do *not* save your original files in the JPEG format, which produces smaller files but tosses some picture data. (See Chapters 1 and 2 for more information about file formats.)

This same advice applies if you aren't scanning directly into your photo software but instead are using your scanner's software alone. The software should offer an option that enables you to choose which format you want to use when storing your scans; JPEG and TIFF are common options.

Applying dust removal and other correction filters

Although the software provided by most scanners offers tools for adjusting exposure, focus, and color, you can get better results and more control over these corrections in your photo editor. The tools found in scanning software are less sophisticated than those offered in photo-editing programs. And when you apply corrections through your scanner software, you can't limit them to just the problem areas, as you can in a photo editor.

The pros and cons of high-bit images

Some digital cameras and scanners can produce *high-bit images,* which are generally defined as having a bit depth of more than 24 bits. Bit depth, as described earlier in this chapter, determines how many colors an image can contain. A 24-bit image can contain more than 16.7 million colors, which is standard — and usually perfectly acceptable — for color photographs.

So why the option for more bits? Well, if you make really extreme adjustments to a 24-bit image, you can introduce *banding,* also known as *posterization.* This defect creates abrupt breaks in areas where you should have smooth color transitions, giving the image a somewhat splotchy look. The 8-bit image in Figure 6-1 has this problem, which also occurs when you scan a photo at a low bit depth — there simply aren't enough colors to produce a quality image.

Theoretically, starting with a higher-bit original enables you to apply more severe corrections to your photo before banding starts to appear, but in the real world, all those extra bits are no guarantee against the problem. And adding bits has several disadvantages: Scanning takes longer; the size of the scan file is larger; and, most important, many photo-editing programs either can't open high-bit files or don't offer the full range of tools for high-bit images. (Elements falls in the latter camp.)

If you opt for high-bit image capture and you use Elements, do your exposure and color corrections inside that program first. Then convert the file to a 24-bit image (by choosing Image⇨Mode⇨8 Bits/Channel) so that you regain the use of the program's entire suite of tools.

The one exception to this rule is the dust removal filter provided by some scanners, which goes by different names depending on the manufacturer. You may be able to save yourself some image-cleanup time by turning on this feature. (Even if you clean your original carefully, some dust specks are inevitable.) But understand that these tools usually work by applying a slight blur to your image, so do some tests to see how much difference the dust-removal option makes.

Adding Density to Faded Photos

Sunlight, environmental pollution, and plain old passing time can cause photographs to fade. Your first instinct when restoring a faded photo like the one in Figure 6-3 might be to try to increase color saturation, using the Hue/Saturation filter discussed later in this chapter, or to increase contrast by using the Levels filter, introduced in Chapter 4. Both approaches can help — although the saturation filter has no effect on a black-and-white photo, of course.

Figure 6-3: The colors in this old photo have faded over time.

But before you use either filter, try this alternative trick, which involves a special layer-blending mode called Multiply. (If you're new to layers, check out Chapter 5.) This mode actually multiplies the pixel values on two layers, which increases color density and produces slightly better results than using either Levels or Hue/Saturation.

Here's how it works:

1. **Open the Layers palette, shown in Figure 6-4.**

 Choose Window➪Layers to display the palette.

 On the DVD, see the QuickTime movie "Getting Started with Adobe Photoshop Elements" if you want your Layers palette to appear as a free-floating window, as shown in the figure.

2. **Duplicate the Background layer.**

 You can do this by simply dragging the layer to the New Layer icon, as illustrated in Figure 6-4. I'm assuming that you haven't added any other layers to your image; if you have, duplicate whatever layer holds your original image pixels.

3. **Choose Multiply from the Blending Mode drop-down list in the Layers palette.**

 The Blending Mode control is labeled in Figure 6-5. You see an instant increase in color density, as illustrated in my multiplied photo in Figure 6-6.

New Layer icon

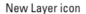

Figure 6-4: Duplicate your original image layer by dragging it to the New Layer icon.

Blending Mode

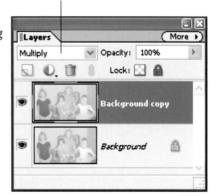

Figure 6-5: Select Multiply as the blending mode for the duplicate layer.

Figure 6-6: Multiplying my original image once was enough to restore color density.

4. **To increase density even more, duplicate the Multiply layer.**

 Just drag the multiplied layer to the New Layer icon. You can duplicate the layer as many times as needed to achieve the desired change.

 If duplicating the layer produces too strong a shift, just lower the opacity of the duplicated layer by using the Opacity control in the Layers palette. You also can use your Eraser tool on the top Multiply layer to erase areas that become too dark. See Chapters 5 and 7 for more about the Eraser tool.

5. **Merge the original and multiplied layers by choosing Layer⇔Flatten Image.**

After you beef up the photo density using this technique, you may be able to improve things even more by next applying the Levels or Hue/Saturation filter to adjust contrast and saturation, respectively.

As you can see from my multiplied image in Figure 6-6, the technique also makes any dirt or scratches more visible. You can remove these flaws using the Clone tool and Dust & Scratches filter, which I cover near the end of this chapter.

Shining Light through Dense Scans

Some types of slide film are very dense and thus a challenge for most scanners. The image in Figure 6-7, scanned from a decades old Kodachrome slide, is a case in point. Although I could boost the scan exposure to get a brighter image than what you see in the figure, I couldn't lighten the shadows sufficiently without blowing out the highlights. Recovering blown highlights in a photo editor is pretty much impossible, so it's best to set up the scan to capture the highlights appropriately and then try to dig out shadow detail after the fact.

Figure 6-7: There's hidden detail lurking in the shadows of this old, too-dark photo.

You can try brightening the scanned photo by applying the Shadows/Highlights filter, which you can read about in Chapter 4. If your photo editor doesn't have such a tool, you may be able to get some benefit from the Levels filter, also explored in Chapter 4, or its equivalent. But for really dense scans like the one in Figure 6-7, I sometimes get better results by using this alternative approach:

1. **Duplicate the original Background layer by dragging it to the New Layer icon in the Layers palette.**

 Refer to Figure 6-4 if you need a reminder of this technique.

2. **Set the blending mode of the new layer to Screen, as shown in Figure 6-8.**

 This blending mode has the opposite impact as the Multiply mode discussed in the preceding section — that is, Screen mixes the layer pixels in a way that results in an immediate brightening of your image. You can see the results on my example image in Figure 6-8.

 If this step produces good results, skip to Step 4. Otherwise, move on to Step 3.

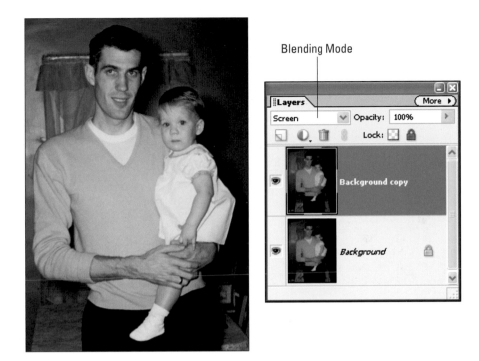

Figure 6-8: Screening a duplicate of the Background layer brightens the image.

3. **Apply the Shadows/Highlights filter to the new, screened layer.**

First, make sure that the screened layer — your duplicate layer — is selected, or highlighted, in the Layers palette, as shown in Figure 6-8. If not, click that layer. Then choose Enhance⇨Adjust Lighting⇨Shadows/Highlights to apply the filter.

I used the filter settings shown in Figure 6-9 to produce the result shown to the left of the dialog box. In addition to lightening the shadows, I used the Darken Highlights control to tone down some of the brightest areas of the picture, which became too bright after Step 2. (You can also apply the Eraser tool on the screened layer to rub away any areas that remain too bright.)

If necessary, you can brighten the image even more by duplicating your Screen layer.

4. **When you're happy with the photo, choose Layer⇨Flatten Image.**

This step merges the screened and filtered layer with the original Background layer.

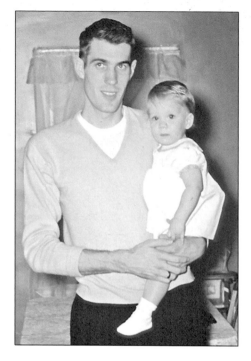

Figure 6-9: Applying the Shadows/Highlights filter to the screened layer further improved the image.

Why not just keep reapplying the Shadows/Highlights filter multiple times to the image? Because doing so tends to produce some weird color variations. As always, your mileage may vary, so it never hurts to experiment — but keep an eye out for odd color distortions if you apply Shadows/Highlights with a heavy hand.

You may find that very dense scans also suffer from too-saturated colors, in which case you can apply the Hue/Saturation filter, explained later in this chapter, to pull the colors back a little. Also, brightening a very dark image tends to introduce *noise,* a defect that looks like tiny grains of colored sand. You can improve things somewhat by applying a blur filter to the noisiest areas; see Chapter 4 for an introduction to one common blur filter.

Correcting Colors

If your photo collection is anything like mine, it's rare to come across a color photo that's more than a decade old and still showing its original colors. Back in my day — shall we say, before the turn of the current century — people didn't know that the plastic sleeves used by some photo albums were going to wreak havoc on pictures, causing all sorts of color shifts. Old slides, too, often exhibit color fading, color shift, or both.

Most photo-editing programs offer tools for correcting colors, and they usually produce pretty good results or at least enable you to make noticeable improvements to your photos. The next two sections discuss two common color-fixer tools: a one-click tint remover and a more sophisticated option known as a color-balance filter.

You also can use these tools for color correction of digital photos. But if pictures from your digital camera exhibit a color cast, the cause is likely related to the camera's white-balance setting. Visit Chapter 2 to find out how to adjust the setting to prevent the problem.

Removing a color cast with one click

Being the second of three children, I share the same fate as all middle kids: The family album contains loads of pictures of the first-born child, plenty of the last baby, but precious few of, well, *me*. So you can imagine my delight when I came across the picture in Figure 6-10, even though I had to dig through my *grandparents'* photo stash to find it. Ah, life was good that Easter Sunday. Little sister had not yet arrived, and for a brief, shining moment, yours truly was the center of attention. Too bad that this rare piece of history is spoiled by an ugly red color cast.

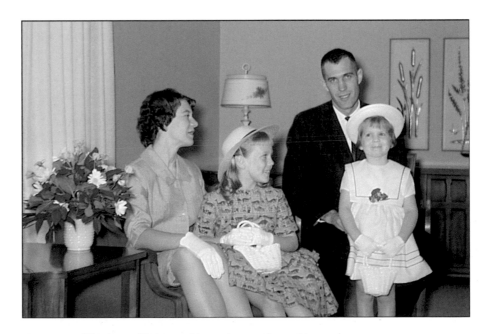

Figure 6-10: Like many old photos, this one has a color problem.

Fortunately, many photo programs offer a tool that can eliminate a color cast with a single click of a mouse. The tool works pretty much the same way in every program: You click on a pixel that you think should be white, black, or gray, and the software shifts the color values as needed to neutralize the color cast.

To apply the tool in Elements, follow these steps:

1. **Choose Enhance⇨Adjust Color⇨Remove Color Cast.**

 Be sure to choose the Remove Color Cast command, not the Remove Color command. The dialog box shown in Figure 6-11 should appear after you choose the command.

Figure 6-11: The Remove Color Cast filter can correct colors with a single click.

2. **Click an area in the photo that should be white, black, or gray.**

 After you click, Elements shifts all the image colors in attempt to remove the color cast. For my image, I clicked the curtains in the background, which memory told me were light gray.

 Don't simply click another pixel if your first click doesn't remove the color cast. Instead, click the Reset button in the dialog box and *then* click a new pixel in your photo. And note that if you click a pixel that's absolutely black or white, you don't get any color shift. (The tool wants you to click something that *should* be white or black, but isn't.)

3. **When the color cast is gone, click OK to close the dialog box.**

When this type of tool works, it works well; you can see my corrected tribute to myself in Figure 6-12. But if you can't neutralize the color cast after a few tries, click Cancel to close the Remove Color Cast dialog box and turn to the alternative filter discussed in the next section.

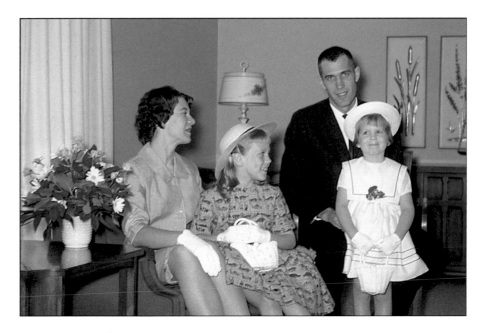

Figure 6-12: Clicking the curtains produced the correct colors.

Balancing colors

In addition to a simple, one-click color remover, your photo software may offer a *color-balance filter*. This tool is based on the RGB color wheel, which you can inspect in Figure 6-13.

Figure 6-13: Color-balance filters are based on the RGB color wheel.

This color wheel is different from the one you learned about in grade school, where you were taught that red, yellow, and blue are the color primaries and orange, green, and violet are the secondaries. On the RGB wheel, which is the one used in digital imaging, the primaries are red, green, and blue — hence, RGB — and cyan, magenta, and yellow are the secondaries. I bring all this up because the RGB color wheel serves as the basis for many photo-editing tools, not just the color-balance filter, and keeping it in mind will help you understand how those tools work.

Anyway, a color-balance filter enables you to add more of one color and subtract its opposite. For example, increasing blue results in an equal diminishing of yellow. Some color-balance filters, including the one in Elements, enable you to make these color shifts in the highlights, shadows, and midtones independently. Either way, you get more control than with a color-cast removal tool, which seeks only to neutralize colors.

As an example of how color balancing works, take a look at Figure 6-14. I shot this picture so long ago that I can't quite remember what the actual colors were, but I'm pretty sure they didn't look like they do in the figure — too heavy in the reds, magentas, and yellows. By subtracting those colors, which in turn adds cyan, green, and blue, I can get things more in balance.

Figure 6-14: This landscape has a serious color-balance problem.

In Elements, the color-balance tool is called the Color Variations filter, and you apply it like so:

1. **Choose Enhance⇨Adjust Color⇨Color Variations.**

 The dialog box shown in Figure 6-15 appears. At the top of the dialog box, you get a Before and After preview.

2. **At the bottom of the dialog box, click the Shadows, Midtones, or Highlights button.**

 Again, Elements enables you to adjust each brightness range individually. I generally start with the midtones.

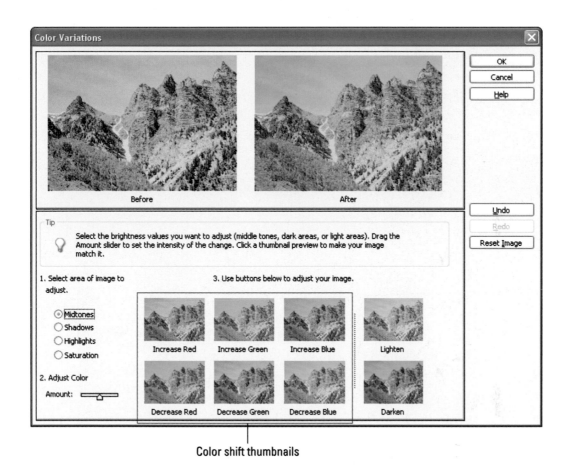

Color shift thumbnails

Figure 6-15: Click a color-shift thumbnail to add more of that color and subtract its opposite.

3. **Click the color-shift thumbnails to adjust the color balance for the selected brightness range.**

 You get three pairs of color-shift thumbnails, highlighted in Figure 6-15. When you click one thumbnail, you add more of that color and subtract an equal amount of the color that's opposite on the RGB color wheel.

 The thumbnail labels, though, can be a little confusing. The lower thumbnails are labeled Decrease Red, Decrease Green, and Decrease Blue, but they could just as easily be labeled Increase Cyan, Increase Magenta, and Increase Yellow. Remember, adding one color subtracts its color-wheel opposite.

4. **If you don't like the results of your last change, reverse it by clicking the Undo button on the right side of the dialog box.**

You also can drag the Amount slider, in the lower-left corner, to control how much change occurs with each thumbnail click. Drag the slider to the right to produce a more intense color change. (The slider setting affects your next thumbnail click.)

If you get completely off track, click the Reset Image button, near the Undo button, to go back to square one and start over.

5. **Repeat the process with the remaining brightness ranges.**

Stay away from the Saturation option and the Lighten and Darken thumbnails. Instead, use the Hue/Saturation filter, discussed in the next section, to adjust saturation. To adjust exposure, use the filters that I discuss in Chapter 4. The filters give you more control than the options in the Color Variations dialog box.

6. **When you're satisfied with your image colors, click OK to close the dialog box.**

Figure 6-16 shows you my corrected landscape image.

Figure 6-16: A pass through the Color Variations filter corrected the image.

Adjusting color saturation

At the start of this chapter, I show you how to strengthen faded colors by using the Multiply blending mode. That technique can work wonders when a photo is significantly lacking in color. When colors are only slightly faded, as in the left image in Figure 6-17, the Multiply technique typically produces too strong a result.

Figure 6-17: A slightly faded Christmas memory (left) is good as new after an application of the Hue/Saturation filter (right).

To apply a subtle saturation boost, instead turn to a Saturation filter, found in most photo-editing programs. In Elements, you apply this tool as follows:

1. **Choose Enhance⇨Adjust Color⇨Adjust Hue/Saturation.**

 The dialog box shown in Figure 6-18 appears.

2. **Select a color range from the Edit drop-down list at the top of the dialog box.**

 If you select Master, as shown in Figure 6-18, the filter affects all colors in your image. As an alternative, you can adjust six individual color ranges by selecting a range from the drop-down list, as shown in Figure 6-19. In case you're curious, these six color ranges represent the three primary and three secondary colors on the RGB color wheel, which I introduce in the preceding section.

3. **Drag the Saturation slider to adjust color intensity.**

 Drag to the right to increase color saturation. Drag left to decrease saturation. For my holiday photo, I increased the saturation of all colors first. Then I gave a small extra boost just to the reds and the yellows.

4. **Click OK to close the dialog box.**

Figure 6-18: Set the Edit option to Master to adjust saturation of all image colors.

Figure 6-19: You also can adjust the saturation of a single color range.

One final word about saturation: Increasing saturation won't bring color back to areas that are so faded that they're white or very light gray. If you want to restore color to such areas, try the painting technique that I discuss near the end of Chapter 5.

Cloning Over Holes and Other Defects

Almost every photo-editing program offers a *Clone tool,* which enables you to duplicate good areas of your photo and then paint the copied pixels onto areas you need to cover up. This tool, although a little hard to understand at first, is an invaluable photo-restoration weapon. You can use it to rid your photo of scratches, holes, water stains, and just about any other type of damage.

For example, I used the Clone tool to repair the stained area in the top-right corner of the image you see in Figure 6-20. I also cloned away the scratch that runs diagonally through the photo. You can see the results in Figure 6-21.

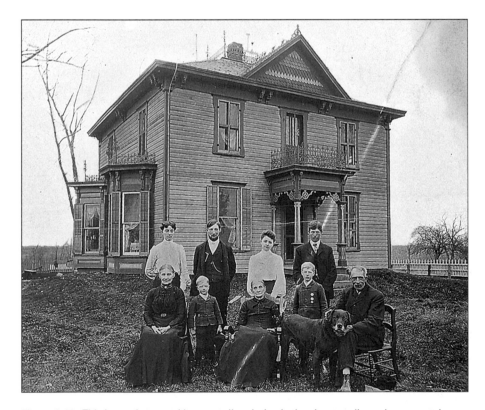

Figure 6-20: This image is marred by some discoloring in the sky as well as a long scratch.

Figure 6-21: I used the Clone tool to copy neighboring pixels over the problem areas.

Here's how to wield the Elements version of this tool:

1. **Open the Layers palette and create a new, empty layer to hold your cloned pixels.**

 You can open the palette by choosing Window⇨Layers. Then click the New Layer icon, labeled in Figure 6-22.

2. **Select the Clone Stamp tool, labeled in Figure 6-22.**

 Be sure to select the Clone Stamp, and not the Pattern Stamp, which is on the same flyout menu in the toolbox. (Most people refer to this tool simply as the Clone tool, and I do the same from here on.)

3. **Select a brush from the Brushes palette, labeled in Figure 6-22.**

 To help your cloned pixels blend with the original area, match the brush softness to the area you need to repair. If the area features soft focus, choose a soft brush. If you're fixing a sharply focused region, use a hard-edge brush instead. Remember that in the Brushes palette, the brush icons with the fuzzy edges indicate a soft brush.

Brushes palette New Layer icon

Clone tool

Figure 6-22: Always do your cloning on a separate layer.

4. **On the options bar, set the Mode control to Normal and the Opacity control to 100%.**

 At these settings, your cloned pixels completely cover the original pixels you want to hide.

5. **Turn on the Aligned option.**

 This option enables you to perfectly duplicate a large area without having to complete the whole process with one drag. (More about aligned and non-aligned cloning later.)

6. **Turn on the Sample All Layers option.**

 Now the tool can duplicate pixels from your original image but paste the duplicates onto your new layer. As discussed in Chapter 5, doing your retouching work on layers gives you extra safety and flexibility.

7. **Set the clone source by Alt-clicking (Windows) or Option-clicking (Mac) at the spot where you want to begin duplicating pixels.**

Wow, that's a mouthful. To break it down: First, press and hold down the Alt key or the Option key, depending on whether you use Windows or Mac. As soon as you press the key, you see the target-cursor shown in Figure 6-23. Move the cursor over the spot where you want to begin lifting good pixels — your *clone source pixels,* in tech lingo. Click to set the clone source and then release the Alt or Option key. In the example image, I set my clone source on the good sky pixels that lie just to the left of the stained area and the scratch.

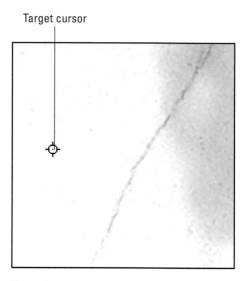

Target cursor

Figure 6-23: The first step is to set the initial clone source position.

8. **Drag over the defect you need to cover.**

As soon as you begin to drag, you see two cursors, as shown in Figure 6-24. The crosshair cursor represents the current clone source — the pixels you're copying — and the round cursor indicates your clone brush. The two cursors move in tandem as you drag, and Elements paints the copied source pixels over the pixels you touch with your tool brush. In the figure, I've cloned some of the good sky pixels over part of the scratch and stain.

If you let up on your mouse button, the crosshair cursor disappears. But as soon as you begin a new drag, it reappears, and you continue cloning from the area you left off.

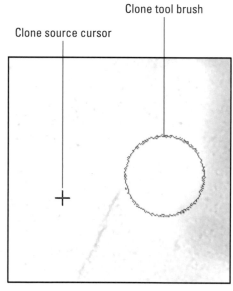

Clone tool brush

Clone source cursor

Figure 6-24: The crosshair represents your clone source; the round cursor, the tool brush.

9. **Keep cloning until the defect is completely hidden.**

At any time, you can reset the clone source as needed by Alt- or Option-clicking again. You may need to do this many times in the course of making a single repair.

10. **Merge the clone layer with the original image layer by choosing Layer⇨Flatten Image.**

 Now your cloned pixels are permanently set in place over the flaw.

That's the basic cloning process. Trust me, it won't make much sense until you actually try it for yourself, and even then, most people need a few run-throughs to completely get the hang of this tool.

In the meantime, here are a few cloning tips to keep in mind:

- ✔ If you don't want your cloned pixels to fully cover the original area, adjust the Opacity of the Clone tool via the control on the options bar. For example, you may want to do this when cloning over blown highlights. Cloning at a lower opacity enables you to tone down the highlights without completely obliterating them.

- ✔ You can use the Eraser tool on the clone layer to wipe away any badly cloned areas. Chapters 5 and 7 explain more about the Eraser tool.

- ✔ If you have only a few good pixels to use as the clone source, turn off the Aligned option. Then, every time you let up on your mouse button at the end of a cloning pass, the clone source resets to its original position, so you can keep cloning those original pixels without having to keep Alt- or Option-clicking.

 To be honest, though, you don't need to worry too much about whether the Aligned option is on or off because you can always reset the clone source at any time as needed. I tell you in Step 5 to turn the option on because that setting makes understanding the tool easiest on the first go-round. After that, use whichever setting appeals to you or works best for the task at hand.

- ✔ For small defects, such as spots of dust, you may be able to repair the problem more quickly by using the Spot Healing Brush, covered in Chapter 5. Or, depending on the severity of the defects, you may be able to eradicate them by using the Dust & Scratches filter, explained in the next section.

- ✔ If you use Elements, also investigate the regular Healing Brush tool, which works almost exactly like the Clone tool, except that after you complete a cloning drag, the program adjusts the brightness, color, and texture of the cloned pixels in an attempt to make them blend in more naturally with their new surroundings.

- ✔ The DVD that accompanies this book contains a video lesson that gives you a look at the Clone tool in action.

Removing Dust and Scratches

To remove specks of dust, tiny scratches, and other minor blemishes, you can use either the Clone tool, explained in the preceding section, or the Spot Healing Brush, introduced in Chapter 5. This type of cleanup work isn't difficult, but it *is* tedious and time-consuming, especially when you're looking at an image as dusty as the one you see in Figure 6-25. So before you pick up either the Clone tool or the Spot Healing Brush, try applying a dust-removal filter.

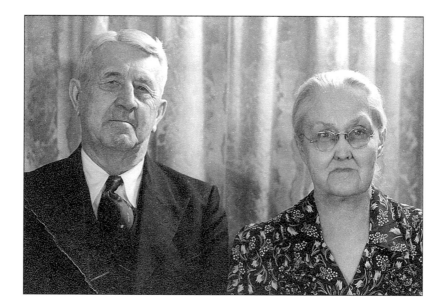

Figure 6-25: You could spend all day zapping each dust spot individually.

This type of filter, found in many photo editors, searches for the type of color and brightness changes that typically indicate dust, scratches, and so on. Then the filter applies a slight blur just to those areas, which can make the flaws appear to fade into the background.

To use the Elements version of this filter, called the Dust & Scratches filter, take these steps:

1. **Choose Filter➪Noise➪Dust & Scratches to display the dialog box shown in Figure 6-26.**

2. **Set the Radius value to 1 and the Threshold value to 0.**

 The Radius value controls the strength of the blur effect. The Threshold value determines how much color or brightness difference must exist between neighboring pixels before Elements applies the blur to them. At a Threshold setting of 0, even a slight difference between pixels results in the blur.

3. **Raise the Radius value until most of the dust disappears.**

 You usually need to stay in the 1–3 range; otherwise, you create an unacceptable amount of blurring.

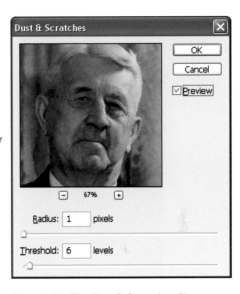

Figure 6-26: The Dust & Scratches filter can speed up your clean-up work.

4. **Raise the Threshold value as far as you can without reintroducing the dust or other defects.**

 By raising the value, you limit the blur just to the dirtiest areas of the photo. You may need to play with both the Radius and Threshold values to find the optimal tradeoff between image blurring and dust removal.

 I used the values you see in Figure 6-26 to produce the cleaned image in Figure 6-27. The large scratch in the coat remains partially visible, but the majority of the dust has disappeared.

5. **Click OK to close the dialog box.**

 Remove any remaining dust or scratches by using the Clone tool or Spot Healing Brush.

Keep in mind that you probably won't be able to completely remove intense flaws with this filter, but you can at least spare yourself the chore of cleaning up every speck of dust. After you apply the filter, you may want to apply the Unsharp Mask filter to bring back some of the details that the Dust & Scratches filter may have blurred. Chapter 4 explains how to use the Unsharp Mask filter in a way that keeps the filter from making dust visible again. (Raise the Threshold value slightly in the filter dialog box.)

Figure 6-27: A light application of the filter removed most of the dust, leaving just a little touch-up work to do with the Clone tool.

If the dust and dirt are isolated in one area, follow the Chapter 4 instructions to select just that part of the photo before you apply the Dust & Scratches filter. That way, you don't run the risk of destroying image detail in the rest of the picture.

Part III
Beyond the Frame: Project Idea Kit

The 5th Wave By Rich Tennant

"That's a lovely scanned image of your sister's portrait. Now take it off the body of that pit viper before she comes in the room."

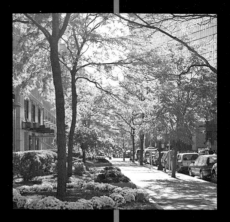

*A*re you ready to unleash your creative side? If you are, check out the projects in this part of the book. In Chapter 7, you find out how to paste pictures together and then manipulate the bits and pieces to create a collage, a digital scrapbook page, or just about anything else you have in mind. I also show you how to combine pictures in a way that leaves no evidence of your creative input behind — a neat trick if you want to put an object into a new background, for example. To further expand your artistic possibilities, Chapter 8's projects explore all sorts of photo embellishments, including text and special effects.

Copy, Paste, Create!

1 have in my bedroom one of those photo-collage frames — the ones that have a matte precut with holes of different shapes and sizes so that you can display a bunch of photographs together. Most of the images are pretty dated, but I've put off swapping them out because it's such a pain. In most cases, you have to tape or glue the photos into place when putting the arrangement together, so you run the risk of tearing your original prints, the matte, or both if you want to change things. Besides, now that I've gone digital, I can create a new photo collage with a lot less effort and mess.

This chapter explains the art of photo *compositing,* which is a fancy way of saying "pasting pictures together." Whether you want to build a collage, blend two photos to create a fantasy image — putting your head on someone else's body, for example — or simply paste a group of pictures together so that you can print them on the same sheet of photo paper, you can use the techniques in this chapter to get the job done.

To find out how to add text and other embellishments to your creation, see Chapter 8. And be sure to check out the DVD that accompanies this book, too. It offers QuickTime movies that demonstrate most of the techniques I cover in this chapter. (See the movies titled "Gluing Photos Together with Digital Paste," "Advanced Image Blending," and "Creating Cool Backgrounds.")

Building a Photo Collage

When most people hear the word *collage,* they think of something like the image in Figure 7-1. But the collage techniques I explain in this chapter apply to any creation that involves pasting one picture into another — even something as simple as the two-picture combo featured in the left example in Figure 7-2. The approach is the same no matter how many pictures you want to combine and whatever creative design you have in mind.

Figure 7-1: Creating a digital collage or scrapbook page is easier than you may imagine.

Figure 7-2: Thanks to digital magic, you can combine two photos in all sorts of creative ways.

If your goal is to join portions of multiple photos to create a scene that appears to be a single photograph, as I did with the dog image at the end of this chapter, you also start with the same basic collage-building steps. After you join your photos, see the section "Blending Images into a New Reality" to discover a few additional secrets to that kind of photo trickery.

Preparing a canvas for your creation

Always begin a collage by creating a new image file. A new file provides you with a blank piece of virtual photo paper to serve as the foundation for your creation, similar to an empty page in a scrapbook or photo album.

Even if you plan to use a photograph as your collage background, as I did in Figure 7-2, starting with a new file is still a good idea in Elements and in other programs that take a similar approach to layers. Here's why: As I explain fully in Chapter 5, every image in Elements starts life with one layer, the Background layer, which is immovable and fully opaque. Atop that, you can add more image layers that can be freely manipulated and can contain pixels of varying opacity.

When you open an existing photograph, the immovable, inflexible Background layer contains the original image pixels. If you simply paste another picture into the image, your creative options are limited because you can't do much of anything with the pixels on the Background layer. You can create something like the first example in Figure 7-2, but that's about it.

But if you create a new image, you get a Background layer that's filled with solid color — white, by default. You then can paste your photos into new layers atop the Background layer, in which case all the photo pixels are fully movable and open to opacity adjustments. So you could, for example, reduce the opacity of the bottom photo so that it appears faded and less visually dominant than the jack-o'-lantern image, as I did for the middle image in Figure 7-2.

You also can blend the bottom photo layer with the Background in some interesting ways by taking advantage of layer-blending modes, as I did in the right image in the figure. To create that version, I filled the Background layer with brown and then set the blending mode of the lower pumpkin layer to Saturation. (The upcoming section, "Playing with opacity and blending modes," shows you how to work with layer opacity and blending modes.)

If all this doesn't quite make sense yet, don't worry — it'll become clear as you start experimenting with collage building. So just trust me on this one for now and take these steps to create a new image file in Elements:

1. **Choose File⇨New⇨Blank File.**

 You see the New dialog box, shown in Figure 7-3.

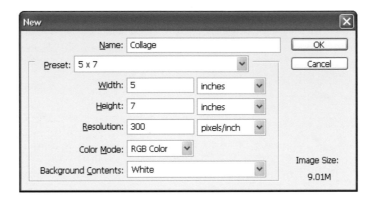

Figure 7-3: Creating a new canvas for your composition provides extra creative flexibility.

2. **Type a name for your collage in the Name box.**

3. **Set the image dimensions.**

 You can either select one of the standard photo sizes from the Preset drop-down list — I chose 5 x 7 in Figure 7-3 — or type in custom dimensions in the Width and Height boxes.

 If you plan to print the image, set the unit of measurement via the drop-down lists adjacent to the Width and Height boxes. You can select inches, picas, or whatever traditional measurement unit strikes your fancy. If the image is destined only for the screen, set the unit of measurement to pixels and follow the Chapter 3 guidelines regarding setting the display size of an on-screen picture.

4. **Specify the image resolution in the Resolution box (for print only).**

 I repeat: This setting is relevant only for print purposes. It determines the number of pixels per inch in your printed photo, which affects your print quality. A resolution of 300 pixels per inch is appropriate for most purposes, but if you're preparing an image for use in a publication such as a newsletter or magazine, ask the publication's art director for guidelines.

5. **Select RGB Color from the Color Mode drop-down list.**

 This assumes that you want your collage to contain color elements. If not, you can instead select Grayscale for a black-and-white image. Don't select Bitmap, which restricts your picture to only black and white, with no shades of gray.

6. **Set the Background Contents option to White.**

 Your new image will contain one layer, the Background layer, which Elements will fill with the color you select here. For now, just choose white; you can fill the layer with another color later if desired. See the next section for details.

7. **Click OK.**

 Your new, empty canvas appears in its own image window. And, as promised, the image contains one layer, the Background layer, which is filled with solid white. You can view the layer by displaying the Layers palette (Window➪Layers).

To find out how to add color or texture to your new background, see the next two sections.

Changing the canvas color

Replacing the original, white background that you create in the preceding steps with a colored or textured background can make a significant impact on your composition. Compare the image in Figure 7-4, for example, with the original in Figure 7-1. The white background gives the collage a more conservative look than the yellow background.

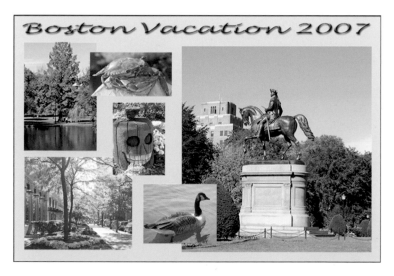

Figure 7-4: Changing the background color gives the collage a warmer look.

The following steps show you how to change the color of your Background layer in Elements:

1. **Open the Layers palette by choosing Window⇨Layers.**

 You can see the bottom three layers of my updated Boston collage in Figure 7-5. Your Background layer will appear white in the palette thumbnail if you haven't yet adjusted its color.

Figure 7-5: Fill the Background layer with color with the Fill Layer command.

2. **If your image contains multiple layers, select the Background layer by clicking it in the Layers palette.**

 You don't need to take this step if you haven't added any photos to your background yet.

3. **Choose Edit➪Fill Layer.**

 The Fill Layer dialog box appears, as shown in Figure 7-5.

4. **Select Color from the Use drop-down list to open the Color Picker, shown in Figure 7-6.**

 To set up the color picker so that it appears as in the figure, click the H option button. Now click or drag in the vertical color bar to select a basic hue. Adjust saturation and brightness by dragging or clicking in the larger color field next to the color bar.

Figure 7-6: Set the main hue via the slider bar and adjust saturation and brightness in the large color field.

 The top color preview, labeled New Color in Figure 7-6, shows you the color you've selected. The lower preview shows the color you chose on your last trip to the Fill Layer dialog box.

 When you find a color you like, click OK to close the dialog box and return to the Fill Layer dialog box.

5. **Set the Blending Mode option to Normal and the Opacity option to 100%.**

 These are the default settings, so you probably won't need to adjust them.

6. **Click OK to close the dialog box and fill the Background layer with your selected color.**

You don't have to stick with the color that you originally set via the Fill Layer box. You can change the color at any time by simply repeating these steps. However, there's an even easier option:

1. **Click the Background layer in the Layers palette to select it.**

2. **Choose Enhance⇨Adjust Colors⇨Adjust Hue/Saturation to open the Hue/Saturation dialog box, shown in Figure 7-7.**

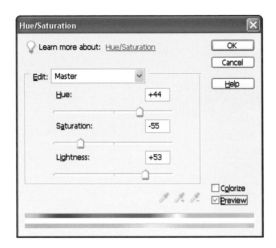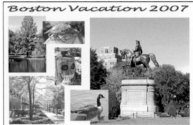

Figure 7-7: After setting the initial canvas color, adjust it via the Hue/Saturation filter.

3. **Adjust the background color by dragging the Hue, Saturation, and Lightness sliders.**

 If you select the Preview check box, you can monitor the color change in the image window, a benefit you don't get when you use the Fill Layer command.

4. **Click OK to close the dialog box.**

You can use this trick to alter the color of any selected object or layer, by the way. (Unfortunately, the filter has no effect on white or black pixels, which is why you can't use it to change the color of your initial white background.) However, don't use the Lightness slider for anything but changing the color of a background or other solid color element; to adjust the brightness of a photograph, apply one of the exposure filters discussed in Chapter 4.

Creating a textured background

To add even more spice to your background, you can fill it with a texture, as I did for the collage variation shown in Figure 7-8. The result is similar to a textured matte that you can buy in your local framing store. Here's how you create this effect in Elements:

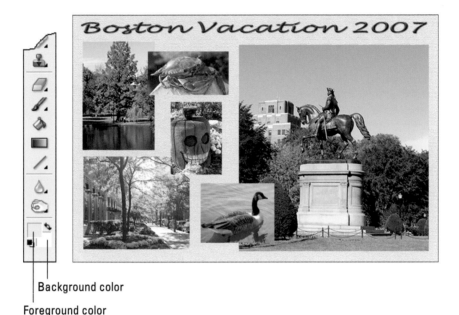

Background color

Foreground color

Figure 7-8: Two shades of yellow serve as the basis for a subtly textured background.

1. **Click the Background layer in the Layers palette to select it.**

2. **In the toolbox, click the Foreground Color swatch, labeled in Figure 7-8, to open the Color Picker.**

 This swatch represents the current foreground paint color.

3. **In the Color Picker, select the main color for the textured background that you want to create.**

 For the example photo, I stuck with the original golden yellow I used in the earlier version of the collage.

4. **Now click the Background Color swatch, also labeled in the figure, and select a slightly darker or lighter color to serve as the secondary texture color.**

 I chose a paler shade of yellow for my background paint color.

5. **Choose Filter⇨Texture⇨Texturizer.**

 You see the dialog box in Figure 7-9. On the left side of the dialog box, you see a preview of the texture effect. Use the controls on the right to adjust the texture design.

6. **Click OK to apply the texture and close the dialog box.**

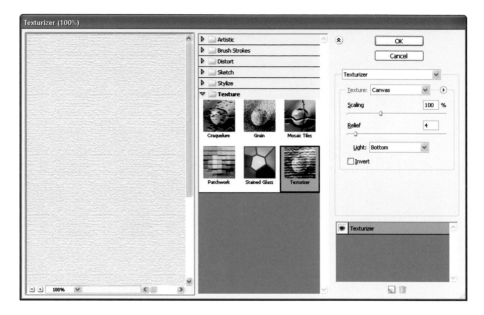

Figure 7-9: The Texturizer filter produces some great background textures.

If you're not happy with the results, you can easily adjust the color, intensity, and brightness of the textured background by applying the Hue/Saturation filter as outlined at the end of the preceding section.

I demonstrate how to create this textured background as well as other background designs on the QuickTime movie titled "Creating Cool Backgrounds," included on the DVD that ships with this book.

Resizing your canvas

If you find that your original background isn't large enough to hold all the photos in your composition, you can change its size at any time. You don't do this through the Image Size command that you use to set print dimensions — that command resizes your entire composition. Instead, you use the Canvas Size command.

Note that I use the term *canvas* in this chapter to describe the white Background layer that you create as the first step in collage building — a metaphor for a real artist's canvas, if you will. But in Elements, the word has an official meaning. In Elements, the canvas refers to the virtual piece of paper on which every photo lives. When you open a photograph, you don't see the canvas because your photo pixels completely cover it. And if you create a new image file, Elements covers the canvas with white, opaque pixels by default. The canvas becomes visible only when you enlarge it or if you delete or erase something on the Background layer.

At any rate, you adjust the official canvas — which also extends your Background layer, or metaphorical canvas — like so:

1. **Choose Image➪Resize➪Canvas Size.**

 Figure 7-10 shows the Canvas Size dialog box that appears when you choose the command.

Figure 7-10: Choose the Canvas Size command to enlarge an existing canvas.

2. **Set the new canvas size.**

 You can do this in two ways:

 • Deselect the Relative check box, as shown in Figure 7-10, and enter the new dimensions in the Width and Height boxes.

 • Select the Relative check box and then type the amount of canvas that you want to add. For example, if you want to add 2 inches to the width of the canvas, enter **2** in the Width box and set the Height box to **0**.

3. **Click an Anchor square to position the image on the new canvas.**

 The empty square — the one without an arrow — represents where your existing image will be placed on the new canvas. If you click the center square, as shown in the figure, your image will appear centered on the enlarged canvas.

4. **Select a color from the Canvas Extension Color drop-down list.**

 The new canvas area will take on this color. You can set the color to the current Background or Foreground paint color (the ones represented by the swatches in the toolbox), white, black, or gray. Or, by choosing Other from the drop-down list, you can open the Color Picker dialog box and select some other color.

5. **Click OK to close the dialog box.**

 The enlarged canvas becomes visible in the image window.

You use the same process to reduce the canvas size. After you click OK in Step 5, Elements displays a message warning that some of the image will be clipped away. Click Proceed to finish the resizing process. (You also can simply use the Crop tool to trim away the entire perimeter of the canvas.)

Adding photos to the collage

Pasting photos into your collage background is pretty simple. Well, okay, nothing's simple when you're first starting with digital photography, but compared to, say, understanding file formats and resolution, combining photos is a lot less brain frazzling.

In fact, if you've ever copied and pasted text in a word processor or your e-mail program, you already know the two commands involved in this bit of digital magic: Copy and Paste.

- ✓ **Copy:** With the Copy command, you can duplicate an entire photo or a portion of a photo.
- ✓ **Paste:** You choose this command to glue the copied photo into the active image.

The following steps show you how to copy and paste in Elements. Things work much the same in every other photo editor, although the location of the Copy and Paste commands may differ. The QuickTime movie titled "Gluing Photos Together with Digital Paste," on the DVD that accompanies this book, demonstrates this process.

1. **Open the pictures that you want to paste together.**

 For clarity's sake, I'll refer to the picture that you want to copy and paste into the collage Picture A and call the background image Picture B.

2. **Make Picture A the active picture.**

 In Elements, just click the image window or choose the image name from the bottom of the Window menu.

3. **Select the portion of Picture A that you want to copy and paste.**

Chapter 4 gives you an introduction to selecting in Elements. If you want to select the entire picture, choose Select➪All. You should see the dotted selection outline around the image.

4. Choose Edit➪Copy.

The program copies the selected pixels and puts them in a temporary storage tank known as the Clipboard in computer lingo. (Note that no dialog box or other message appears after you choose the Copy command.)

5. Make Picture B the active image.

Again, just click the image window or choose the picture name from the bottom of the Window menu in Elements.

6. Choose Edit➪Paste.

The copied portion of Picture A appears inside Picture B.

In Elements, as well as in some other programs, you also can copy and paste by simply dragging a selected area from one image to another. Here's how:

1. Display both image windows side by side, as shown in Figure 7-11.

You can choose Window➪Images➪Tile to display the windows for all open images in the work area. Then drag the windows by their title bars (tops) to arrange them.

Move tool

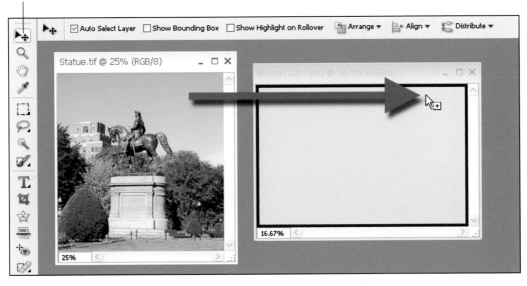

Figure 7-11: You can copy one image into another by just dragging it to the other window with the Move tool.

2. **Click the window for Picture A and then select the portion of the picture you want to copy.**

 If you want to copy the entire picture, you can skip this step.

3. **Select the Move tool, labeled in Figure 7-11.**

 I cover the Move tool in more detail in the upcoming section "Moving photos and objects with the Move tool," but for now, don't worry about the settings of the options bar controls.

4. **Click and drag the selected area into Picture B, as illustrated in the figure.**

 A little plus sign appears next to your cursor, as shown near the tip of the red direction arrow in the figure. The plus sign indicates that you're copying a selection. (You don't see the red arrow; I added that for illustrative purposes.)

 As you begin to drag, the selected area or photo appears to be moving out of its original window, but don't panic. As soon as you let up on your mouse button, Picture A returns to its original state, and the copy appears inside Picture B.

Whichever copy-and-paste method you choose, a pasted photo or object automatically appears on its own layer in Elements. You can view and manage your image layers by choosing Window➪Layers, which displays the Layers palette, shown in Figure 7-12. Layers are a critical part of photo compositing, so if this is your first encounter with this feature, make a quick side trip to the beginning of Chapter 5 for an introduction.

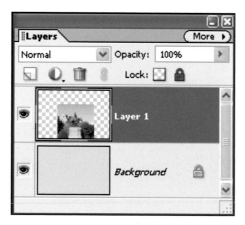

Figure 7-12: In Elements, a pasted photo or object appears on its own layer.

To bring the rest of your photos into the collage, just repeat the copy-and-paste process. Or, if you prefer, head into the next section to find out how to resize and reposition your newly pasted photo and take that step before adding more pictures.

Resizing pasted photos

When you paste a photo or selected area into another image, it may appear to change size in its new home. It really doesn't; its size simply reflects whatever difference exists between the pixel dimensions of both images. For example, if your collage background has dimensions of, say, 1000 x 1000 pixels, and you paste in an image that measures 3000 x 2000 pixels, the pasted photo fully covers the background and then some. On the other hand, if your pasted photo has a small pixel count, it may be tiny compared to your background.

You can easily resize any pasted photo as long as it remains on its own image layer. But beware: Enlarging a digital image lowers quality. You can usually get away with a little enlarging, but if you go too far, expect to seriously degrade the picture. (See Chapter 2 for details on this issue.)

The steps for *scaling* — the image-geek term for *resizing* — the contents of a layer in Elements are as follows:

1. **Select the layer by clicking it in the Layers palette.**

2. **Choose Image⇨Resize⇨Scale.**

 Little boxes called *handles* appear around the perimeter of the selected photo, as shown in Figure 7-13. You also see the options bar controls shown in the figure.

3. **Make sure that the Constrain Proportions check box on the options bar is selected.**

 This option ensures that you don't distort your photo as you resize it.

4. **Drag any corner handle to resize the photo.**

 Don't try to drag a side or top handle. If you do, the Constrain Proportions option is automatically disabled, and you change only the photo width or height, respectively, distorting the photo. If you mistakenly grab one of those handles, just select the Constrain Proportions box again to automatically restore the original proportions.

 If you have trouble sizing the picture by dragging a handle, you also can type a value into the W (width) or H (height) box on the options bar.

5. **Click the green check mark button to accept the size change.**

Or, if you need to cancel out of the operation, click the neighboring red cancel button instead. I labeled both buttons in Figure 7-13 (but note that they may appear to the side of your photo instead of directly underneath, depending on the size of the image window).

Handle

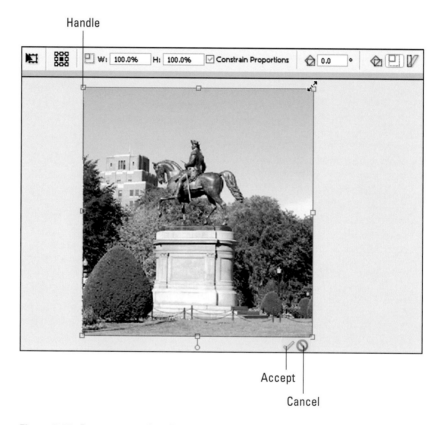

Accept

Cancel

Figure 7-13: Drag a corner handle to resize the pasted photo.

Rotating collage elements

To rotate the contents of a layer, first click the layer name in the Layers palette. Then choose any command from the middle section of the Image⇨ Rotate submenu. Be sure to select a command that has the word *layer* in its name; the other commands, at the top of the Rotate menu, rotate the entire image.

If you choose the Free Rotate Layer command, you see the same handles and options bar controls that appear when you choose the Scale command, discussed in the preceding section. Place your mouse pointer outside a corner handle until you see a curved, double-headed arrow cursor like the one labeled Rotate cursor in Figure 7-14. Then drag up or down to rotate the layer. You also can enter a specific degree of rotation into the Rotate box on the option bar, labeled in the figure. Either way, click the green check mark to complete the rotation.

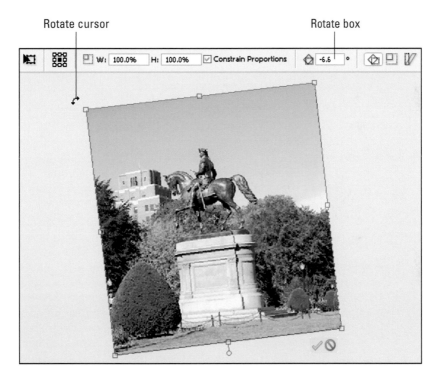

Figure 7-14: Drag outside a corner handle to rotate a collage element.

Positioning the collage photos

In Photoshop Elements, you have two ways to arrange the photos that you place into your collage background. You can reposition a photo within its own layer, or you can change the layer's position in the stack of layers that make up your collage. The next two sections provide details.

Moving photos and objects with the Move tool

To position a photo within the confines of its layer, just drag it with the Move tool, labeled in Figure 7-15.

Move tool

Figure 7-15: Use the Move tool to drag a photo to a new position.

Here are a few details about the Move tool options:

 ✓ **Auto Select Layer:** When this option is enabled, Elements automatically selects whatever layer contains the object on which you click, saving you the trouble of clicking the layer name in the Layers palette to select it. This feature is great unless the layer contains only a very small object, in which case clicking the right spot to select the layer you want can be tricky. If that occurs, just deselect the option and then select the layer by clicking its name in the Layers palette.

 ✓ **Show Bounding Box:** This feature, when enabled, surrounds the layer contents with a box similar to the one you get when you scale or rotate the layer. You then can immediately shift into scale or rotate mode by dragging one of the handles around the perimeter of the box. Because it's easy to inadvertently grab a handle, I suggest that you turn off the option, however. Note that if part of your layer is hidden because the photo on that layer is larger than your background, the bounding box indicates the actual span of the photo, which can be helpful at times.

 ✓ **Show Highlight on Rollover:** This feature displays a bold outline around the contents of layers that aren't selected when you pass your cursor over them. If the highlight helps you, turn it on; if it distracts you, disable it.

 ✓ **Arrange:** Click this drop-down list to access options that change the layer's placement in the layer stack. Or, to save time, see the next section to find out how to do the same thing by using the Layers palette.

 ✓ **Align and Distribute:** With these options, you can align two or more layers or space them evenly across a given area. To select the layers you want to manipulate, click the first layer in the Layers palette and then hold down Ctrl (Windows) or ⌘ (Mac) as you click the other layers that you want to align or distribute. Then choose the alignment or distribution option you want from the drop-down list on the options bar.

Note that the last three options are new to Elements 5.0; in Version 4, you must align and arrange your photos using the Move tool and the Layers palette method described next.

TIP

After you select the Move tool, you can nudge a photo one pixel in any direction by pressing the arrow keys on your keyboard. Add the Shift key to nudge the layer ten pixels in the direction of the arrow key.

Shuffling the layer stacking order

The position that a pasted photo occupies in the Layers palette determines its *stacking order* in the composition. If two photos overlap, the one on the upper layer appears to rest atop the one on the layer below. For example, in Figure 7-16, you can see the stacking order for the Boston collage. Notice that the crab photo is above the pond photo, so it obscures part of the pond. The same thing applies to the other pairs of overlapping images. Where images don't overlap, the stacking order doesn't matter.

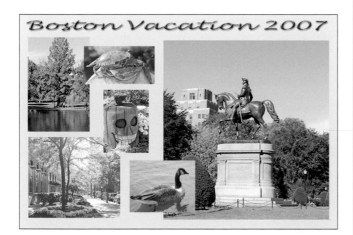

Figure 7-16: When two photos overlap, the one on the upper layer hides a portion of the one below.

In Elements 5.0, you can select a layer and then change its position in the layer stack by using the Arrange drop-down list that appears when you select the Move tool. (See the preceding section for details.) But an even faster solution is to simply drag the layer up or down in the Layers palette. When you begin to drag, your cursor changes into a little fist to let you know you grabbed the layer successfully. Figure 7-17 shows me in the process of dragging the pond layer above the crab layer; in Figure 7-18, you see close-ups of the result in the image and the Layers palette.

Figure 7-17: Drag a layer up or down to change its position in the stack.

Note that I renamed the layers in the figures in this chapter so that you can more easily see what each one contains. By default, Elements names the layers in the order you create them: Layer 1, Layer 2, and so on. The layer number doesn't restrict you in any way — you can move Layer 1 above Layer 2, for example. But if you want to change a layer name, double-click it in the palette, type the new name, and press Enter.

Removing all or part of a pasted element

Suppose that you decide that you want to get rid of part of a layer in your collage. For example, the left photo in Figure 7-19 shows one of the variations of my pumpkins collage. To create the right image, I erased the background of the jack-o'-lantern image.

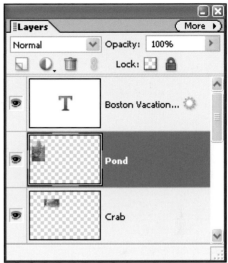

Figure 7-18: After I moved the Pond layer above the Crab layer, the pond image hides part of the crab image.

Figure 7-19: I erased the background of the jack-o'-lantern photo to create the variation on the right.

You can erase part of a layer in two ways:

- ✏ Select the area that you want to eliminate and press Delete on your keyboard. Chapter 4 offers an introduction to selecting if you need one.

- ✏ Grab the Eraser tool, labeled in Figure 7-20, and drag over the area you want to remove. For best results, set the Mode control on the options bar to Brush mode. Set the Opacity control to 100% to completely erase the pixels you touch with the tool. At a lower opacity, erased pixels remain partially visible.

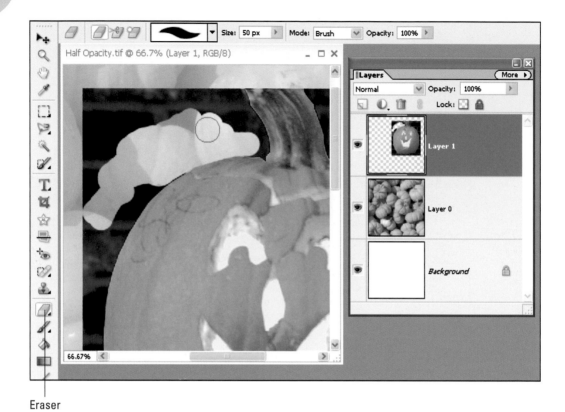

Eraser

Figure 7-20: Set the tool Opacity to 100% to completely erase layer pixels.

If you select a hard brush from the Brushes palette, your Eraser strokes have precise edges. If you select a soft brush, the strokes fade at the edges. Which option works best depends on the effect you want to create. In Figure 7-20, I chose a hard brush because I wanted a clean edge between the jack-o'-lantern and the background photo. Remember that the fuzzy icons in the Brushes palette represent soft brushes.

To completely eliminate a layer, just drag it to the Trash icon in the Layers palette, labeled in Figure 7-20. Away goes the layer and everything on it.

Playing with opacity and blending modes

By using the Opacity and Blending Mode controls in the Layers palette, you can create endless variations of your layered collage. In fact, I encourage you to play around with these options — you're bound to discover some creative results that you wouldn't otherwise imagine, which is part of the fun of digital compositing.

To get you started, here are the recipes I used to create the two variations of the original pumpkins collage (refer to the right image in Figure 7-19):

- ✔ To produce the variation shown in Figure 7-21, I simply lowered the Opacity value to 50% for the layer that holds the pumpkins image. Because the underlying layer (the Background layer, in this case) is white, the result is a faded version of the photo.

- ✔ To produce the version shown in Figure 7-22, I started by filling the Background layer with brown. (See the earlier section "Changing the canvas color" for details.) Then I set the Blending Mode option for the pumpkins layer to Saturation. For this variation, I set the layer's Opacity value back to 100%.

TIP

The results you get from any blending mode using this recipe varies depending on the colors in your photo and in the Background layer. So after filling the Background layer with a solid color and choosing a blending mode, use the Hue/Saturation filter to play with the color of the Background layer. You can find details at the end of the earlier section, "Changing the canvas color."

Layer opacity control

Figure 7-21: Reducing the opacity of the pumpkins photo gave it a faded look.

Blending Mode control

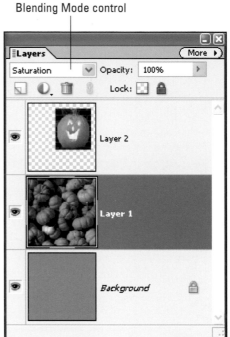

Figure 7-22: After filling the Background layer with brown, I changed the blending mode of the pumpkins layer to Saturation.

To see an on-screen demonstration of working with layer opacity and blending modes, watch the QuickTime movie titled "Advanced Image Blending," on the DVD that accompanies this book. That same movie also includes a demonstration of the techniques discussed in the following section.

Blending Photos to Create a New Reality

If you weren't reading a chapter about combining photos, you probably wouldn't be able to tell that something in the photo in Figure 7-23 isn't exactly as it appears — aside from the text effect, of course, which I added using the Elements type tool, covered in the next chapter. The base photo of the dog sitting next to a tree branch actually is a blend of two photos, which you can see in Figure 7-24.

The idea for the photo, which provided the basis for a holiday greeting card, was to make it look as though the dog had written the message in the snow with the stick, a concept that my dog-owner friends thought was hilarious

and my "cat people" friends didn't get. Anyway, I tried for some time to get my dog to pose next to the stick, but if you've ever seen a Wheaten Terrier in the snow, you know that it's rare that they even sit still, let alone do it where directed. So, I followed him around the yard and offered treats until he was willing to cooperate and then quickly snapped the shot you see on the top in Figure 7-24. Then, while he went off for another romp through the white stuff, I took a second shot of just the stick. (I suspect that I keep my neighbors well entertained with these little backyard adventures.)

Figure 7-23: The dog image actually is a blend of the two images in Figure 7-24.

Figure 7-24: I selected and pasted the stick and some of its surrounding snow into the shot of my dog.

To create a seamless photo composite such as this, you follow the same process as when building a collage. But depending on the two subjects that you're joining, you may need to add one or all of the following additional steps:

- **Match the color, sharpness, and tonal qualities of the images.** For example, the color and brightness of the snow in my original dog and stick images weren't exactly the same. So I adjusted the stick image to match the dog image, using the filters and techniques covered in Chapter 4. Because I used the same focus setting for both shots, they were similar enough in that department that I didn't need to adjust sharpness.

- **Blend the edges of the pasted object by erasing with a soft brush and lowered opacity.** Your goal is to fade the pasted object at the perimeter so that the pixels gradually blend with the underlying background. For example, I dragged the Eraser tool along the edge of the stick layer at half opacity, as shown in Figure 7-25, resulting in snow pixels that were half from the stick photo and half from the dog photo. (I hid the underlying layers so that you can see just the stick layer in the figure. The checkerboard pattern represents transparent pixels.) You may need to adjust the Eraser tool opacity as you work; some areas may call for an abrupt transition between the two images, and others may call for lower opacity.

You can alternatively create a feathered selection outline before you copy and paste the object. As detailed in Chapter 4, a feathered outline also creates a pasted object that fades at the edges. However, sometimes you don't know in advance how much feathering will produce the best blend with the destination photo, so I typically use a nonfeathered outline for copying and pasting and then use the Eraser tool to fuzz up the edge of the pasted object.

- **Recreate shadows, don't copy them.** If an object casts a shadow in its original photo, don't include that shadow when you copy and paste the object. Why? Because the color and texture of a shadow in a photograph usually reflects the surface on which it's cast. So unless the background into which you paste the object is very similar to its original background, that shadow may look odd. Instead, recreate the shadow using the special effect option discussed in the next chapter.

- **Be sure that both photos are of similar image quality.** If the two are very different in quality, the transition between them will be visible no matter what other steps you take. For more on image quality, visit Chapter 2.

Eraser

Figure 7-25: I erased the edges of the stick photo with the Eraser tool set to 50% opacity so the snow pixels would be a blend of both images.

Merging or Preserving Collage Layers

I touch on this subject in Chapter 5, but it's important enough to mention again here. As you're working on your collage, remember that you must save the image file in either the TIFF format or the PSD (Photoshop) format *and* you must enable the Layers check box in the Save As dialog box. Otherwise, all your independent layers are merged together, and you can no longer freely manipulate the collage elements.

When you're finished with the collage, however, you can choose to merge all the layers so that you can't accidentally move something out of place. To do so in Elements, choose Layer➪Flatten Image. Or you can simply save a copy of the file with the Layers feature disabled in the Save As dialog box.

For more about saving files, see Chapter 3.

Finishing Touches

In This Chapter

▶ Adding text

▶ Embellishing photos with shadows and borders

▶ Creating digital mattes and framing effects

▶ Converting a color image to black and white

▶ Adding a sepia tint

▶ Experimenting with special effects

Some aspects of working with digital photos can be classified as, well, not terribly exciting. Creating a selection outline, for example, is a necessary part of many photo projects, but I hardly consider it an entertaining endeavor.

This chapter, on the other hand, is all about Fun (with a capital F, even). The projects you find here help you unleash your creative side and add all sorts of embellishments to your pictures: text, borders, special effects, and more. You also can find out how to turn a full-color photo into a black-and-white or sepia-toned image and how to create a faux frame or matte.

I offer only one gentle word of caution before you enter the playground: Don't try to cram all your creative urges into one photo. The photo, after all, should always be the focal point of your creation, so be sure that whatever text or effects you add work with the image rather than compete with it for attention.

Writing on Your Pictures

Figure 8-1 shows you an unadorned photo along with a text effect that I created in Photoshop Elements. Whether you want to create a fancy effect such as this or just a plain headline such as the one I added to the Boston collage in Chapter 7, you can do so easily in most photo programs.

I should qualify the "easily" part of that last sentence, though: Although creating short bits of text is simple, adding long blocks of text can be cumbersome in a photo editor. So if your project involves more than a very short paragraph, take the opposite approach to combining words and pictures. Open whatever word-processing program you use — Microsoft Word, Corel WordPerfect, or any of their lesser-known rivals — and create your text in that program. Then add your pictures to the text document, instead of the other way around. (You can find the steps for adding a picture to a Microsoft Word document in Chapter 9.)

That caveat out of the way, the next section walks you through the basics of using the Photoshop Elements Text tool. Following that, I show you how to create text effects like the one in Figure 8-1 and how to position and otherwise manipulate your text.

Figure 8-1: Simple images provide the best backdrop for complicated text effects.

Creating basic text

To add text in Elements, follow these steps:

1. **Open the Layers palette by choosing Window⇨Layers.**

 Elements creates text on its own layer, and you may need the palette controls to manipulate your text after you create it. (For an introduction to layers, see Chapter 5.)

2. **If your image contains more than one layer, click the layer that's directly below where you want the text to go.**

 For example, if your image contains three layers and you want the text layer to be above Layer 2, click that layer. If your image contains only one layer, you can skip this step.

3. **Select a Type tool from the toolbox.**

 Photoshop Elements gives you four tools for creating text:

 - *Horizontal Type tool:* Use this tool to add regular text — that is, type that reads from left to right, as in Figure 8-1.

 - *Vertical Type tool:* If you want your type to read from top to bottom, choose this tool instead.

 - *Horizontal and Vertical Type Mask tools:* These tools enable you to create a selection outline that's in the shape of your type. The projects in this book don't call for that particular task, but you can see an example of one use of the feature in the Elements Help system.

 You can convert a line of horizontal type to a vertical orientation easily, so if you're not sure which layout you want, just start with the Horizontal Type tool, labeled in Figure 8-2.

4. **To add a single line of text, click the spot where you want to place the first letter.**

 In addition to the tool cursor, you see a blinking *insertion mark* cursor, similar to what you see in a word-processing program. This cursor shows you where the next character you type will appear. You can reposition your text later, so don't worry about precise positioning when you click. Move to Step 6 after you click.

5. **To create a paragraph, drag to create a text box.**

 After you release the mouse button, you see a dotted outline that represents your text box, as shown in Figure 8-2. Again, you see both the tool cursor and the insertion mark cursor, which indicates the position where the next character you type will appear.

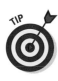

 You can resize the text box if needed by dragging the square boxes, or *handles,* that appear around its perimeter.

Insertion mark cursor

Text box

Type tools

Text cursor

Figure 8-2: To create normal text, use the Horizontal type tool.

6. Set the initial text color.

After you click with the Horizontal or Vertical Type tool, the options bar offers the controls you see in Figure 8-2. Click the Color swatch to open the Color Picker and set the text color. (You can change the color later also.)

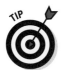

With the Color Picker open, you can click in your image to select a color that's featured in the photo. For example, I clicked the rust-colored area of my leaf photo to set my type color.

If you click the drop-down arrow instead of the Color swatch, you display a palette of color swatches. You can either click one of those swatches or click the More Colors button to open the Color Picker.

7. Select a font, type style, and type size.

Figure 8-3 shows a close-up view of the options bar controls that enable you to establish these characteristics of your text. Note that some fonts don't offer variations in type style (bold, italic, and so on) but you can use the "faux" style options to give the font a bold and italic look. (The official styles are created by the font designer; the faux ones simply darken or slant the text.) You also can add an underline or strikethrough using the two icons to the right of the bold and italic faux style icons. And, yes, you can adjust these properties of your text after you create it as well.

Figure 8-3: Set the font, size, and style through these controls.

8. Turn on the Anti-aliased feature, labeled in Figure 8-3.

Anti-aliasing smooths the jagged edges that can occur when you create objects that have diagonal or curved lines in a photo program. Unless you're going for that jagged look for some reason, turn on the Anti-aliased option.

9. Type your text.

The standard rules of computer-typing apply:

- To create a line break, press Enter.

- In a text box, press Tab to indent the line. (You don't get any control over the position of the indent, however.)

- To delete a word, drag over it to highlight it and then press Delete. You can also delete characters by using the Delete and Backspace keys just as you do in a word processor. (Some Mac keyboards don't have a Backspace key, however.)

10. **Adjust the text alignment, line spacing, and position if needed.**

Use these techniques:

- *Alignment:* For type inside a text box, use the Alignment controls labeled in Figure 8-4 to align the text with respect to the margins of the box. Note that if you pressed Enter to create line breaks within your text, you must align each line of type separately. Click inside the line and then click an alignment option to do so.

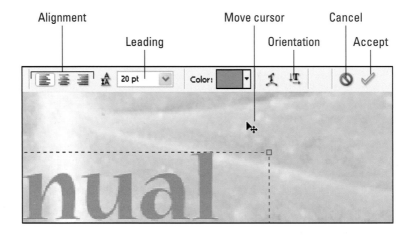

Figure 8-4: Use the Leading option to adjust the spacing between lines.

- *Line spacing (leading):* To adjust spacing between lines, select the text and then select a value from the Leading control, labeled in Figure 8-4. If you select Auto, the program sets the leading (line spacing) it deems appropriate for the current type size.

- *Orientation:* To change horizontal type to vertical and vice versa, click the orientation icon, labeled in the figure. This feature works best on single lines of type; if you swap the orientation of a text box, the type is likely to get jumbled.

- *Position:* To relocate the text, move your cursor outside the text box or, if you clicked to create a single line of text, away from that line until the cursor changes into the Move cursor, as shown in Figure 8-4. Then you can drag the text to a new position. For more ways to reposition text, see the next section.

11. **When you finish typing, click the green Accept check mark on the options bar.**

I labeled the check mark in Figure 8-4. If you instead want to escape out of the text-creating process, click the Cancel button.

Notice that as soon as you start to create text, Elements creates a new layer to hold your words. After you click the Accept check mark in Step 11, the layer name changes to reflect the first few words in the text, as shown in Figure 8-5. If you create additional text, you get another text layer.

Editing text

You alter existing text in Elements differently depending on whether you want to change all the text or just selected letters. By "all" the text, I mean everything that's on the current text layer.

Either way, your first step is to click the text layer in the Layers palette. Then use these editing techniques:

Type layer

Figure 8-5: Elements creates a new layer each time you create text.

 ✓ **Change the formatting of an entire text layer:** Select the Type tool but don't click with the tool. As soon as you select the tool, the options bar changes to give you the controls shown in Figure 8-6. Any settings you select from those controls affect the entire text layer. In addition to the standard formatting options (font, size, and so on), you get a new control, Style, near the right end of the options bar. This control is your ticket to special effects; see the upcoming section, "Creating text effects," for details.

 Enlarging characters on a text layer doesn't damage picture quality, by the way. To find out why, see the upcoming sidebar "Pixels versus vectors, and why you should care."

 ✓ **Move all text on the current layer:** Select the Move tool, labeled in Figure 8-7, and then use the techniques discussed in Chapter 7 to relocate the text. With respect to the Move tool, a text layer operates like any other image layer.

 ✓ **Remove a text layer:** Drag the layer to the Trash icon in the Layers palette. Again, see Chapter 7 for details on this layer operation.

 ✓ **Alter only selected words or characters:** Select the Horizontal or Vertical Type tool (depending on which one you used to create the text) and click in the line or text box that you want to edit. Then select the characters that you want to change by dragging over them. A highlight appears over the selected text, as shown in Figure 8-7.

Trash icon

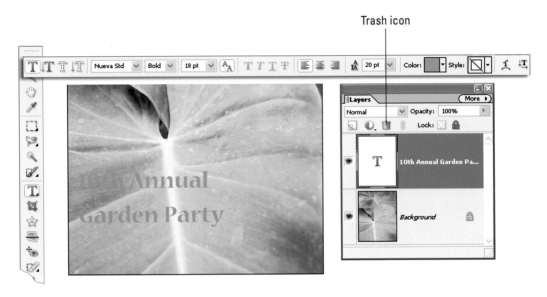

Figure 8-6: To change the formatting of a type layer, select the Text tool but don't click with it.

Move tool

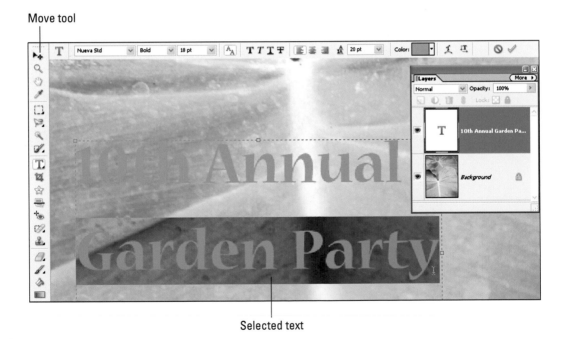

Selected text

Figure 8-7: Drag with the Type tool to highlight and select individual words or characters.

When you release the mouse button, the options bar shows you the same controls you get when first creating text (see Figure 8-2). You then can alter the formatting of just the selected text. Click the green Accept check mark on the options bar to apply the changes.

You can't add special effects via the Style control shown in Figure 8-5 to just a portion of a text layer. If you want different effects for different words, create the words separately so that they wind up on individual layers.

Bending, distorting, and rotating text

You don't have to stick with plain ol' horizontal or vertical text; you can bend, distort, and rotate your words to suit your photo, as I did in Figure 8-8.

You can use a few different controls to manipulate your type in this way:

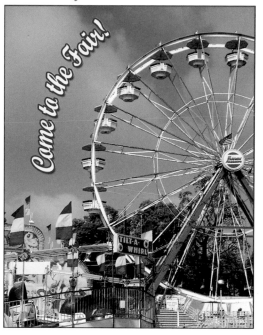

Figure 8-8: After bending the text, I rotated it to follow the curve of the Ferris wheel.

- ✒ **Rotate text:** Click the text layer in the Layers palette and then choose any of the commands in the middle of the Image⇨Rotate submenu. (Be sure to choose a command that has the word *layer* in its name.) For details on the Free Rotate command, see Chapter 7.

- ✒ **Bend and warp text:** Click the text layer in the Layers palette, select the Horizontal or Vertical Type tool, and then click the Warp Text button on the options bar, labeled in Figure 8-9. You then see the Warp Text dialog box, also shown in the figure. Select a basic warp shape from the Style drop-down list and then drag the sliders to customize the effect. Note that you can't warp just selected characters in a text box or line.

Warp Text icon

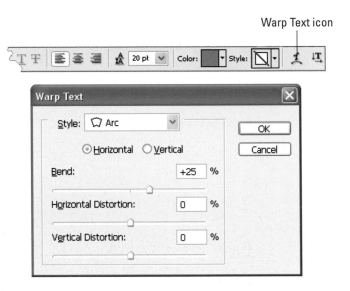

Figure 8-9: To create curved or wavy type, use the Warp Text control.

Creating text effects

In Elements, you can create a virtually endless variety of text effects via the Style control on the options bar. I used this feature to create the effects shown in Figures 8-1 and 8-8.

Note, though, that you can apply effects only to all characters on a text layer. So if you want to give different looks to different words, create each text object separately. Also, the effects aren't available until after you create your text as spelled out in the earlier section, "Creating basic text."

Here's how to explore and apply the available effects:

1. **In the Layers palette, select the text layer by clicking it.**

2. **Select a Type tool but don't click in your image.**

 You then see the options bar controls shown earlier in Figure 8-5. The Style control, featured in Figure 8-10, resides at the far right end of the options bar.

3. **Click the Style button to open a palette that shows thumbnails of available effects, as shown in Figure 8-10.**

Figure 8-10: Access text effects via the Style control on the options bar.

4. **Click the arrowhead labeled in Figure 8-10 to display a palette menu and choose a category of effects.**

 After you select a category, the thumbnails in the palette update to show you the available effects.

5. **Click the thumbnail of the effect you want to apply.**

 If you don't like the result, choose Edit➪Undo. Or move on to Step 6 to find out how to modify the effect.

6. **To modify an effect, double-click the Effects icon in the Layers palette.**

 The Effects icon in Elements 5.0, labeled in Figure 8-11, appears as soon as you apply an effect from the Style palette. In version 4.0, the icon looks like the letters *fx* (for *effects*). When you double-click the icon, you see a box that enables you to adjust various characteristics of the effect, as shown in Figure 8-11. (The available controls depend on the initial effect, and again, the dialog box design is slightly different in Elements 4.0 than what you see in the figure.) Click OK to close the dialog box when you're happy with the result.

Effects icon

Figure 8-11: Double-click the Effects icon to tweak the text effect's properties.

If you later decide to remove all effects from a text layer, open the Style palette menu as indicated in Figure 8-10 and then choose Remove Style.

Preserving text

If you choose certain commands or try to use certain tools on a type layer, Elements may ask permission to simplify the layer. This converts your text from a vector object to a pixel-based object, the ramifications of which are spelled out in the sidebar titled "Vectors versus pixels, and why you should care." Be sure that you're really ready to make the shift to the pixel lane before you take that step.

Additionally, when you save your photo, be sure to use either the TIFF or PSD file format and enable the Layers option in the Save As dialog box. Otherwise, not only do your vectors turn into pixels, the type pixels and image pixels are forever fused.

Vectors versus pixels, and why you should care

Digital art comes in two forms: *vector-based objects* and *raster objects*. A vector object is made up of lines and curves that can be defined by mathematical equations. Raster objects are created out of pixels, those square tiles that make up your digital photos.

The most important point to remember about these two digital life forms is that you can enlarge vector objects indefinitely with no reduction in picture quality. Enlarging a photo or other pixel-based being degrades the image, as illustrated in Chapter 2.

I bring up this tedious technical fact because most photo-editing programs actually incorporate both types of graphics. Photographs, of course, are pixel-based. But most Text tools and Shape tools (used for creating simple shapes) typically create vector objects. Clip-art embellishments usually are vector based as well.

The two types of objects, however, exist together only inside your photo program and only if you save your file in the program's own format (PSD, in Elements). Some programs also offer a special flavor of the TIFF format that can retain both vectors and pixels independently. Either way, you must also turn on the file-saving option that retains image layers. If you save in another format or without enabling layers, not only do vectors become pixels, but all the image layers are fused together.

In some programs, including Elements, you can also convert vector objects into pixel objects by choosing Layer➪Simplify Layer. Why would you do so? Because some Elements editing commands aren't available for vector objects. The downside of simplifying vector objects is that you can no longer adjust their color, shape, and so on as easily as you can when they're in the vector state.

Casting Shadows

When you layer images, as I did with the two-photo pumpkin composition in Figure 8-12, adding a shadow behind the top photo can help set it apart from its background.

Most photo programs offer a shadow special effect, making this an easy enhancement to apply. In Elements, take these steps to cast a shadow behind the contents of an image layer:

1. **Display the Layers palette and the Artwork and Effects palette.**

 In Elements 4.0, the second palette is named Styles and Effects. In either version, you access the palettes via the Window menu.

2. **In the Layers palette, click the layer to which you want to add the shadow.**

You must apply the shadow to the entire layer; you can't cast a shadow behind only selected areas on a layer.

3. **In the Artwork and Effects palette, click the Special Effects icon, labeled in Figure 8-12.**

 In Elements 4.0, you can skip this step.

4. **Select Layer Styles and Drop Shadows from the drop-down lists in the palette, as shown in the figure.**

 The palette then displays icons representing several styles of drop shadows.

5. **Click one of the shadow icons and then click the Apply button at the bottom of the palette.**

 Select the shadow icon that looks closest to the effect that you want to create; you can fine-tune the result later. As soon as you choose an icon, the shadow appears in the image.

6. **To adjust the shadow effect, double-click the Effects icon in the Layers palette.**

 The icon appears to the right of the layer name.

Special Effects icon

Figure 8-12: Adding a shadow behind the jack-o'-lantern makes it appear to float above the background.

In Elements 4.0, choose Layer⇨Layer Style⇨Clear Layer Style. Note that the command removes all styles currently applied to the layer; you can't remove individual styles in Elements 4.0.

Adding a Border

To add a solid-colored border around a picture, as shown in Figure 8-13, follow these steps:

Figure 8-13: Use the Stroke command to add a border inside the existing image boundaries.

1. **Select the entire photo by choosing Select⇨All.**

2. **Choose Edit⇨Stroke (Outline) Selection to display the dialog box shown in Figure 8-13.**

3. **Enter the border size in the Width box.**

 Be sure to include the unit of measurement — pixels, inches, whatever — as shown in the figure.

4. **Click the Color box to open the Color Picker and set the border color.**

 Chapter 7 provides details about the Color Picker if you need help.

5. **Select the Inside option in the Location area of the dialog box.**

 You can *stroke a selection* — that is, paint a solid line along the selection outline — in three ways in Elements. You can put the line entirely inside the outline, center it on the outline, or position it outside the outline. But the Center and Outside options work only if you select just a portion of your photo in Step 1. When you select the entire image, there's nowhere for Elements to put the border pixels except inside the selection outline. If you select Center, you simply get a border that's half as thick as you specify in the Width box.

6. **Set the Blending Mode control to Normal and the Opacity value to 100%.**

 These are the default values, so you're probably already good to go.

7. **Click OK to close the dialog box and apply the border.**

8. **Choose Select⇨Deselect to get rid of your selection outline.**

If you want to add a border *outside* your existing image area, follow the Chapter 7 instructions for increasing the image canvas size. When you enlarge the canvas, set the canvas extension color to the color of the border you want to create. Remember, though, that this technique enlarges the overall dimensions of your image. In this case, the enlargement doesn't affect your photo quality because you're not altering the photo itself, just adding some solid-colored pixels.

Here's one more tip about borders: For extra flexibility, you can create a new layer before you take Step 1. Putting your border on a separate layer enables you to more easily adjust the border down the road. You can change its color by applying the Hue/Saturation filter (see Chapter 7 for how-to's). You also can apply special effects to create faux frames such as the one featured later in this chapter, in Figure 8-16.

Creating a Vignette Effect

Many consumer-level photo programs offer a special effect that creates the "fading frame" look you see in Figure 8-14 — known as a *vignette,* in official photo lingo. But because the available vignette effects can be limiting in terms of the softness of the frame edge or the size of the frame opening, the following steps show you how to create your own custom vignette frames. All you need is a rectangular or oval selection tool that offers the option of creating a *feathered* (or fading) selection outline, which is found in most photo programs.

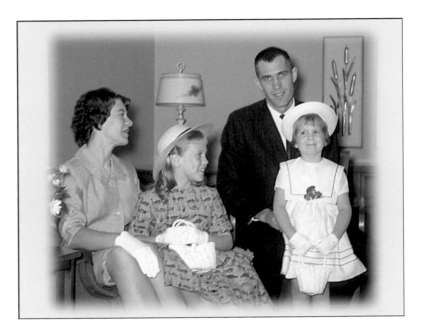

Figure 8-14: This soft vignette effect takes only seconds to create.

Here's how I create this effect in Elements:

1. **Create a new image that is either larger than or the same size as your photo.**

 Use the File⇨New⇨Blank File command, which I detail in Chapter 7. Set the Resolution (ppi) option in the New dialog box to match that of your photo. Set the photo dimensions to the final print or display size you have in mind and set the Background Contents option to white.

2. **Open your photo and then copy and paste it into the new image.**

 Again, Chapter 7 spells out how to complete this step. But here's the quickest option: Select the Move tool and then drag the photo into the new image.

 If you open the Layers palette (Window⇨Layers), you should see that your photo now rests on its own layer atop the white Background layer of the new image. You can close the original photo image if you want.

3. **Select the Rectangular Marquee or Elliptical Marquee tool from the toolbox.**

 These two tools share a slot near the top of the toolbox, labeled in Figure 8-15. Choose the Rectangular Marquee tool if you want a rectangular or square vignetted frame like the one in my example image; choose the Elliptical Marquee for an oval or circular frame.

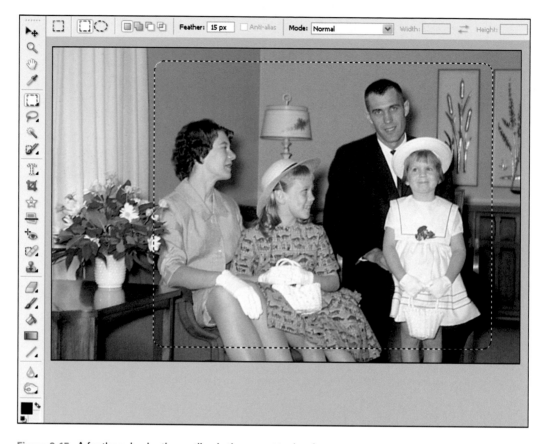

Figure 8-15: A feathered selection outline is the secret to the vignette treatment.

4. On the options bar, set the Mode to Normal and be sure that the New Selection icon is selected, as shown in Figure 8-15.

Or, if you want to create a circular or square frame, set the Mode control to Fixed Aspect Ratio and enter **1** into both the Width and Height boxes. (The boxes become available after you change the Mode setting.)

5. Enter a Feather value other than 0.

The higher the value, the more gradually the vignette effect will fade at the edges and the more the effect will eat away the perimeter of the photo. Usually, a value between about 5 and 20 works well, depending on the size of your photo. Finding the right value takes some experimentation, so just enter a guesstimate for now.

For more information about feathering and other Marquee tool options, watch the QuickTime movie titled "Selection Basics," found on the DVD included with this book.

6. **If you're using the Elliptical Marquee, enable the Anti-alias feature on the options bar.**

 This option smooths any jagged edges that can otherwise occur around the edges of the selection outline that you're about to create.

7. **Drag to create a selection outline around the portion of the photo that you want to frame.**

 When you release your mouse button, the dotted outline represents your selection outline, as shown in Figure 8-15. The outline isn't accurate in terms of how much feathering will result, however, so don't pay any attention to that aspect of the outline.

 If you don't get the outline just right, either start over and try again or use these tricks to refine the outline:

 - *Move the outline.* Put your cursor inside the outline and drag. Or press the arrow keys on your keyboard to nudge the outline into place.

 - *Enlarge the outline.* Choose Select⇨Modify⇨Expand and then specify how many pixels you want to add to the outline in the resulting dialog box.

 - *Shrink the outline.* Choose Select⇨Modify⇨Contract and specify how much you want to reduce the outline size, in pixels.

8. **Choose Select⇨Inverse to reverse the selection outline.**

 This command swaps the selection outline so that whatever was previously selected becomes *not* selected, and vice versa. So your photo background is now selected instead of the photo area that you want to keep.

 Why not just select the background in the first place? Because no selection tool automatically creates an outline in the shape needed for this project — the space outside the rectangular or elliptical area of the picture. When approaching selecting, always select the area that's easiest to tackle first, knowing that you can inverse the resulting outline if needed.

9. **Press Delete to erase the selected background area.**

 The remaining photo area now fades out according to the shape of the outline that you created.

 If the edges of the vignette aren't to your liking, choose Edit⇨Undo and try again using a different Feathering value.

10. **If desired, fill the Background layer with color or a pattern.**

 Ah, now it may become clear to you why I suggest the two-layer approach to this effect. Because your photo floats above the Background layer, you're free to fill that Background layer with a solid color, texture, or anything else that comes to mind. I filled the layer with a soft yellow to produce the image in Figure 8-14. Chapter 7 provides details on this step. See the sections related to filling the image canvas.

11. **When you're happy with the effect, merge the photo and background layer by choosing Layer⇨Flatten Layers.**

 Don't take this step if you think you may want to alter the background later. After you merge the two layers, you can't easily change the color or texture of the background.

Placing a Photo in a Digital Frame

By combining the border technique explored earlier with some techniques covered in Chapter 7, you can create a faux matte and frame effect like the one shown in Figure 8-16. This effect is a great solution if you need a print that has proportions different from those of your photo. For example, suppose that you cropped a photo to a size of 4 x 4 inches. But you want to frame the picture in a standard, 11 x 14-inch frame, behind a matte that has an 8 x 10-inch opening for a photo. You can surround your image with a "digital matte" to fill out the rest of that 8 x 10-inch opening.

Figure 8-16: Adding the digital matte around the photo enabled me to put the picture in a standard rectangular frame.

The following steps show you how to create the effect shown in the figure. After you build this matte, you can use the same basic recipe to create countless variations on the idea.

1. **Create a new canvas by choosing File⇨New⇨Blank File.**

 Set the canvas size to match the final print dimensions and resolution (ppi) you have in mind. Chapter 7 has details if you need help.

2. **Fill the canvas with color and texture as explained in Chapter 7.**

 Keep the texture and color subtle, so that they don't visually overwhelm the photo.

3. **Copy and paste your photo into the new canvas.**

 Again, Chapter 7 explains this process, but here's a quick recap: Just open the photo and then use the Move tool to drag it into the new canvas.

4. **Open the Layers palette and create a new image layer above the photo layer.**

 To do so, first make sure that the photo layer is highlighted in the palette. (If not, click the layer name.) Then click the New Layer icon, labeled in Figure 8-17.

 The new layer will hold the frame effect that you're about to create.

New Layer icon

Figure 8-17: After creating a border on the top layer, I applied a special effect to create the illusion of a metal frame.

5. **Hold down Ctrl (Windows) or ⌘ (Mac) as you click the thumbnail that represents your photo layer in the Layers palette.**

 This trick creates a selection outline that encompasses the contents of the photo layer — which becomes the basis for your border in the next step. Note that you aren't selecting the photo layer itself; you're simply creating a selection outline based on that layer's contents. The new layer you created in Step 4 is still the active layer, or should be. If that layer isn't highlighted in the palette, click it in the palette.

6. **Choose Edit⇨Stroke (Outline) Selection and add a simple border.**

 See the earlier section, "Adding a Border," for details about the options inside the Stroke dialog box that appears. Set the border size to match the thickness of the frame you want to create. In this case, you can position the border inside, outside, or centered on your selection outline, so choose which option works best for your photo.

7. **Choose Select⇨Deselect to get rid of the selection outline.**

8. **Decorate the border with a special effect.**

 In Elements 5.0, choose Window⇨Artwork and Effects to display the palette shown on the right in Figure 8-17. Click the Special Effects icon at the top of the palette (it's just to the left of the T icon). In Elements 4.0, choose Window⇨Styles and Effects to display a similar palette.

 In both versions, select Layer Styles from the left drop-down list, select an effects category from the right drop-down list, and then click one of the specific effects icons that appear. Click the Apply button to add the effect to the border. I selected an effect from the Wow Chrome category to create the frame effect you see in Figure 8-16.

 If you don't like the results of the effect, choose Edit⇨Undo and try again. Or tweak the effect as explained in Step 8.

9. **To adjust the effect, double-click the Effects icon for the border layer in the Layers palette.**

 The icon appears to the left of the layer name in the palette. You also can choose Layer⇨Layer Style⇨Style Settings. This opens the Style Settings dialog box, where you can control many different characteristics of the effect. Click OK to close the dialog box after you're satisfied with your creation.

10. **Save the image in the PSD (Photoshop) or TIFF format, with the Layers box enabled.**

 This step preserves your image with independent layers so that you can easily change the matte color and texture as well as the frame effect at any time. If you need a *flattened* image — that is, one with all the layers merged together — either disable the Layers box or save in a format that doesn't support layers, such as JPEG. But save this flattened image under a different name so that you don't overwrite your original, layered version.

Creating Black-and-White Photos

Converting a color photo to black and white can dramatically change the impact of the subject. Consider the color portrait in Figure 8-18, for example. It's nice enough, but the blue background really draws the eye away from the model, who should be the primary point of interest. Removing the color diminishes the prominence of the background and redirects the eye to the subject's face.

Before I show you how to make this conversion, I need to point out one bit of imaging terminology: Technically speaking, what most people refer to as a black-and-white photo is called a *grayscale* image in the world of digital imaging. A true black-and-white image can contain only black and white, with no shades of gray.

In addition, you need to know about an official color mode called the Grayscale mode. This type of image can contain just 256 colors — black, white, and shades of gray in between. But in Elements and in many other programs, you can suck the color out of a photo — *desaturate the image,* in other words — but leave the picture in the RGB, or full color mode. (Remember, RGB stands for red-green-blue, the primary colors in a digital image.)

Figure 8-18: Converting the color image to grayscale restores emphasis to the subject's face.

This distinction is important for two reasons:

- If you're asked to submit a black-and-white photo to a publication, you most likely need to send the image in the official Grayscale mode. (Ask the publication designer for guidance.)

- If you leave the picture in the RGB mode, you can add new color elements to the photo. For example, you can add red text on top of your black-and-white photo, or you can paint with color atop the image to create the look of a hand-tinted image.

With those bits of business out of the way, use these techniques to convert your image:

- **To convert the photo to grayscale but keep it in the RGB color mode:** The fastest option is to choose Enhance⇨Adjust Color⇨ Remove Color. But this command doesn't give you any input into how the conversion is made. So in version 5.0, Elements also provides the Enhance⇨Convert to Black and White command, which provides you with the more sophisticated conversion controls shown in Figure 8-19. Start by selecting a basic photo type from the Select a Style list. Then fine tune the results by clicking the thumbnails to the right. Drag the Adjustment Intensity slider to control how much change you get from each click of a thumbnail.

If you have trouble getting the look you want, remember that you can always apply the Levels filter to tweak image brightness and contrast after you make the conversion. In fact, you're probably better off adjusting contrast with that filter than with the contrast controls provided with the Convert to Black and White dialog box. Chapter 4 covers the Levels filter.

- **To convert to the Grayscale color mode:** Choose Image⇨Mode⇨ Grayscale. Elements may ask permission to dump the image colors; click OK to proceed. If you later change your mind and want to add colored text or some other color element to the photo, just choose Image⇨Mode⇨RGB Color. Doing so *does not* bring back your original image colors; it simply allows you to add new colors.

Always save your converted image under a new name from the original in case you ever need the full-color version again.

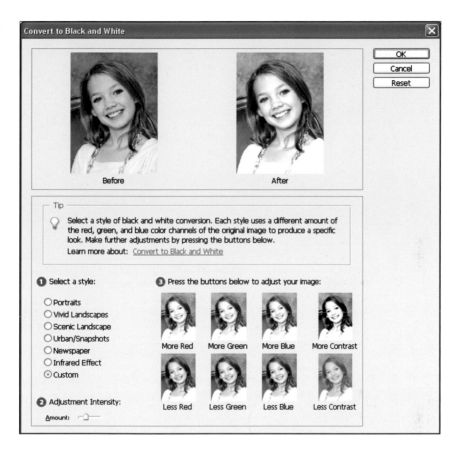

Figure 8-19: Elements 5 offers a new tool that offers more control over color to grayscale conversions.

Creating a Sepia-Toned Image

A so-called *sepia tone* (tint) such as the one you see in Figure 8-20 is another nice portrait effect. You can easily go from a full-color original to this result in Elements; the secret lies in the Hue/Saturation dialog box, also shown in the figure.

To access the dialog box, choose Enhance⇨Adjust Color⇨Adjust Hue/ Saturation. Inside the dialog box, select the Colorize box. After you do so, your original colors disappear, and you get a tinted image. Drag the Hue slider to adjust the tint color; use the Saturation slider to adjust the intensity of the tint. If you need to adjust overall image brightness and contrast, however, I suggest that you bypass the Lightness slider in this dialog box and instead work with the exposure filters covered in Chapter 4.

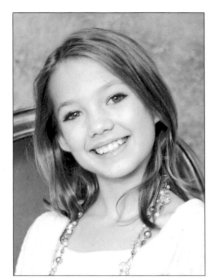

Figure 8-20: Enable the Colorize box and then drag the Hue slider to adjust the tint color.

Note that this technique works only on images that are in the RGB color mode. If your image is in the Grayscale color mode, choose Image⇨Mode⇨RGB to send the photo to the RGB color planet. (See the preceding section for an explanation of the Grayscale mode.) You then can create your tint by using the Hue/Saturation filter.

Playing with Artistic Effects

Without a doubt, the most entertaining (and addictive) way to spend time with your digital photos is to play with the special effects filters offered by most photo-editing programs. With just a click or two, you can make your photo look as though it was created with watercolors, pastels, or about any other traditional art media you can imagine. You also can add wacky special effects that have no real-life equivalents.

As fun as they are, however, special effects also have a practical use. If your photo suffers from irreparable focus problems or other serious issues, a special effects filter can disguise the defects. The example in Figure 8-21 is a case in point. Despite my best efforts, the retouched scan (left) of an old color slide remains pretty softly focused. In addition, the image is a little grainy — the original slide was very dark, and brightening it brought forth that unfortunate side effect — and the background isn't what you would call exactly appealing. Applying a watercolor effects filter softened the background elements, and

the grain and focus problems are hidden by the "brushstrokes" of the paint. This, in the computer biz, is called "turning a bug into a feature."

Figure 8-21: Adding a watercolor filter to this photo gave it a softer, more artistic look.

Every photo program that I've seen offers a good selection of artistic filters, so check the Help system or manual to find out how to access them. In Elements, you select the effects filters from the Filter menu. After you choose an effect, you see the dialog box shown in Figure 8-22, where you can adjust various aspects of your selected effect. You can monitor your changes in the preview pane on the left side of the dialog box; use the controls at the bottom of the preview to zoom and scroll the display. If you don't like the effect, just choose a different one from the pane in the middle of the dialog box.

For even greater creative control, apply the effects filter to a duplicate of your original Background layer. Open the Layers palette and then drag the Background layer to the New Layer icon (refer to Figure 8-17). Apply the effect to the duplicate layer. Then you can adjust the impact of the effect by changing the Opacity value for the layer in the Layers palette. You also can mix the filtered layer with the original layer in new ways by playing with the layer blending mode in the palette. (The Blending Mode control is the drop-down list to the left of the Opacity control.)

Figure 8-22: You can experiment with different effects inside the Filter Gallery dialog box.

Part IV
The Part of Tens

The 5th Wave By Rich Tennant

"Try putting a person in the photo with the product you're trying to sell. We generated a lot of interest in our eBay listing once Leo started modeling my hats and scarves."

*I*n keeping with the popular *For Dummies* tradition, chapters in this part of the book are short and sweet, offering ten brief nuggets of information.

Chapter 9 provides you with recipes for ten more photo projects, including some that come in handy for business purposes and others that are just for fun. Chapter 10 gives you easy-to-implement suggestions for improving your digital photos — because after all, whatever projects you have in mind, great results start with good pictures.

9

Ten More Projects for Home and Office

*T*hink of this chapter as one of those boxes of assorted candies, only it's serving up creative treats instead of third-rate chocolates filled with unidentifiable jellies and crèmes. The ten projects herein offer a sampling of the many ways you can incorporate digital photography into your home and work life.

If you let your imagination wander as you explore this chapter, you're sure to think of dozens of ways that you can customize these basic recipes. For example, the first two projects show you how to create business documents that contain digital photos, but you follow the same approach to create bake-sale flyers, posters, or annual holiday letters. Another project explains how to use panoramic photography techniques to capture a subject that's too large to fit

in a single frame. The example image is of a house, but the process works just as well for capturing an awesome landscape, a row of classic cars at an auto show, or a large office complex.

Unlike a box of chocolates, this goodie tray is a no-risk proposition, too. If you bite into a project that's not to your taste, you don't need to pretend that it's delicious or hide the half-eaten candy under your napkin. Just choose the Undo command, close your image, and move on to something else.

Create a Photo Business Card

Help potential clients put a face with a name by adding your picture to your business card, as shown in Figure 9-1. You can take your finished design to any quick-print shop for reproduction on business-card paper stock.

Jonathan Doe Consulting

Jonathan Doe

(317) 555-1000

JDoe@ConsultMePlease.net

555 Old Town Drive Indianapolis, IN 46200

Figure 9-1: Adding a photo to your business card makes it easier for people to remember you.

I created the card in Figure 9-1 in Photoshop Elements, but the basic steps are the same in any photo program:

1. **Create a new image file and set the image dimensions to business-card size (2 x 3.5 inches is standard).**

In Elements, choose File➪New➪Blank File. Set the Width and Height values to 2 x 3.5 inches or vice versa, depending on how you want to orient the card. Set the image resolution to 300 ppi and set the Background Contents option to white. (Chapter 7 provides details about the Blank File command; see the section about creating an image canvas.)

2. **Open your photo and crop and retouch it as needed.**

3. **Copy the photo into the new image you created in Step 1.**

 If you place the two image windows side by side, you can use the Move tool to drag the photo into the blank image. (Again, Chapter 7 shows you how.)

4. **Follow the instructions in Chapter 8 to add the text to the card.**

 It's best to create each line of text separately rather than putting it all in a single text box. Having single lines makes positioning the text elements easier.

5. **Use the Shape tools to add lines, boxes, or bullets.**

 The Shape tools share a flyout menu near the bottom of the toolbox, as shown in Figure 9-2. I used the Line tool to add the horizontal rule (line) to the business card. You simply drag with the tool to create the shape, setting the shape formatting with the controls on the options bar. (For bullets, try using the Ellipse tool.)

 Shapes appear on their own layers and work similarly to text layers, explained in Chapter 8. You can find specifics in the Elements Help system. (Choose Help➪Photoshop Elements Help.)

6. **When you're finished with the card, choose File➪Save As and save a layered version of your file.**

 You must select either the PSD or TIFF format and enable the Layers check box in the Save As dialog box. By retaining your individual layers, you can easily alter the text or replace the photo in the future if needed.

 Chapter 3 discusses these and other details of saving files.

7. **Create a single-layer version of the file to take to the copy shop for reproduction.**

 With the original file open, choose File➪Save As. Give the file a new name and then save it in the TIFF format with the Layers option *disabled*. This creates a flattened (single-layer) copy of the image file that you can take to your quick-print shop for reproduction. (Check with the shop first to find out about any special file-prep requirements.)

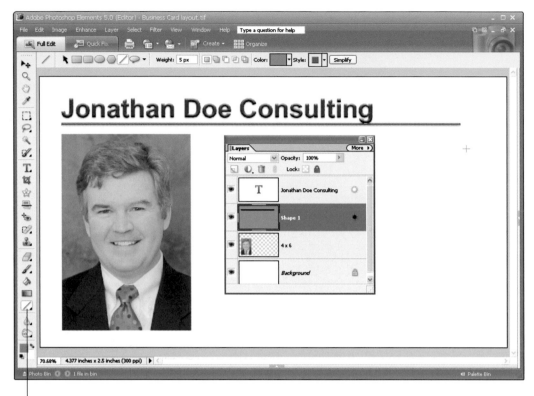

Shape tools

Figure 9-2: Use the Shape tools to create rules and bullets.

Add Pictures to a Text Document

Chapter 8 shows you how to add captions and other bits of text to an image in Photoshop Elements. But the text tools found in Elements and other photo-editing programs aren't very sophisticated, so if your project calls for more than a line or two of type, you're better off creating it in a word-processing program such as Microsoft Word or Corel WordPerfect. After you enter and edit your text, you can then add a photo to the page, as I did for my profes-sional bio, a portion of which appears in Figure 9-3.

Picture toolbar

Figure 9-3: You can insert digital photos into any text document.

The following steps show you how to insert a picture into a Microsoft Word document. Note that as I write this, Microsoft is introducing a new version of the program (Word 2007). The basic steps for inserting pictures are the same, but the way you access the controls varies. The figures and steps here relate to earlier versions of Word, but I added notes within the steps to point you in the right direction if you use the new version. If you use some other word processing program, the basic process is the same, too, but check your software's Help system for specific command names and formatting options.

1. **In your document, click the spot where you want to insert the picture.**

2. **Choose Insert⇨Picture⇨From File.**

 In Word 2007, click the Insert tab and then click the Picture icon. Either way, you then see a variation of the standard file-opening dialog box.

3. **Locate and select the picture you want to use and then click Insert.**

 Your picture appears in your document.

4. Click the picture to select it and then choose Format⇨Picture to set the initial formatting options for the picture.

You see the Format Picture dialog box, shown in Figure 9-4.

You can skip this step in Word 2007; the Format tab should pop into view as soon as you insert your picture. (If not, click the tab.) All the options for formatting your picture appear on the tab, so you can skip Steps 5 and 6 also.

5. Click the Layout tab and set the Wrapping Style option.

This setting determines *text wrapping,* which affects how the program positions your photo with respect to the text.

Figure 9-4: Options on the Layout tab control how text flows around the picture.

6. Visit the other tabs of the dialog box to continue formatting your text and then click OK to close the dialog box.

In addition to formatting text through the dialog box, you can click the picture to display little boxes around its perimeter, as shown earlier around the picture in Figure 9-3. Your picture is now selected, and you can manipulate it as follows:

- To move the picture, click and drag it.
- To resize the photo, drag a corner handle. Remember that enlarging the photo significantly can reduce image quality.

In Word 2007, other controls for adjusting your picture appear on the Format tab. In earlier versions, you can access other controls via the Picture toolbar, labeled in Figure 9-3. To display the toolbar, choose View⇨Toolbars⇨Picture. For details on the toolbar controls as well as other aspects of working with graphics in Microsoft Word, check the program's Help system.

These same steps work for adding pictures to documents that you create in other Microsoft Office programs, including Excel and PowerPoint.

Turn a Portrait into a Coloring Book Page

Here's a fun project to do with children: Photograph your subject against a white backdrop, as shown in the left image in Figure 9-5. Then turn the photo into a coloring book page by applying a special-effects filter in your photo editor, as shown on the right.

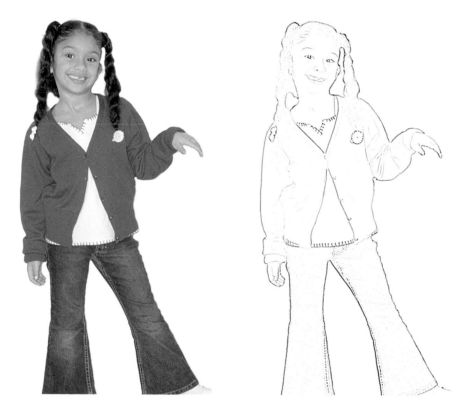

Figure 9-5: You can create a personalized coloring book page by applying a special-effects filter.

To create the effect in Elements, follow these steps:

1. **Press D to set the foreground paint color to black.**

 The *D* stands for *default* colors — black for the foreground paint color and white for the background paint color.

2. **Choose Filter⇨Sketch⇨Photocopy.**

 The dialog box shown in Figure 9-6 appears.

3. **Adjust the sliders on the right side of the dialog box to produce an outline effect you like. Then click OK to close the dialog box.**

4. **If needed, use the Eraser tool to clean up the image.**

 When used on the Background layer, the Eraser tool applies the background paint color, which you set to white in Step 1. On the options bar, set the tool mode to Brush and the Opacity to 100% and then drag to erase any lines that you don't want in your coloring-book image.

 If a large portion of the background needs help, select it by using the selection tools, introduced in Chapter 4. Then just press Delete to make the selected area white.

5. **Print the image on white paper.**

 See Chapter 3 to find out how to establish the print size and resolution before you print.

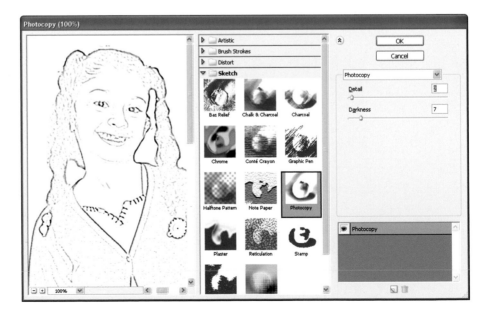

Figure 9-6: The Photocopy filter creates a black-and-white outline of your image.

As a variation on the theme, you can create a watercolor page by printing the image on watercolor paper, assuming that you own an inkjet printer that can accept such specialty papers.

Shoot and Stitch a Panoramic Image

Can't get your entire subject to fit in the frame, even if you use your camera's widest-angle setting? Record the scene in pieces and then stitch them together in your photo editor to create a panoramic image. For example, because of the location of the house shown in Figure 9-7, I wasn't able to move far enough away to capture it all in one shot. So I shot two images, capturing different portions of the house, and then fused the images into the panoramic version shown in Figure 9-8.

Figure 9-7: Frame the segments of your panorama so that they overlap by at least 30%.

Figure 9-8: The stitched panorama appears to be a single image.

Most photo programs offer a tool that automates the process of stitching multiple photos into a panorama. In Elements, just open the photos that you want to seam and then choose File⇨New⇨Photomerge Panorama. You then see a dialog box that contains a preview of the stitched image, as shown in Figure 9-9. You can use the dialog box controls to tweak the stitching job if needed.

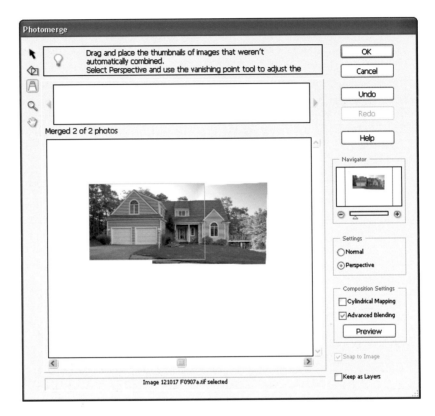

Figure 9-9: A panorama-stitcher simplifies the job of seaming multiple images.

For the most part, automated panorama stitching programs work very well and are easy to use *if* — and this is a big *if* — you shoot your original pictures correctly. Follow these guidelines:

✓ **Maintain the correct axis of rotation as you pan the camera.** When you pan (rotate) the camera to shoot each piece of the panorama, keep the optical center of the lens on the same axis of rotation, as shown in the

left illustration in Figure 9-10. Contrary to what you may expect, putting the camera on a tripod isn't a good solution. The center stem of the tripod then becomes the axis of rotation, and when you mount most cameras on a tripod, the lens is positioned in front of that axis of rotation, as shown in the right illustration in the figure.

You can buy fancy (and expensive) panoramic tripod heads that solve this problem, but an easier option is just to align the lens visually with some stationary point. For example, have a friend hold up a finger and align the lens so that it is directly above that finger for each shot. Or place a quarter or some other small marker on the ground and use that as your axis reference marker.

Note that although this trick should alleviate major stitching problems, it's still pretty crude. The steps involved in precise positioning are too complex to cover here, but you can find good tutorials online if you're interested. Just use Google or your favorite Web search tool to look for sites that discuss *panorama nodal points*.

✔ **Keep the camera on the same level for each shot.** If you're shooting a landscape, for example, make sure that the horizon line appears at the same position in each frame.

Figure 9-10: Keep the lens centered on the same axis of rotation for each shot.

- **Maintain the same focus distance, aperture, and exposure for each frame.** Otherwise, visible breaks may appear in your stitched photo due to shifts in depth of field (zone of sharp focus) and changes in the brightness of areas found in both frames — the sky, for example. This shooting dilemma is tricky if you shoot in fully automatic mode because the camera may choose different focus points, f-stops, and exposure settings for each frame, especially if one part of the scene is brightly lit and another is in the shadows. If possible, switch to manual mode so that you can use the same settings for every frame. Some cameras also offer a feature that enables you to lock in a particular autoexposure setting.

 As a workaround for getting the job done in automatic mode, pick one object that is of average brightness and distance and set the focus and exposure on that same area for each frame. Remember, you can lock in focus and exposure in auto mode by pressing and holding the shutter button halfway down. While continuing to hold the button halfway, reframe the picture to take the shot.

- **Overlap each shot by at least 30 percent.** For example, in my panorama, both original images include the front porch area and a portion of the garage. This overlap gives the stitching program reference points that it needs to assemble the images correctly.

- **Watch out for people moving through the scene.** If people are walking through the area you're shooting, be sure that each person appears only in a single frame. Otherwise, when you stitch the photos, you may wind up with the same person appearing multiple times in the image. Ditto for cars, boats, and other moving vehicles.

If you follow these guidelines, your stitching program should be able to produce a seamless composite with very little trouble. Because each program works a little differently, check your software's Help system or user manual to find out exactly how to use the stitching function if you don't work with Elements.

Change the Color of an Object

Suppose that you have a product shot that features, say, a blue background, like the one on the right in Figure 9-11. But then for some reason, you need a differently colored background — perhaps the image is going on a Web page, and your original background clashes with the page background, or you just decide on another color scheme for aesthetic reasons.

Figure 9-11: To change the background, I selected it and filled it with a new color in my photo-editing program.

You can make this change easily in most photo editors. Here's the most efficient way:

1. **Select the area that you want to change.**

 Chapter 4 shows you how to create a selection outline if you need help.

2. **Open the Layers palette (Window⇨Layers) and create a new, empty layer.**

 Just click the New Layer icon, shown in Figure 9-12.

3. **Select Color from the Layer palette's Blending Mode control, labeled in Figure 9-12.**

Blending Mode control

New Layer icon

Figure 9-12: The Color blending mode is the secret to realistic color changes.

4. **Fill the selected area with paint.**

The quickest way to fill the selection with your new color is to choose Edit⇨Fill Selection, which opens the Fill Layer dialog box. Inside the dialog box, choose Color from the Use drop-down list to open the Color Picker and select your paint color. Click OK to close the Color Picker and click OK again to close the Fill Layer dialog box. (Chapter 7 details this process; see the section related to changing the canvas color.)

Keep in mind that after you paint, you can adjust the opacity of the paint if needed by using the Opacity control in the Layers palette. And you can easily experiment with other paint colors by using the Hue/Saturation filter as explained in the aforementioned section of Chapter 7.

5. **Merge the paint layer with the underlying image by choosing Layer⇨Flatten Image.**

Unfortunately, when you use the Color blending mode, pixels that are completely white or black don't change. If you need to recolor black or white pixels, follow the same steps but set the Blending Mode control to Normal. Then lower the layer opacity (by using the Opacity control in the Layers palette) as needed to produce the results you want.

Create a Web Photo Gallery

Have a bunch of photos that you'd like to share online with friends and family? Don't waste your time (and that of your recipients) by attaching the images one by one to an e-mail message. Instead, create an online gallery of your photos.

You can create and post a gallery in several ways:

- ✔ Join a free online photo-sharing site such as Kodak Gallery (www.kodakgallery.com) or Snapfish (www.snapfish.com). You use the site's software to upload your images and arrange them into albums. Then you can send e-mail invites to everyone you want to be able to view the photos. Visitors can order prints of their favorite images — saving you the time and expense of doing so.

Note that most sites that provide free photo sharing require that you buy a print or some other photo product during the year. If you don't, your pictures are usually deleted.

✓ Purchase a membership in an album site such as Phanfare, at www.
phanfare.com. (A one-year membership to Phanfare is currently about
$55.) The advantage to a paid site is that you usually get more storage
space for your pictures, which means that you can upload full-resolution
pictures to your gallery, an option not available on all free sites. If you
need a convenient way to get high-resolution photos to clients or col-
leagues, this type of site is a great option. Paid sites also aren't cluttered
with the advertising common on free sites.

✓ If you have a Web site or have access to free pages via your Internet
provider, you can create your own custom image gallery. Most photo-
editing programs offer templates for creating galleries; Figure 9-13 shows
a look at a screen found in the gallery-maker in Photoshop Elements.
To get started in that program, choose File⇨Create⇨Photo Galleries.
In Elements 4.0, the command is slightly different: File⇨Create⇨HTML
Photo Gallery. The dialog box was also redesigned in version 5.0, but the
basic options are the same in both versions.

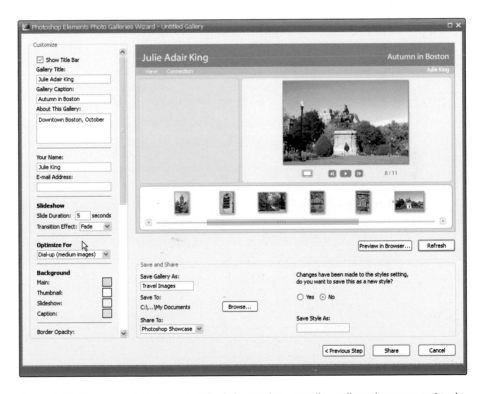

Figure 9-13: You can quickly turn a batch of pictures into an online gallery via automated tools
such as the one in Elements.

Create a Slide-Show Screen Saver

When your computer is turned on but not in use, the monitor probably displays a *screen saver,* a series of graphics or images that move across the screen. You can replace the prefab screen savers that ship with the Windows and Mac operating systems with one that features your favorite images. The next two sections give you the steps.

Putting together a screen saver in Windows XP

To create a screen saver in Windows XP, take these steps:

1. **Put the images that you want to feature in the screensaver in a separate folder.**

 If you don't want to move the pictures out of their current folders for organizational purposes, just make copies to use for the slide show. Then put the copies in a new folder.

 To really do the job correctly, you should resize all the photos to the resolution of your monitor, as explained in Chapter 3. Okay, so you don't absolutely *have* to — Windows will adjust the size of the pictures on the fly in the screensaver — but you didn't hear it from me.

2. **Right-click an empty area of the Windows desktop and choose Properties from the pop-up menu that appears.**

 You see the Display Properties dialog box, shown in Figure 9-14.

3. **Click the Screen Saver tab to display the options shown in Figure 9-14.**

4. **Open the Screen Saver drop-down list and choose My Pictures Slideshow.**

5. **Click the Settings button to open the dialog box shown in Figure 9-15.**

6. **Click the Browse button to open a second box from which you can select the folder that contains the images you want to use in the slide show.**

 Click OK to close the box after you choose the folder.

7. **Adjust the other settings in the My Screen Saver Options dialog box and then click OK to return to the Display Properties dialog box.**

8. **Select the Wait time and password option as desired and then click Apply.**

 If you enable the password control, be sure to write down your password or choose one that's easy to remember! If you forget the password, you won't be able to stop the screen saver to access your normal computer functions.

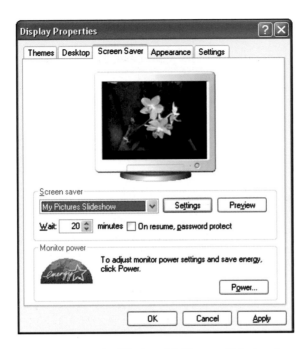

Figure 9-14: Use the Windows My Pictures Slideshow feature to create a custom screen saver.

Figure 9-15: Specify the folder that contains the images you want to include in the slide show.

Creating a photo screen saver on a Mac

If you use a Macintosh computer, follow these steps to create a slide-show screen saver:

1. **Open the System Preferences dialog box by choosing System Preferences from the Apple menu.**

2. **Click the Show All icon and then click the Desktop and Screen Saver icon to display the dialog box shown in Figure 9-16.**

3. **Click the Screen Saver button to display the options you see in Figure 9-16.**

4. **From the Screen Savers list on the left side of the dialog box, choose the folder that contains the images that you want to include in the screen saver.**

 If the folder you want isn't visible, click the Choose Folder option to access additional folders on your system. Click Choose after you find the folder you want to return to the dialog box shown in Figure 9-16.

5. **Use the other controls in the dialog box to customize the screen saver timing and display.**

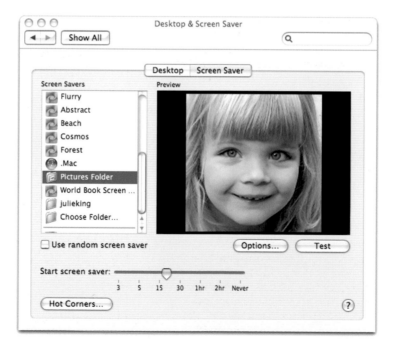

Figure 9-16: On a Mac, create your screen saver via the Desktop and Screen Saver panel of the System Preferences dialog box.

Blur Your Way to an Abstract Image

Want to give a collage or other photo composition an interesting background? You can play around with special effects filters or fill your canvas with prefab patterns or textures (see Chapter 7), but here's another idea: First, find a colorful object to photograph. Then, when you take the picture, simply move your camera slightly back and forth during the exposure. The result will be a blurry pattern featuring the colors in the subject. I used this technique to create the pattern you see on the bottom in Figure 9-17; the image on the top shows a close-up of the hand-painted plate that served as my subject.

Figure 9-17: By intentionally moving my camera while exposing the picture of the plate, I created the cool abstract image on the bottom.

To achieve a significant blur, you need a slow shutter speed. I used a shutter speed of 1 second for my image, for example. If your camera doesn't offer manual exposure or shutter-priority exposure — meaning you have no direct control over shutter speed — try using Nighttime scene mode, if that's available, or check your camera manual to discover other scene modes that may produce a slower shutter.

Of course, if you can't produce the extent of blur you like in camera, you can increase the blur in your photo editor. For example, I applied the Radial Blur filter in Elements to the original plate image to create the variation shown in Figure 9-18. To apply the filter, choose Filter⇨ Blur⇨Radial Blur. This particular filter offers no real-time preview of the resulting effect, so just experiment until you get the look you like. To create the effect in Figure 9-18, I set the filter Amount slider to 100, selected Spin as the Blur Method, and set the Quality option to Best.

Figure 9-18: I created the spinning-colors look by applying the Radial Blur filter in Elements.

Print a Contact Sheet

A *contact sheet,* in photography lingo, is simply a page that contains thumbnails of a batch of images. You can print a contact sheet that shows thumbnails of all the photos that you copied onto a CD or DVD, for example. I take this step every time I archive my images onto a CD, in fact, so that when I'm searching for an image, I can just scan my contact sheets instead of loading CDs into my CD drive.

Most photo-organizer programs offer a command that prints contact sheets. In the Windows version of Elements, for example, you open the Organizer, select the folder or images that you want to include on the contact sheet, and then choose File⇨Print. In the resulting dialog box, shown in Figure 9-19, select Contact Sheet from the Select Type of Print drop-down list, as shown in the figure. You can then specify various aspects of the contact sheet, including the number of thumbnails per page and what data prints with each thumbnail. The center of the dialog box shows a preview of the contact sheet.

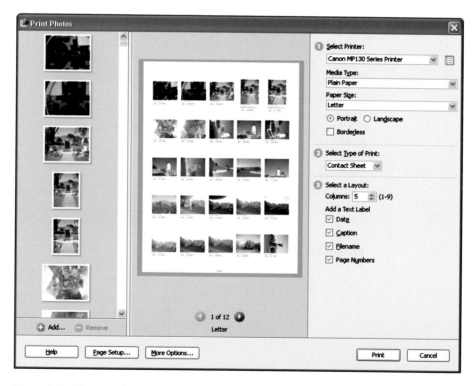

Figure 9-19: You can print a contact sheet showing thumbnails of selected images.

If you use iPhoto, the free organizer provided with recent versions of the Mac operating system, you create a contact sheet in much the same way. Select the images to include on the sheet, click the Print button, and then select Contact Sheet from the Style drop-down list in the resulting dialog box.

Creating One-of-a-Kind Photo Gifts

You probably already know that you can use your digital photos to create custom greeting cards, calendars, and other standard print products. Most photo programs offer templates that simplify the process, and, if you're short on time or energy, just about any quick-print shop, online print service, or local photo lab can do the job for you.

You may not be aware, though, of some of the more unusual types of gifts that you can create from your photos. Here are some of my favorites:

- **Photo postage stamps:** That's right, you don't have to be famous and dead to get your picture on a postage stamp. One online company offering this product is PhotoStamps (http://photo.stamps.com). Some digital-print kiosks found in photo labs also enable you to produce your own stamps. And, yes, the stamps are accepted as standard postage by the post office.

- **Notebook skins:** A *notebook skin* is a self-sticking vinyl cover that you can adhere to your laptop computer case — think grade-school book jacket done up for the digital age. Companies such as Skinit (www.skinit.com) enable you to upload a favorite photo and turn it into your own, personal notebook skin. You can also create skins for mobile phones, MP3 players, and other digital devices.

- **Pillows and other home décor items:** By printing your images on fabric transfer paper, available for most inkjet printers, you can create pillows, blankets, baby bibs, and any other type of fabric-based gift or decorator item you can imagine. For example, I recently turned a collage of family images into a "memory pillow" for my grandmother. The top image in Figure 9-20 shows you the original collage, which I created using the techniques spelled out in Chapter 7; the lower image shows the finished project. Don't sew? You can order a variety of similar items from most photo labs and some scrapbooking stores.

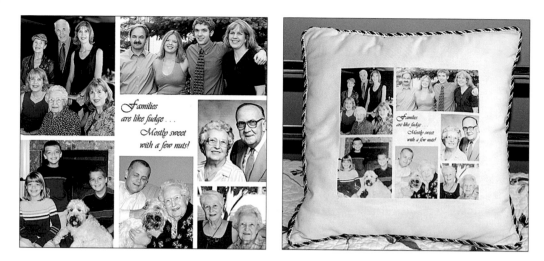

Figure 9-20: I used fabric-transfer paper to put my collage onto the front of the pillow.

Ten Steps to Better Digital Photos

*F*or most folks, getting started in digital photography is a pretty confusing prospect. Even technically savvy people spend a lot of time saying, "huh?" when they go digital.

Earlier chapters of this book break down all the stuff you need to know to master your camera and digital darkroom. But until you have time to digest all that information, don't settle for mediocre pictures. Instead, give this chapter a quick scan during your afternoon coffee break. Just by taking the ten simple steps outlined herein, you can immediately get better results from your digital camera.

Lock in Exposure and Focus Properly

If you use an autofocus, autoexposure camera and haven't taken any photography classes or read other books on the subject, you may not be aware that you need to press the shutter button in a certain way for the automatic mechanisms to work properly.

You can't just jab the shutter button down in one quick press. Instead, frame the shot and press and hold the button down halfway. Wait until the camera signals you — usually with a beep or a light in or near the viewfinder — that it has locked in the exposure and focus. Then press the button the rest of the way down.

Chapter 2 offers more tips about solving exposure and focus problems.

Take Advantage of Automatic Scene Modes

Experienced photographers adjust two main camera controls, aperture (f-stop) and shutter speed, to manipulate focus and exposure. For example, when shooting a portrait, many photographers throw the background into soft focus by using a large aperture (low f-stop number).

For people who don't have the time or inclination to dig into this area of photographic science, most digital cameras offer *automatic scene modes* or *creative* modes. You tell the camera the type of picture you want to take — portrait, action photo, and so on — and it automatically chooses the best aperture, shutter speed, and other options to capture that type of image.

Scene modes typically are indicated by icons like the ones listed in Table 10-1. (The symbols in the table are generic; check your manual to find out how the symbols look on your model.) Note that some cameras have dozens of scene modes to discover; start by getting acquainted with the four standard modes listed in the table. Usually, you can select the major modes via a dial or button on the back of the camera and choose other modes through the camera menus.

Table 10-1		Standard Automatic Scene Modes
Symbol	**Mode**	**What It Does**
🧍	Portrait	Produces softer backgrounds by using a larger aperture
🏃	Sports	Results in faster shutter speed to capture action without blurring
🌷	Macro	Allows for closer focusing to capture close-up shots
⛰️	Landscape	Brings more of the background into sharper focus by reducing aperture size

Use Flash Outdoors; Go Without Indoors

That's right, if you're outside, shoot with flash. If you're inside, shoot without flash. I know, that advice is probably the exact opposite of what you've always believed about using your camera's flash. But because the built-in flash on most cameras produces strong, narrowly focused light, it often results in uneven lighting and harsh shadows like the one you see in the left portrait in Figure 10-1. Flash can also mar the skin with tiny *hot spots* — areas of glare — and red-eye. With still-life shots, flash can produce flares in metal, glass, and other reflective objects. So whenever possible, set your camera to "no flash" mode for indoor pictures.

To light the scene, turn on lots of room lights. You also can pose your subject by a window if you're shooting during the daytime. For my example photo, I posed the subject in the front hallway of his home, which was flooded by sunlight coming through a large window. If lighting is dim, put the camera on a tripod to ensure a blur-free shot; the exposure time required may be longer than you can handhold the camera. Also note that you may need to switch to manual white balance when the room is illuminated both by household lights and daylight; Chapter 2 covers this issue.

Figure 10-1: A built-in flash creates harsh shadows (left). For better results, turn off the flash and shoot by available light (right).

For outdoor shots, on the other hand, the small burst of light from a built-in flash helps eliminate shadows that often occur when your light source — in this case, the sun — is above the subject. Chapter 2 also offers an illustration of the difference a flash can make to outdoor portraits, even on a sunny day.

Pay Attention to the Background

A busy background can draw the eye from your subject and spoil an otherwise great shot, as illustrated by the top image in Figure 10-2. So before you press the shutter button, scan the frame for distracting objects and reposition your subjects if necessary. Look for a plain or subtly patterned background — curtains, a couch cushion, or large floor pillow can work for candid snapshots around the house, as illustrated in the lower image in Figure 10-2.

For my images, taken in a windowless basement where I was forced to use my flash, the change in background had a side benefit, too. In the first image, the flash bounced off the bookshelves, creating a halo of reflected light. And at the original camera angle, the subjects were looking almost directly into the flash, a sure path to red-eye. Posing the pair on the floor pillow and changing the camera angle solved both problems. The fabric didn't reflect light, and the eyes were angled upward instead of directly at the flash, eliminating red-eye.

Figure 10-2: A change in background and camera angle produced a nicer portrait.

If you take lots of product shots or business portraits, visit a fabric store and paw through the remnant table to find inexpensive backdrops. That was my source for the backdrop in Figure 10-1, in fact; I paid all of $2 for it. A canvas drop-cloth from the hardware store also makes a good, neutral background.

For times when you absolutely have no control over the background, visit Chapter 4 to find out how to make it less distracting by applying a blur filter in your photo editor.

Follow the Rule of Thirds

For more interesting pictures, imagine that your viewfinder or LCD monitor is divided into thirds horizontally and vertically, like a tic-tac-toe board. Then place your subject or focal point at one of the spots where those lines intersect, as shown in Figure 10-3.

At first, you'll need to remind yourself to follow this time-honored compositional technique, known as the *rule of thirds*. But after a while, you'll instinctively frame your pictures this way.

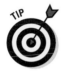

Notice one other aspect of the photo in Figure 10-3: The composition is arranged to create movement — that is, lead the eye from one side of the frame to the other, providing additional visual interest. In this case, the eye is drawn from the rocks in the lower right corner to the boats in the upper left corner.

Figure 10-3: Divide the frame into thirds and position your subject at a spot where the lines intersect.

Frame Loosely to Allow for Flexible Cropping

Most digital cameras create images with an *aspect ratio,* or proportions, of 4:3. Those proportions stem from the fact that digital cameras were originally designed to create photos for viewing on computer monitors, which until recently had screens that were four units wide by three units tall.

The problem is that our standard photo print size, 4 x 6 inches, was created for reproduction of film negatives, which have an aspect ratio of 3:2. So if you want a 4 x 6-inch print of a digital original, you have to crop away part of the photo. Ditto for a 5 x 7 or 8 x 10. The same problem arises, of course, when you enlarge a 3:2 film negative to either of those larger print sizes.

To give yourself the flexibility of cropping your photos to any traditional print size, frame your pictures loosely, leaving a good margin of background around your subject. For example, the image in Figure 10-4 shows a 4:3 digital original. The white border inside the image shows the amount of the composition that will remain if the picture is cropped to a 4 x 6-inch photo.

Figure 10-4: Leave a margin of background around your subject so that you can crop the image to standard frame sizes.

Check Your Camera's Quality Settings

Three settings affect the quality of the images that your digital camera can capture. Chapter 2 explains the details, but here's the short story:

- ✔ **Resolution (megapixels):** Set your camera to capture enough pixels to generate prints that contain at least 200 pixels per inch (ppi). For example, if your end goal is an 8 x 10-inch print, your resolution setting should be 1600 x 2000 pixels or more. Up the pixel count if you plan to crop the image in your photo editor.

- ✔ **ISO:** As you raise the ISO, you increase the camera's light sensitivity, enabling you to snap a picture in less light. But a higher ISO usually

translates into a defect called *noise,* which gives your picture a speckled look, so keep the ISO as low as possible. (Also avoid Auto ISO, which adjusts the setting without your input.)

✔ **File Format (JPEG, TIFF, or Camera Raw):** JPEG, the standard picture format, applies *lossy compression,* which removes some image data in order to create smaller files. JPEG produces excellent pictures *if* you select the highest-quality JPEG setting that your camera offers. (Check your manual for instructions.) TIFF and Camera Raw, available on some cameras, don't apply lossy compression and so offer the highest picture quality. But both TIFF and Camera Raw create large files, and you must convert those files to JPEG in your photo editor before you can share them online.

Say "Cheese"? Please Don't!

For more captivating people pictures, resist the urge to line up everyone into a formal grouping and photograph them standing at attention, shouting "cheese!" Instead, capture people interacting or doing activities they love. Not only will your pictures be more interesting, they'll reveal more of your subjects' personalities. I offer up the photos in Figure 10-5 as an example. After capturing the traditional, side-by-side pose, I asked the brother-and-sister team to "go crazy and have fun!" The right image, taken during that part of the shoot, perfectly captures the playful but loving nature of this duo.

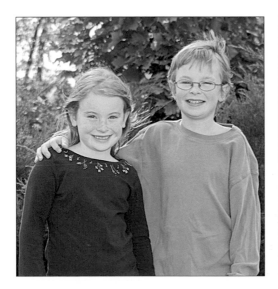

Figure 10-5: This brother-and-sister team looks fine in the formal shot (left), but the unposed version is more engaging (right).

Don't Save Edited Photos in the JPEG Format

If you open a photograph in your photo editor and then make changes to the picture, don't save your edited photo in the JPEG format. Every time you resave in the JPEG format, you apply more lossy compression, dumping more image data and degrading picture quality. (Merely opening and viewing the photo doesn't do any damage.)

Always save your edited photos in a lossless format, such as TIFF or, in Photoshop Elements, the PSD (Photoshop) format. If you want to share your edited photo online, make another copy of the finished picture in the JPEG format.

Chapter 3 talks about saving photos; Chapter 2 explains more about file formats.

Calibrate Your Monitor for Color Accuracy

For you to properly assess your photos on your computer monitor, the monitor must provide an accurate display. Unfortunately, most monitors are slightly out of whack in that department, adding a slight red, green, or blue color cast to everything you see on-screen. And if your display colors are off base, you can't make good decisions about whether your photo needs any color correction in your photo editor. You also increase the likelihood that your on-screen colors won't match your printed colors. In many cases, the printer is actually on target, and the monitor is to blame for color-matching problems.

To avoid these problems, calibrate your monitor every few months (or more often, if you can). If you use Photoshop Elements for Windows and have a CRT monitor — in other words, not an LCD monitor — a free calibration tool called Adobe Gamma is available to you. In Windows XP, click the Start button, click Control Panel, set the Control Panel to Classic View, and then double-click the Adobe Gamma icon. You see the screen shown in Figure 10-6. Click the Step By Step button and then click Next to start the calibration process. (Note: You may need to install Adobe Gamma separately from the program installation CD, depending on the version of Elements you use.)

If you use an LCD monitor, you can buy a third-party calibration tool from companies such as Gretag-Macbeth (www.gretagmacbeth.com) and Colorvision (www.colorvision.com). But note that LCD monitors aren't the best choice for color-correction projects because the colors vary so much depending on the angle of viewing.

Figure 10-6: Elements for Windows provides a calibration tool called Adobe Gamma.

On the Mac, the System Preferences dialog box offers a similar tool, provided with the operating system itself. Navigate to the Displays section of the dialog box to get to the panel shown in Figure 10-7. Click the Color button, choose your monitor, and then click Calibrate.

Figure 10-7: On a Mac, the System Preferences dialog box contains a calibration tool.

Appendix

Bonus Content on the DVD

*T*his book ships with a DVD that contains all sorts of goodies, including trial photo software plus video lessons in which I show you exactly how I created some of the photo projects. Before I detail exactly what's on the DVD, though, I need to emphasize a couple of critical points about this type of DVD:

✔ **The DVD is a data disc, not a movie DVD.** That means that the DVD plays only in the DVD drive on your computer, not on the player you may have hooked up to your TV or on a portable DVD movie player.

✔ **To play the tutorial movies, you need Apple QuickTime Movie Player.** If you don't already have the player, you can download a free copy from the Apple Web site, www.apple.com. See the upcoming section "Using the DVD" for more information about viewing the tutorials.

✔ **If your computer has a separate CD drive and DVD drive, be sure to use the DVD drive.** I don't say this to insult your intelligence — they look exactly the same from the outside, and it's easy to get them mixed up. Or is it just me? At any rate, a CD drive won't be able to read the DVD.

✔ **Keep the DVD in its protective sleeve when not in use.** Otherwise, the disc may become scratched or otherwise damaged, and thus unplayable.

With that bit of housekeeping out of the way, the rest of the appendix explains how to install the trial software, adds a few notes about viewing the video tutorials, and provides a complete list of the DVD contents.

System Requirements

In order to access and use all the content on the DVD, your computer needs to meet the following system requirements:

- ✔ A PC with a Pentium or faster processor; or a Mac OSX computer with a G3 or faster processor
- ✔ At least 512MB of system memory (RAM) and enough empty hard drive space to hold the programs that you want to install
- ✔ Microsoft Windows 2000 or later; or Mac OSX system software 10.1 or later
- ✔ A DVD-ROM drive

Also note that to run Adobe Photoshop Elements, the software featured in this book, your system must offer a monitor resolution of at least 1024 x 768.

If your computer doesn't match up to most of these requirements, you may have problems using the software and files on the DVD. For the latest and greatest information, please refer to the ReadMe file included on the DVD.

If you need more information on the basics of computer systems, check out these books published by Wiley Publishing, Inc.: *PCs For Dummies,* by Dan Gookin; *Macs For Dummies,* by Edward C. Baig; *Windows Vista For Dummies* or *Windows XP For Dummies,* both by Andy Rathbone.

Using the DVD

To get starting using the content on the DVD, take these first steps:

1. **Insert the DVD into your computer's DVD-ROM drive.**

 The license agreement appears.

 Note to Windows users: The interface won't launch if you have autorun disabled. In that case, choose Start➪Run. In the dialog box that appears, type **D:\start.exe**. (Replace D with the proper letter if your DVD-ROM drive uses a different letter. If you don't know the letter, see how your DVD-ROM drive is listed under My Computer.) Click OK.

 Note for Mac users: The DVD icon will appear on your desktop. Double-click the icon to open the DVD and then double-click the Start icon.

2. **Read through the license agreement, and then click the Accept button if you want to use the DVD.**

 The DVD interface appears.

3. **On the left side of the window, click the Software, Video Tutorials, or Sample Images button, depending on what you want to do.**

To install the trial software, follow the on-screen instructions. To view the movies or work with the sample images, see the further instructions laid out in the next two sections.

Viewing the tutorial movies

To view the movies, you need a copy of the Apple QuickTime Player. If you don't have the player, visit the Apple Web site, www.apple.com, to download a free copy of the player. Follow the instructions at the Web site to install and start the player.

To ensure that the movies play smoothly, I recommend that you copy the movie files to your computer's hard drive before attempting to play them. The movie files are large, so many computers may have trouble playing them directly from the DVD. If your hard drive is limited in space, copy and watch a single movie at a time, deleting the movie after you view it to make room for the next one.

Here's the process for copying and viewing the movies:

1. **Follow Steps 1 and 2 in the preceding section and then click the Video Tutorials button.**

2. **Click the category of the movie that you want to view.**

 See the upcoming section "Video tutorials" for a complete listing of what each category contains. After you choose a category, a window appears showing you the contents of the folder. The window follows the standard Windows or Mac operating system design, depending on which type of computer you use.

3. **Copy the movie files to your hard drive as you would copy any file.**

 Windows: Select the movie file and then choose Edit⇨Copy to Folder to start the copying process.

 Mac: On a Mac, drag the file to the folder where you want to store the movie, following the normal Finder techniques.

4. **Exit the DVD interface by clicking the Exit button at the top of the window.**

5. **Start QuickTime Player.**

 Follow the same procedure you use to start any program on your system.

6. **Choose File⇨Open File to display the standard Windows or Mac file-opening dialog box.**

7. **Navigate to the spot on your hard drive where you copied the movie files.**

8. **Select the movie you want to view, and click Open.**

From this point forward, just click the Play button in the player window. If you need help using the player, choose Help⇨QuickTime Player Help in the program window.

Working with the sample images

As with the video tutorials, I suggest that you copy the sample images to your computer's hard drive before opening them. Your photo-editing software can process images located on your hard drive faster than images located on a CD or DVD.

To copy the images, just follow Steps 1 through 4 in the preceding section. You then can open the pictures from inside your photo editor as you do any photo.

What You'll Find on the DVD

The following sections are arranged by category and provide a listing of the DVD contents. If you need help with installing the items provided on the DVD, refer to the instructions in the preceding section.

For each photo program listed, I include the Web address where you can find more information and purchase the full retail product. I also provide the program platform (Windows or Mac) plus the type of software. For future reference, programs fall into one of the following categories (although not all are represented on this DVD):

Shareware programs are fully functional, free, trial versions of copyrighted programs. If you like particular programs, register with their authors for a nominal fee and receive licenses, enhanced versions, and technical support.

Freeware programs are free, copyrighted games, applications, and utilities. You can copy them to as many computers as you like — for free — most of them offer no technical support.

Trial, demo, or *evaluation* versions of software are usually limited either by time or functionality (such as not letting you save a project after you create it).

Photo-editing programs for beginners

The following programs are aimed at the novice digital photographer, providing lots of on-screen help and easy-to-use tools. Some programs also offer tools for organizing your pictures; see the later section "Photo organizing programs" for a list of other programs specifically designed for that bit of business.

- **Adobe Photoshop Elements 5.0,** Adobe Systems Incorporated, 30-day tryout for Windows, www.adobe.com

- **ArcSoft PhotoImpression,** ArcSoft, Inc., 30-day trial for Windows, www.arcsoft.com

- **Corel Snapfire Plus,** Corel Corporation, 30-day trial for Windows, www.corel.com

Advanced photo-editing programs

If you need higher-level tools than are found in most beginner photo-editing programs, check out these products:

- **ArcSoft Photo Studio,** ArcSoft, Inc., 30-day trial for Windows and Mac, www.arcsoft.com

- **Corel Paint Shop Pro,** Corel Corporation, 30-day trial for Windows, www.corel.com

- **Nikon Capture NX,** Nikon Inc., 30-day trial version for Windows, www.NikonUSA.com.

- **Ulead PhotoImpact,** Ulead Systems, Inc., 30-day trial version for Windows, www.ulead.com

Photo organizing programs

Need a tool to keep track of all your digital photos? Many of the aforementioned photo-editing programs offer that capability, but the following programs specialize in the task. Note that some of these programs also offer basic photo-editing tools, although their primary function is photo organizing.

- **ACDSee Photo Manager,** ACD Systems, 30-day trial for Windows, www.acdsee.com

- **Extensis Portfolio,** Extensis, 30-day trial for Windows and Mac, www.extensis.com

- **ThumbsPlus,** Cerious Software, 30-day trial for Windows, www.thumbsplus.com

Specialty programs

The programs in this group are geared to special photo-editing needs or photo artistry; I added a brief description of each product to give you an idea of what you can do with it.

- **ArcSoft Panorama Maker,** ArcSoft, Inc., 30-day trial for Windows, www.arcsoft.com. Use this program to stitch multiple images into a photo panorama, a topic introduced in Chapter 9.

✔ **ArcSoft Scrapbook Creator Memories Edition,** ArcSoft, Inc., 30-day trial for Windows, www.arcsoft.com. Love scrapbooking? This program has all the tools you need to explore the digital version.

✔ **ArcSoft Photo Greeting Card,** ArcSoft, Inc., 30-day trial for Windows, www.arcsoft.com. Don't settle for store-bought greeting cards; make your own photo cards with this program.

✔ **Corel Painter,** Corel Corporation, 30-day trial for Windows and Mac, www.corel.com. This popular digital-painting program also has a neat automated tool that helps you turn your digital photos into paintings, even if you have absolutely no artistic experience.

✔ **Dfine, Nik Sharpener Pro 2.0 Complete, and Nik Color Efex Pro 2.0 Complete,** Nik Software, 30-day demos for Windows and Mac, www.niksoftware.com. These three so-called *plug-ins* add extra functionality to Adobe Photoshop, Photoshop Elements, and other compatible photo-editing programs. Dfine helps you eradicate noise, a photo defect discussed in Chapter 2. Nik Sharpener Pro offers tools for sharpening the focus of your photos based on their intended final use (commercial printing, inkjet printing, and so on). And my favorite, Nik Color Efex Pro, provides a super lineup of color filters and other special-effects filters.

Video tutorials

To help you better understand some of the more complex projects in this book, I've created custom video tutorials that enable you to watch me actually complete the steps involved. I narrate each step, providing additional tips and hints along the way. In addition, I recorded tutorials about some Photoshop Elements tools and tricks that I didn't have room to cover in the book.

Table 1 lists all the book tutorials that are included on this book's DVD.

Table 1	Book Tutorials
Title	*Length*
Getting Started with Adobe Photoshop Elements	15:08
Opening Files in Adobe Camera Raw	10:53
Selection Basics	17:03
Selecting with the Magic Wand	6:36
Retouching Eyes and Teeth	15:13

Title	Length
Improving Exposure and Focus	14:26
Repairing Skin	13:22
Gluing Photos Together with Digital Paste	16:22
Advanced Image Blending	7:50
Creating Cool Backgrounds	13:06

Just to sweeten the, er, disc, the DVD also contains a few sample movies from my 4-hour tutorial DVD, *Adobe Photoshop Elements 4.0 for the Family Photographer*. And my friend Rick Sammon, the noted photographer and Photoshop expert, also agreed to let me share with you a few movies from two of his DVDs, *Rick's Roundup of Adobe Photoshop Enhancements* and *Rick Live!*. Both DVDs, plus additional titles by other photographers and Photoshop gurus, are available for purchase online through Rick's Pixel Magic, www.rickspixelmagic.com. See Table 2 for a list of the sample movies that are included on the *Digital Photo Projects For Dummies* DVD.

Table 2	Sample Movies from Commercial DVDs (Julie King and Rick Sammon)		
Title		Length	Author
Power Selecting with the Selection Brush (Elements 4.0)		6:45	Julie King
Introduction to Layers (Elements 4.0)		14:23	Julie King
Removing Flaws with the Clone Tool (Elements 4.0)		14:33	Julie King
Basic Flash Techniques (photography tips)		5:20	Rick Sammon
CS2 Selective Saturation (Photoshop)		2:36	Rick Sammon

Sample images

You probably already have lots of your own digital photos, but you may find it easier to understand the project steps if you work through them the first time using the same images that you see in the book. So I've included as many of those photos as possible on the DVD. (I don't include most portraits, to protect the privacy of the people who appear in them.)

The photos are located on the DVD in a folder called Sample Images. You can either copy them directly from that folder to your hard drive or open them directly from the DVD.

Please remember that all the sample photos are copyrighted, so you may not reproduce them either in print or online without the publisher's permission. See the earlier section "Using the DVD" for specifics.

Troubleshooting

I tried my best to compile programs that work on most computers with the minimum system requirements. Alas, your computer may differ, and some programs may not work properly for some reason. The two most common causes of problems are that your computer doesn't have enough memory (RAM) for the programs you want to use, or that other programs are running that are affecting installation or running of the software. If you get an error message such as *not enough memory* or *setup cannot continue*, try one or more of the following suggestions:

- **Turn off any antivirus software running on your computer.** Installation programs sometimes mimic virus activity and may make your computer incorrectly believe that it's being infected by a virus.

- **Close all running programs.** The more programs you have running, the less memory is available to other programs. Installation programs typically update files and programs; so if you keep other programs running, installation may not work properly.

- **Have your local computer store add more RAM to your computer.** This is, admittedly, a drastic and somewhat expensive step. However, adding more memory can really help the speed of your computer and allow more programs to run at the same time.

Customer Care

If you have trouble with the DVD, please call the Wiley Product Technical Support phone number at 1-800-762-2974. Outside the United States, call 1-317-572-3994. You can also contact Wiley Product Technical Support at http://support.wiley.com. John Wiley & Sons will provide technical support only for installation and other general quality control items. For technical support on the applications themselves, consult the program's vendor or author.

Index

Don't forget about these bestselling For Dummies® books!

Get started on eBay
and begin making and saving money

eBay®
FOR DUMMIES®

5th Edition

**All you need to
bid, buy, sell,
and succeed**

A Reference
for the
Rest of Us!®

FREE eTips at dummies.com®

Marsha Collier
Author of eBay Business All-in-One
Desk Reference For Dummies

0-470-04529-9

Get the best view of Vista
from the all-time Windows bestseller!

Windows Vista™
FOR DUMMIES®

Here's how to
make Vista behave
and work for you

A Reference
for the
Rest of Us!®

FREE eTips at dummies.com®

Andy Rathbone
Bestselling author of all previous
editions of Windows® For Dummies

0-471-75421-8

Wiley Publishing, Inc.
End-User License Agreement

READ THIS. You should carefully read these terms and conditions before opening the software packet(s) included with this book "Book". This is a license agreement "Agreement" between you and Wiley Publishing, Inc. "WPI". By opening the accompanying software packet(s), you acknowledge that you have read and accept the following terms and conditions. If you do not agree and do not want to be bound by such terms and conditions, promptly return the Book and the unopened software packet(s) to the place you obtained them for a full refund.

1. **License Grant.** WPI grants to you (either an individual or entity) a nonexclusive license to use one copy of the enclosed software program(s) (collectively, the "Software") solely for your own personal or business purposes on a single computer (whether a standard computer or a workstation component of a multi-user network). The Software is in use on a computer when it is loaded into temporary memory (RAM) or installed into permanent memory (hard disk, DVD-ROM, or other storage device). WPI reserves all rights not expressly granted herein.

2. **Ownership.** WPI is the owner of all right, title, and interest, including copyright, in and to the compilation of the Software recorded on the physical packet included with this Book "Software Media". Copyright to the individual programs recorded on the Software Media is owned by the author or other authorized copyright owner of each program. Ownership of the Software and all proprietary rights relating thereto remain with WPI and its licensers.

3. **Restrictions on Use and Transfer.**

 (a) You may only (i) make one copy of the Software for backup or archival purposes, or (ii) transfer the Software to a single hard disk, provided that you keep the original for backup or archival purposes. You may not (i) rent or lease the Software, (ii) copy or reproduce the Software through a LAN or other network system or through any computer subscriber system or bulletin-board system, or (iii) modify, adapt, or create derivative works based on the Software.

 (b) You may not reverse engineer, decompile, or disassemble the Software. You may transfer the Software and user documentation on a permanent basis, provided that the transferee agrees to accept the terms and conditions of this Agreement and you retain no copies. If the Software is an update or has been updated, any transfer must include the most recent update and all prior versions.

4. **Restrictions on Use of Individual Programs.** You must follow the individual requirements and restrictions detailed for each individual program in the "Bonus Content on the DVD" appendix of this Book or on the Software Media. These limitations are also contained in the individual license agreements recorded on the Software Media. These limitations may include a requirement that after using the program for a specified period of time, the user must pay a registration fee or discontinue use. By opening the Software packet(s), you agree to abide by the licenses and restrictions for these individual programs that are detailed in the "Bonus Content on the DVD" appendix and/or on the Software Media. None of the material on this Software Media or listed in this Book may ever be redistributed, in original or modified form, for commercial purposes.

5. **Limited Warranty.**

 (a) WPI warrants that the Software and Software Media are free from defects in materials and workmanship under normal use for a period of sixty (60) days from the date of purchase of this Book. If WPI receives notification within the warranty period of defects in materials or workmanship, WPI will replace the defective Software Media.

 (b) WPI AND THE AUTHOR(S) OF THE BOOK DISCLAIM ALL OTHER WARRANTIES, EXPRESS OR IMPLIED, INCLUDING WITHOUT LIMITATION IMPLIED WARRANTIES OF MERCHANTABILITY AND FITNESS FOR A PARTICULAR PURPOSE, WITH RESPECT TO THE SOFTWARE, THE PROGRAMS, THE SOURCE CODE CONTAINED THEREIN, AND/OR THE TECHNIQUES DESCRIBED IN THIS BOOK. WPI DOES NOT WARRANT THAT THE FUNCTIONS CONTAINED IN THE SOFTWARE WILL MEET YOUR REQUIREMENTS OR THAT THE OPERATION OF THE SOFTWARE WILL BE ERROR FREE.

 (c) This limited warranty gives you specific legal rights, and you may have other rights that vary from jurisdiction to jurisdiction.

6. **Remedies.**

 (a) WPI's entire liability and your exclusive remedy for defects in materials and workmanship shall be limited to replacement of the Software Media, which may be returned to WPI with a copy of your receipt at the following address: Software Media Fulfillment Department, Attn.: *Digital Photo Projects For Dummies*, Wiley Publishing, Inc., 10475 Crosspoint Blvd., Indianapolis, IN 46256, or call 1-800-762-2974. Please allow four to six weeks for delivery. This Limited Warranty is void if failure of the Software Media has resulted from accident, abuse, or misapplication. Any replacement Software Media will be warranted for the remainder of the original warranty period or thirty (30) days, whichever is longer.

 (b) In no event shall WPI or the author be liable for any damages whatsoever (including without limitation damages for loss of business profits, business interruption, loss of business information, or any other pecuniary loss) arising from the use of or inability to use the Book or the Software, even if WPI has been advised of the possibility of such damages.

 (c) Because some jurisdictions do not allow the exclusion or limitation of liability for consequential or incidental damages, the above limitation or exclusion may not apply to you.

7. **U.S. Government Restricted Rights.** Use, duplication, or disclosure of the Software for or on behalf of the United States of America, its agencies and/or instrumentalities "U.S. Government" is subject to restrictions as stated in paragraph (c)(1)(ii) of the Rights in Technical Data and Computer Software clause of DFARS 252.227-7013, or subparagraphs (c) (1) and (2) of the Commercial Computer Software - Restricted Rights clause at FAR 52.227-19, and in similar clauses in the NASA FAR supplement, as applicable.

8. **General.** This Agreement constitutes the entire understanding of the parties and revokes and supersedes all prior agreements, oral or written, between them and may not be modified or amended except in a writing signed by both parties hereto that specifically refers to this Agreement. This Agreement shall take precedence over any other documents that may be in conflict herewith. If any one or more provisions contained in this Agreement are held by any court or tribunal to be invalid, illegal, or otherwise unenforceable, each and every other provision shall remain in full force and effect.

R.C.L.

SEP. 2007

G